FILM POSTERS
HORROR

FILM POSTERS
HORROR

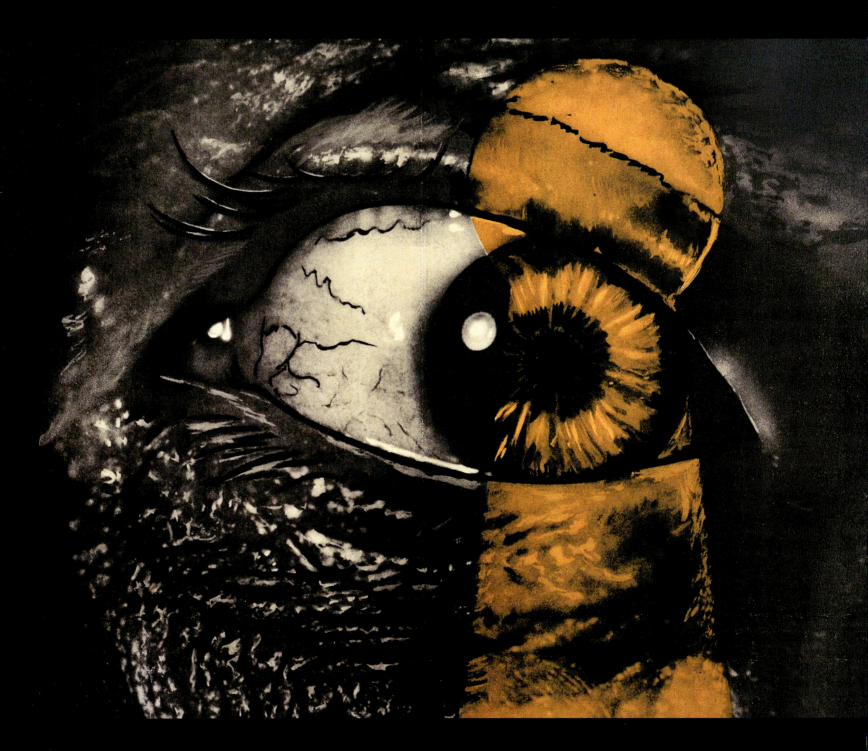

edited by tony nourmand and graham marsh
foreword by professor sir christopher frayling

EVERGREEN is an imprint of
TASCHEN GmbH

© 2006 TASCHEN GmbH
Hohenzollernring 53, D-50672 Köln
www.taschen.com

ISBN 978-3-8228-5626-0

Printed in Singapore

Art direction and design by Graham Marsh
Text by Tony Nourmand and Alison Aitchison
Research and Co-ordination by Alison Aitchison
Page layout by Trevor Gray
Editing by Roxanna Hajiani
Proof-reading by Priya Elan
Principal photography by A.J. Photographics

Unless otherwise stated, all images used in this book are from
The Reel Poster Archive

ACKNOWLEDGEMENTS

Richard & Barbara Allen, Farhad Amirahmadi, Martin Bridgewater,
Kamyar Broumand, Joe Burtis, Glyn Callingham, Jean-Louis Capitaine,
Andrew Cohen, Martin Coxhead, Tony Crawley, Andrew Curtis,
Chris Dark, Stephen Durbridge, Todd Feiertag, Greg Ferland,
Film Museum, Berlin, Leslie Gardner, Armando Giuffrida,
Helmut Hamm, Kirk Hammett, The Hastings Collection,
Yoshikazu Inoue, Eric & Prim Jean-Baptiste, Andy Johnson,
John & Billie Kisch, Peter & Betty Langs, Andrew MacDonald,
Krzysztof Marcinkiewicz, Sylvestrova Marta, June Marsh,
Philip Masheter, Kirby McDaniel, Russell Mulcahy, Museum of
Decorative Arts, Prague, The Crew from the Island, The Nouvelle
Vague Collection, Tomoaki 'Nigo' Nagao, Stephen O'Connor,
Tony Sasso, Separate Cinema, Steve Smith, Dan Strebin,
Jonathan Wilkinson, The X-Rated Collection and Kim Goddard

Special thanks to Bruce Marchant; without his help, these books would
not be possible.

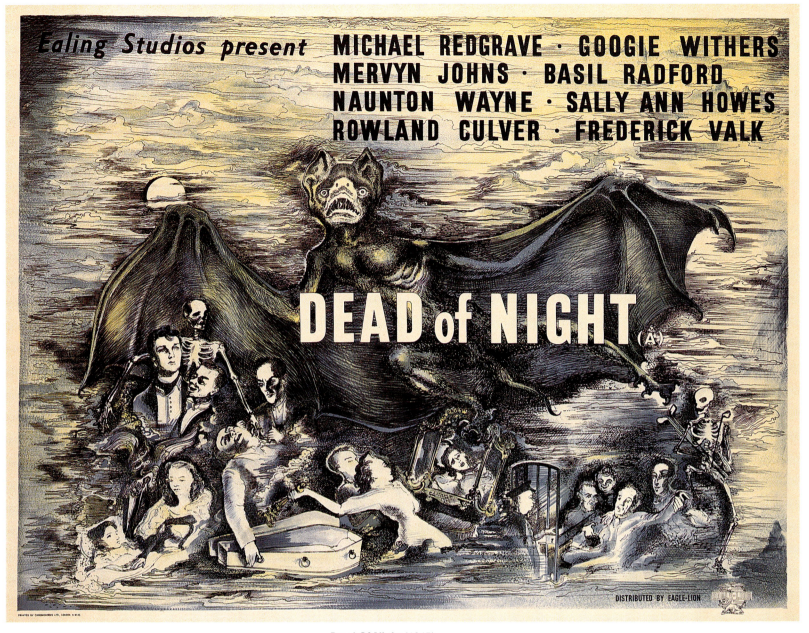

Dead Of Night (1945)
British 30 × 40 in. (76 × 102 cm)
Art by Leslie Hurry
Courtesy of The Reel Poster Gallery

CONTENTS

FOREWORD

In July 1935, the novelist and critic Graham Greene wrote a review of *The Bride Of Frankenstein* for *The Spectator*:

Poor harmless Mary Shelley, when she dreamed that she was watched by pale, yellow, speculative eyes between the curtains of her bed, set in motion a vast machinery of actors, of sound systems and trick shots and yes-men. It rolls on indefinitely … presently, I have no doubt, it will be colour-shot and televised; later in the Brave New World to become a smelly.

Greene's point was that the journey from literary text to Hollywood film involved a steep decline, which was likely to get steeper. For him, the richness and the horror of the original had been lost on the way, and Mary Shelley's nightmare – experienced when she was just eighteen years old in June 1816 on her famous summer holiday in Geneva – had turned into the product of a modern assembly line. Part of the problem, Greene concluded, was that film-makers had to be so very *literal* in their visualizations of the horror.

It is true that in the three foundation texts of the horror genre – *Frankenstein* (1818), *The Strange Case Of Dr Jekyll And Mr Hyde* (1886) and *Dracula* (1897) – the horror tends to be seen out of the side of the eye; out of the corner of the retina, as ghost-story writer M. R. James reckoned the most effective ghosts should be seen. Impressions rather than facts. Much of the anxiety they created was about what they *didn't* reveal.

Mary Shelley's three-volume *Frankenstein* is not presented as a straightforward linear narrative of the kind which screen-writers are comfortable with. It is presented as a collage of documents: the letters of explorer Robert Walton to his sister – the framing device – Victor Frankenstein's personal reminiscences and his creature's auto-biography. As late as 1928, the studio was despairing of ever being able to turn this material – even after it had been successfully dramatized on the stage – into an acceptable movie. In the case of *Dr Jekyll* there are documents written by the doctor's bachelor friends Utterson and Lanyon, followed by the confessions of Henry Jekyll himself. *Dracula* consists of journals, diaries, newspaper cuttings and transcribed phonograph recordings. These literary collages reveal different perspectives on the horror, multiple points of view, and, in *Dr Jekyll* and *Dracula*, the points of view which are missing are those of Mr Hyde and the Count himself. The horror does not have a voice.

Nor does it have much of an appearance. Where physical descriptions are concerned, there was very little for dramatists and screenwriters to get their teeth into. How did Mary Shelley describe Frankenstein's first view of the creature?

His limbs were in proportion, and I had selected his features as beautiful. Beautiful! – Great God! His yellow skin scarcely covered the work of muscles and arteries beneath; his hair was of a lustrous black, and flowing; his teeth of a pearly whiteness; but these luxuriances only formed a more horrid contrast with his watery eyes, that seemed almost of the same colour as the dun white sockets in which they were set …

And how did Robert Louis Stevenson describe Mr Hyde? 'It wasn't like a man; it was like some damned juggernaut'; 'I had taken a loathing to my gentleman at first sight'; 'The look of him … went somehow strongly against the watcher's inclination'; 'And still the figure had no face by which he might know it; even in his dreams it had no face …'

And how did Bram Stoker describe Jonathan Harker's first view of Dracula?

His face was a strong – a very strong – aquiline, with high bridge of the thin nose and peculiarly arched nostrils; with lofty domed forehead, and hair growing scantily round the temples, but profusely elsewhere. His eyebrows were very massive, almost meeting over the nose, and with bushy hair that seemed to curl in its own profusion. The mouth, so far as I could see it under the heavy moustache, was fixed and rather cruel-looking, with peculiarly sharp white teeth … The general effect was one of extraordinary pallor.

In the process of turning these descriptions into cinematic experiences, various changes took place. Frankenstein was to become, not a new Adam, but a thing of scars and stitches and skewers – loosely based by make-up designer Jack Pierce on an image of the madhouse entitled *The Chinchillas* from Francisco Goya's series of prints *Caprichos/Caprices* (1799). His huge dome-like forehead and big feet made him resemble, as did Goya's print, someone with an acromegalic condition and a serious pituitary problem: an image of disability (like many 'monsters' in popular culture) rather than of beauty. It simultaneously made him resemble a well-built working man.

Universal Studios' make-up department briefly toyed with the idea of making their monster look like a robot, or mechanical man (an early teaser campaign famously held onto this idea): but, in the end, the only remnant of that design concept was the steel bolt through Karloff's neck, something to plug him into. Mary Shelley had never once mentioned the exaggerated forehead, the stitches *or* the steel bolt. And, when describing the nightmare which gave birth to her story, she referred casually, maybe too casually, to 'the working of some powerful engine' which made the creature 'show signs of life and stir within an uneasy, half vital motion'. In the novel, she was even less specific: 'I collected the instruments of life around me, that I might infuse a spark of being into the lifeless thing that lay at my feet.'

And that's all. Hollywood, in 1931, was more than ready to fill the gap (films do indeed have to be literal about these things) with pieces of technology which had not been invented in 1816 – lightning-arc generators, bakelite dials and an adjustable metal hospital bed – plus some pieces which had: among them, a huge Voltaic battery. Result: 'IT'S ALIVE'. The main influence here was not *Frankenstein* at all, but Fritz Lang's film *Metropolis* (1926) – with its climactic transformation of a human being into a soft machine at the hands of the evil designer/necromancer Dr Rotwang.

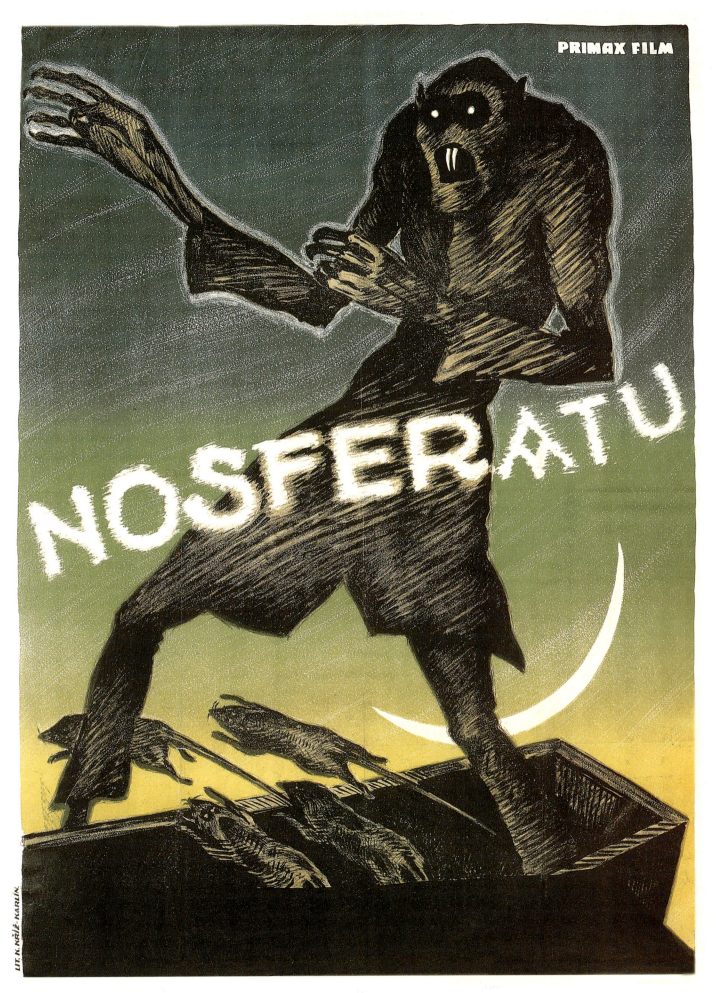

Nosferatu, Eine Symphonie Des Grauens (Nosferatu The Vampire) (1922)
Czechoslovakian 39 × 32 in. (98 × 80 cm)
Courtesy of the Museum of Decorative Arts, Prague

At about the same time, the faceless Mr Hyde turned into a crouching, ape-like creature who enacted Dr Jekyll's secret desires on the streets of the East End of London (rather than the West End of the original novella): an immature lout and a throwback to an earlier, less repressed, stage of evolution. And the cinematic Hyde was always, following theatrical tradition, from John Barrymore (1920) onwards – including Fredric March (1932), Spencer Tracy (1941) and Boris Karloff (1953) – played by the same actor as Dr Jekyll. Robert Louis Stevenson insisted that 'Hyde was the *younger* of the two', that Jekyll was 'not good looking' in the first place and that Hyde was *not* 'a mere voluptuary' who was jealous of Jekyll's attraction for his girlfriend. But the film forgot about all that, and even decided to mix *Dr Jekyll* and the Whitechapel murders while they were about it. The transformation of Count Dracula from elderly military commander with massive eyebrows and a breath problem into red-eyed lounge-lizard in evening dress was less straightforward.

The first authorized illustration, on the cover of the British paperback edition of 1901, stayed with the military commander, only it had him crawling down the wall of the castle – a very different kind of lizard. But the first cinematic Dracula, *Nosferatu* (1922) – arguably the most influential horror film of all time – was cursed from the start, because it was made illegally without clearing copyright on the literary property. The Count still had massive eyebrows and a lofty domed forehead but this time he owed his existence to an equally massive breach of copyright. There were a few changes of name (Orlok for Dracula, Hutter for Harker) but no one was fooled. Production sketches, graphics and poster designs were by expressionist painter, devout spiritualist and amateur film producer Albin Grau – the poster had diagonal rats running over the Count's great-coated legs, to match the diagonal shadows of the film itself – and the Count became a creature of folklore with pointy ears, rodent teeth and bald head; a penis with fangs. A German court eventually ruled that all positive and negative copies of *Nosferatu* be destroyed. But then, a print surfaced in London and … so on. There was no stopping the circulation of the vampire. He just went on resurrecting from his legal grave, which was just as well, because *Nosferatu* contains probably the most beautiful intertitle of the whole silent era: 'And when he had crossed the bridge, the phantoms came to meet him.' The film also led inexorably to the first Hollywood version of *Dracula* which, when it opened at the Roxy Theatre in New York on Valentine's Day 1931, was billed as 'good to the last gasp!'. No longer a repulsive folkloric Count, Dracula had become utterly irresistible to the female characters and it was hoped to the paying customers as well. Bela Lugosi rolled his r's too much, the castle staircase was infested with armadillos, for some reason, and all the interesting action took place off-screen but, despite all this, *Dracula* was a box-office sensation.

So Graham Greene was right when he wrote that the journey from literary text to Hollywood film involved a series of elaborate transformation scenes. But it was not a question of decline. It was, and is, a question of an even more important transformation – from nineteenth-century literature to twentieth-century popular myth. The narratives have been made linear; the missing facts in the case have been supplied; the absences have been remedied; the surface realism which was lacking in the originals has had to be invented and visualized; and the great horror stories have been recreated over and over again – as myths, as vehicles for receiving the demons and fears of successive audiences, or rather the demons and fears of audiences as interpreted by Hollywood professionals. The stories have become parallel texts, ones that are of more immediate appeal and instantly recognisable. The stories have made new sense. They have come to play a large part in global culture – via films, sequels of films, posters, advertisements, toys, games, computer software, popular novels, comics, even themed restaurants. You name it, Frankenstein, Dr Jekyll and Dracula have been in some way associated with it. Everything from operas to breakfast cereal products. If a six-year-old can eat it, then these three demons are on it. They have even been absorbed into everyday speech: 'A Frankenstein monster', 'Frankenstein foods', 'a Jekyll-and-Hyde character', 'a vampiric relationship'. Frankenstein's creature and Count Dracula are both in the list of 'top five characters most often portrayed in film', while *Dr Jekyll* is the third 'most remade story' in film history.

Charles Dickens wrote of ghosts in *A Christmas Tree* (1850) that 'it is worthy of remark [that they are] reducible to a very few general types and classes; for, ghosts walk in a beaten track.' The same could be said of horror films. And so the foundations of the genre – in literary and early cinematic form – are of much more than antiquarian interest. Some people reckon, as writer Geoffrey O'Brien has perceptively written, that these foundations are:

> … crucial to a genre that seems to define itself by constantly recapitulating everything it has been…. To watch many horror movies is in some sense to watch the same movie over and over: they are drawn to their past in the same way that their characters are compelled to go back to the ancestral crypt…. The rest is ornament and variations on a theme, a matter of more masks or bigger masks or more convincingly detailed masks.

This super-movie has survived all the variations of which the book you are about to read is a visual chronicle: the expressionism of the 1920s and the camp expressionism of the 1930s; the drive-in triple features of the 1950s; the rise of Hammer Films, where British cinema discovered sex and the gore was in chocolate-box colours; the Italian pop surrealism of the 1960s; the psycho killers and seriously dysfunctional families of the 1970s and 1980s; the shift from margin to mainstream in the 1990s; above all, the change from pre-Second World War horror (where normal society was where the good guys lived) to post-70s horror (where the horror has become a form of liberation, and normality has itself become strange).

Throughout all this history, the more masks and bigger masks and more detailed masks have taken on a life of their own. And as a result the atmosphere surrounding horror films from the beginning has been that of a carnival sideshow – not quite respectable, a guilty pleasure, a glimpse of another world where transgressive things happen, a bit tacky (let's face it) and above all an experience which does not quite live up to the poster, the promotional gimmicks and the slightly mad showman standing outside the tent. As historian David J. Skal has pointed out, the culture of horror has always had as much to do with carnival-style promotional gimmicks as with the films themselves – just like Dr Caligari standing outside his side-show at Holstenwall Fair, and inviting the hapless students in to see the

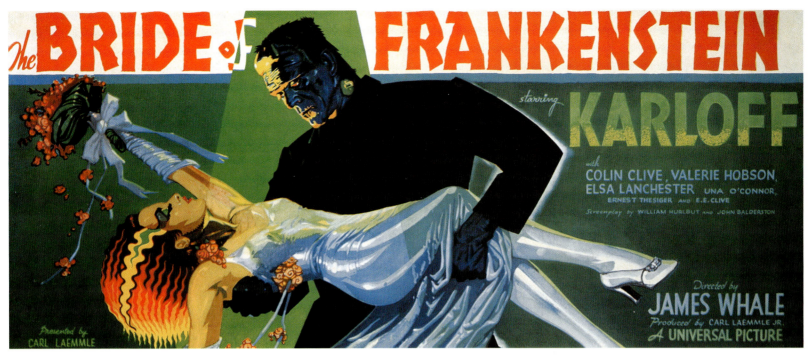

The Bride Of Frankenstein (1935)
US 14 × 28 in. (26 × 71 cm)
(Pictorial Snipe – Style B)
Art by Karoly Grosz

somnambulist Cesare with a lot of hype and a life-sized poster which looks like it was painted by Edvard Munch. Such gimmicks do not use the same campaign tactics as mainstream Hollywood movies: the names of the stars, the quality of the production, the timeliness of the story. Instead they blare out a warning or a challenge usually in the colour yellow: 'Warning! The monster demands a mate', 'When the screen screams you'll scream too …', 'You'll wish it were only a nightmare' and, my personal favourite (from *Whatever Happened To Baby Jane?*), 'Sister, sister/ oh so fair/ why is there blood/ all over your hair?'

Stephen King tells the story of producers Samuel Z. Arkoff and James H. Nicholson, who were the kings of AIP drive-in movies between 1954 and 1968. Their pre-production style was simple and effective. They would think up a catchy title, trawl interest in it, then produce an even more catchy poster, trawl interest in that, and only then – if there was enough take-up – would they begin to think about actually making a movie. Title first, poster second, movie third. Producer William Castle, in the late 1950s, added a few carnival refinements of his own: the offer of medical treatment, for those who found the horror too much; insuring audiences with Lloyds of London if any of them should die during *Macabre*, some cinema seats wired to produce mild electric shocks for *The Tingler*. His autobiography was called *Step Right Up! I'm gonna scare the pants off America*. Of course it was.

Astonishingly, some of the visuals used in these campaigns and movies came indirectly – very indirectly – from the world of high art. I have mentioned Frankenstein's monster and Goya. The monster's female victim – being carried or lying in terror on a bed – as often as not derives from Fuseli's painting *The Nightmare*. Skull Island in *King Kong* is from Bocklin's *Isle Of The Dead*. Norman Bates' mansion echoes Edward Hopper's *House By The Railroad*. The *Alien* design is

kin to Francis Bacon's *Figures At The Base Of A Crucifixion*. Edvard Munch's *Scream* is everywhere, as is the gnarled dying oak tree and waxing moon from Caspar David Friedrich's *Two Men Contemplating The Moon*. The shadow of Friedrich lies over the whole of *Nosferatu*. And so on. For some reason, much of the art comes from Northern Europe in the nineteenth century. The transformation of literary text into full-blooded horror movie grabbed its influences wherever it could find them – always trying to ensure that the devil had all the best tunes. High art, carnival art, what the hell?

In the end, the patter of the carnival barker boils down to this: he assumes we want to be scared; he assumes we want to see, from the relative safety of our cinema seat, the horror that normally would not dare to speak its name. The Romantic poets called this 'desire and loathing strangely mixed' or 'the tempestuous loveliness of terror'. Charles Dickens' fat boy in *The Pickwick Papers* put it more bluntly: 'I wants to make your flesh creep.' We believe these old, old stories and we don't believe them – both at the same time. We approach them as we do the carnival magician in *The Wizard Of Oz*, even when we have realized he is a charlatan. Okay, the posters do not always bear much resemblance to the movies they are promoting, but after the fadeout they are among the strongest images we take away – part of a rich visual store-house. This book, edited with characteristic flair and care and understanding by Tony Nourmand and Graham Marsh, includes many of the best. As you read it, think of William Castle's high-impact advertising line from *Straightjacket*: 'Just keep saying to yourself, "It's only a movie … It's only a movie … IT'S ONLY A MOVIE".'

Christopher Frayling
April 2004

WARNING! THE MONSTER IS LOOSE!

A man once wrote to Alfred Hitchcock explaining that after seeing *Psycho* his wife was afraid of bathing or showering. He wanted to know what Mr. Hitchcock would suggest. 'Sir', replied Hitch, 'have you ever considered sending your wife to the dry cleaner?' But for those who are affected by it, on-screen horror fear is no joking matter. There are countless people throughout the world who, years after seeing Steven Spielberg's *Jaws*, will not swim out of their depth while taking a dip in the sea – or, indeed, ever venture into the water again.

Nonetheless, many, if not all, of us enjoy the titillating prospect of being frightened out of our wits by a horror movie, and it is the job of film poster artists to whet our appetites. The disturbing Czechoslovakian poster for *Psycho* by Zdenek Ziegler and Mick McGinty's frightening illustration for *Jaws* are just two examples that show how successful they have been over the years. Of course, the horror genre is packed with creations that just beg artists to give their imaginations free rein – from blood-sucking vampires and Gothic monsters to giant apes and human mutants. Many of the images they have created have become iconic, like S. Barrett McCormick and Bob Sisk's artwork for *King Kong*, or the posters for *The Shining*, *The Exorcist* and *Halloween* which feature key-art that is as famous as the films they promote.

Alongside the classics we reproduce lesser-known posters and in many ways these are often even more interesting. The Czechoslovakian poster for F. W. Murnau's infamous *Nosferatu* has never been seen before and is a stunning depiction of the repulsive vampire. Bernhard Atelier Ledl's poster for *Das Cabinet Des Dr Caligari* and the German poster for *M* are fantastic examples of art from the expressionist era. Closer to home, the British poster for Ealing's *The Dead Of Night* is one of the best posters from the studio's long history and Jan Lenica's British poster for *Repulsion* owes more to the styles and approach of the art of his native Poland than to the traditions of classic British poster design.

The range and variety of poster designs and styles from around the world is enormous. Though there are national traditions in the field – the abstract poster art of Eastern Europe forms an obvious contrast with the more literal American tradition – styles can also vary widely within the same country; Roger Rojac and Raymond Gid were both French poster artists working in the 40s and 50s, but their designs for, respectively, *The Lodger* and *Les Diaboliques* could hardly be more different. And, of course, there are posters, like that for the Swedish *Vargtimmen (Hour Of The Wolf)* which defy categorization and stand alone as isolated footnotes in the history of horror poster art.

Cinematic horror was derived from a strong literary tradition many of whose classic works – Mary Shelley's *Frankenstein*, Bram Stoker's *Dracula* and Robert Louis Stevenson's *Dr Jekyll And Mr Hyde* – have successfully made the transition to the screen. And it is ironic that the actors who gave us the definitive portrayals of these monsters, Lon Chaney, Boris Karloff and Christopher Lee did not like the term 'horror', preferring instead the French description: 'the theatre of the fantastic'. But, whatever he liked to call it, Karloff owed everything to horror and was the first to admit that Frankenstein was the best friend he ever had.

Once dismissed as a disposable advertising medium, movie posters are now recognized as a seriously collectable art form. And when it comes to the prices collectors are willing to pay, eight of the top ten movie posters, and all of the top five, have come from the horror or science-fiction genres. The most expensive, Karoly Grosz's poster for *The Mummy*, sold for more than double the record price ever paid for a Toulouse Lautrec poster. This makes Grosz the most expensive poster artist on record.

Horror Poster Art is a celebration of the artists, both famous and anonymous, who have been responsible for some of the most memorable movie posters ever produced. The book is certainly not intended to be a definitive catalogue, but rather to provide just a taste of what is out there. Mysteriously, both of us were stricken with long and unusual illnesses during the few months we have been working on this book. We therefore want to add a disclaimer before you proceed: 'Warning! The Monster is Loose!'

Tony Nourmand and **Graham Marsh**
May 2004

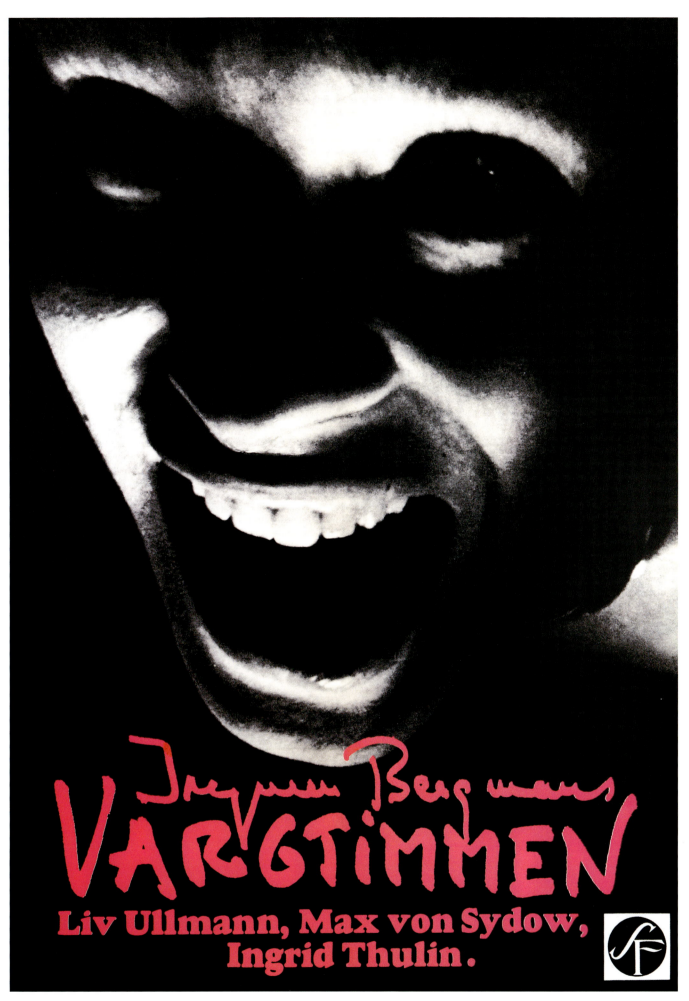

Vargtimmen (Hour Of The Wolf) (1967)
Swedish 39 × 27 in. (99 × 69 cm)
Courtesy of The Reel Poster Gallery

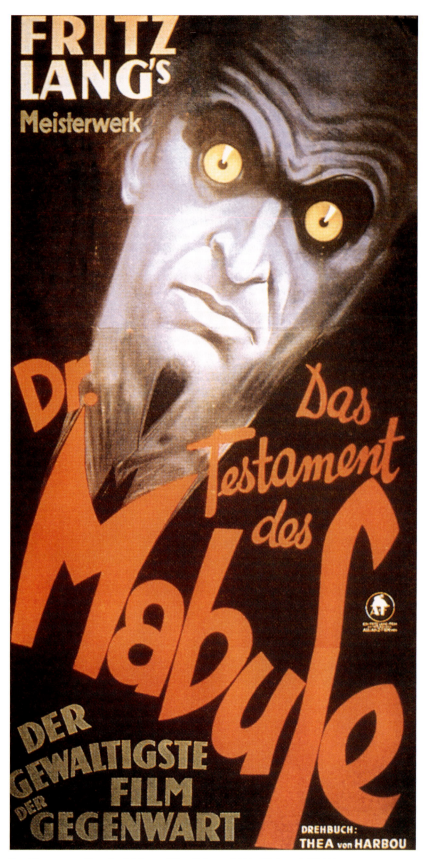

Das Testament Des Dr. Mabuse (The Crimes Of Dr. Mabuse) (1933)
German 56 × 37 in. (142 × 95 cm)
Art by R. Vogl
Courtesy of the Film Museum, Berlin

Fritz Lang (1890–1976) was born in Vienna. He studied architecture for a while before leaving home at twenty to travel the world, supporting himself through his drawing and painting. He was conscripted into the Austrian Army in the First World War, but was discharged after being wounded four times. While he was convalescing, he began to write screenplays and shortly afterwards he moved into the film world. His directorial debut was in 1919 with *Halbblut (Half-breed)*. Lang worked in Berlin where he produced several masterpieces including *Metropolis*, his *Dr Mabuse* series and his first 'talkie', *M*. He fled Germany the same day the Nazis came to power, leaving behind everything, including a wife who had joined the National Socialists, and arrived in Hollywood with nothing but his reputation. Adapting quickly to the different styles and demands of the American industry, Lang was soon making a name for himself in his adopted country. His first film in America was *The Fury* in 1936. Many years later, in 1960, he revisited one of his early themes with another exploration of the character of Dr Mabuse in *The Thousand Eyes Of Dr Mabuse*, the last film he ever made. Although his later work is commendable, it is his early expressionist masterpieces that earned him a place in cinematic history.

His work in the 20s and 30s was always on a grand scale, using striking cinematography that anticipated the style of *film noir*. Lang's lens was often focused on cruelty, horror and the ways in which power could be misused by evil men, themes that he explored with particular care in the *Dr Mabuse* series.

First released in 1922, *Dr Mabuse* is a tour de force of silent cinema in which several genres – mystery, police drama and horror – are combined. Almost four hours long, it was often shown in two parts; *Dr Mabuse: The Gambler* and *Dr Mabuse: King Of Crime*. It is set amid the social and economic chaos of post-war Germany, an environment where people made money any way they could in order to stay alive, and one which offers Dr Mabuse full scope for his talents as a master of the underworld. The film does not attempt to judge Mabuse's choice of occupation; his downfall is not attributed to his criminality, but to the fact that, even by his own standards, he is a cheat and this is the ultimate sin. Mabuse remains one of the screen's most memorable villains and, with the benefit of hindsight, the film offers an almost prophetic vision of the fate that befell Germany ten years later.

Das Testament Des Dr Mabuse was Lang's talkie sequel to *Dr Mabuse*. The last film of the German expressionist movement, it makes no attempt to disguise the parallels that the director drew between criminals and Nazis. It was Lang's final film before he fled the country and was banned in Germany by Goebbels. The premiere of the film took place in Budapest and it would not be shown in its country of origin until 1951.

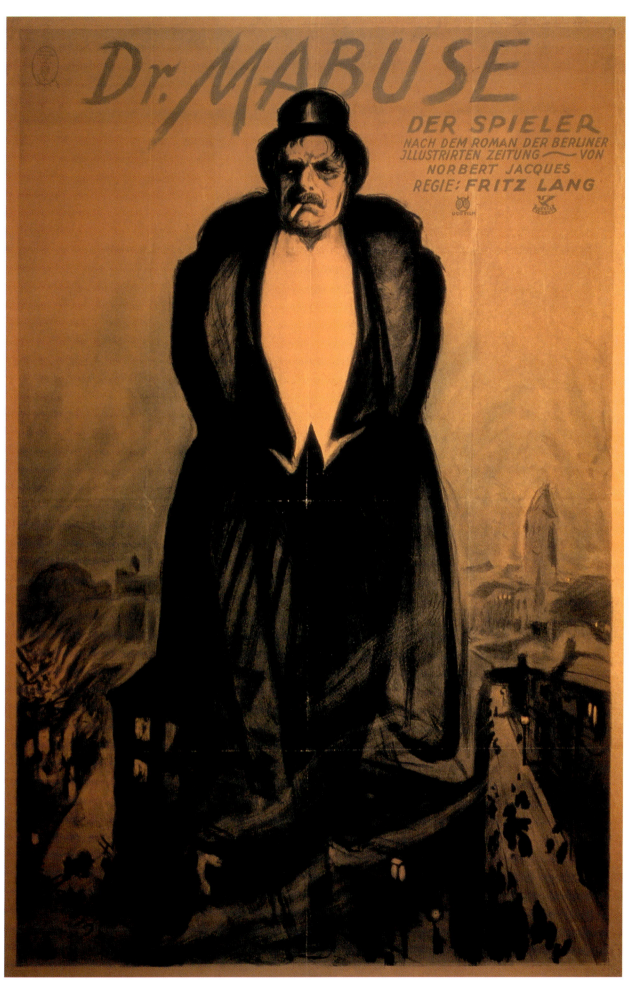

Dr. Mabuse, Der Spieler (Dr. Mabuse: The Gambler) (1922)
German 110 × 50 in. (280 × 126 cm)
Art by Theo Matejko
Courtesy of the Film Museum, Berlin

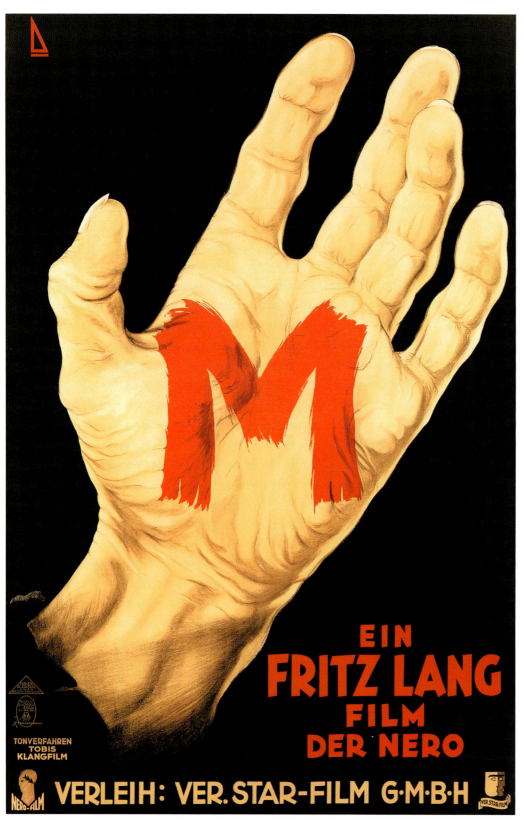

M (1931)
German 56 × 38 in. (142 × 97 cm)
Courtesy of the Andrew Curtis Collection

Das Cabinett Des Dr Caligari was born out of the horror of the First World War. Germany had suffered hugely in the war itself and in the turmoil that followed and had been left humiliated by the Treaty of Versailles. Two disillusioned ex-soldiers, Hanz Janowitz and Carl Mayer, wrote the screenplay for the film as a political metaphor for the way that millions had been marched to war by the Kaiser's government. But its historical importance extends well beyond the realm of politics: it is credited with being both the first 'art' film and the first horror film. It is set in a fantasy world and has a dream-like quality, which was unheard of for the time. With bizarre and amazing set effects and cinematography, the original film was tinted in shades of brown, green and metallic blue. When it premiered in Germany on 6 February 1920, the reaction was overwhelming, with crowds cheering and applauding. The same happened when it was shown in New York a few years later. It was a huge hit with both intellectuals and the public at large.

Caligari heavily influenced *Nosferatu, The Golem* and *Metropolis,* and later *Citizen Kane, Vertigo* and the director Tim Burton, to name but a few. The film was part of the expressionist movement in art, literature and cinema that grew out of the experiences of the First World War. The German expressionists were much concerned with the problems that beset their country and the apparent failure of the new Weimar Republic to provide the answers. The films of this period convey a pervasive atmosphere of unreality: their style is characterized by chiaroscuro tones, dream-like settings, surreal set designs and bizarre protagonists. *Das Cabinet Des Dr Caligari* has it all. The film posters from this period are also examples of expressionistic art and all the European posters that survived are outstanding and unique artworks.

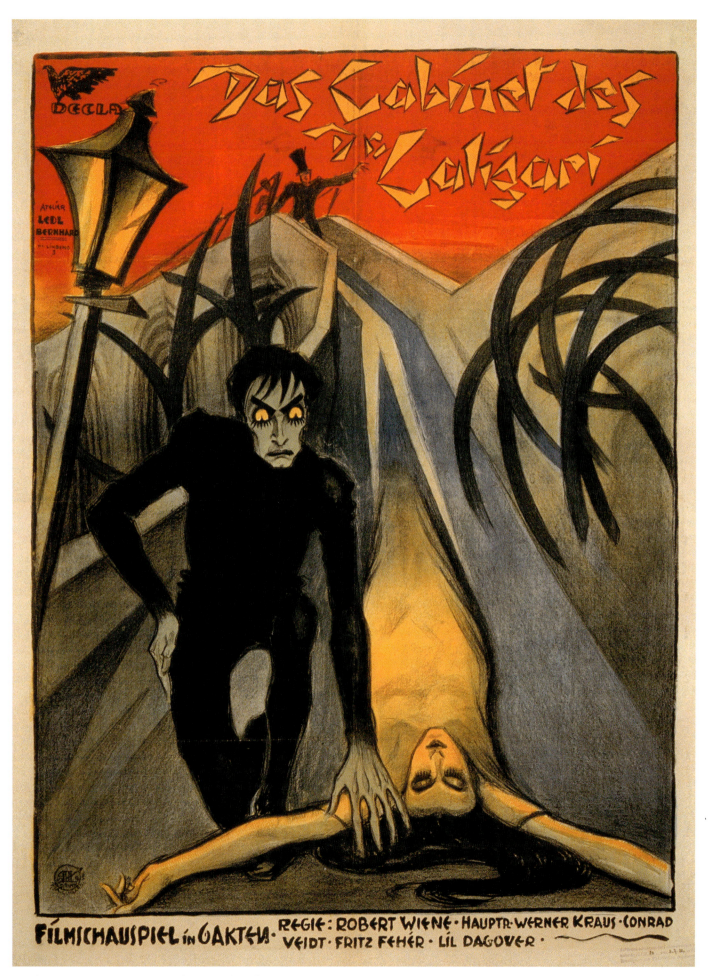

Das Cabinet Des Dr. Caligari (The Cabinet Of Dr. Caligari) (1919)
Austrian 50 × 37 in. (127 × 95 cm)
(Premiere)
Art by Bernhard Atelier Ledl
Courtesy of the Film Museum, Berlin

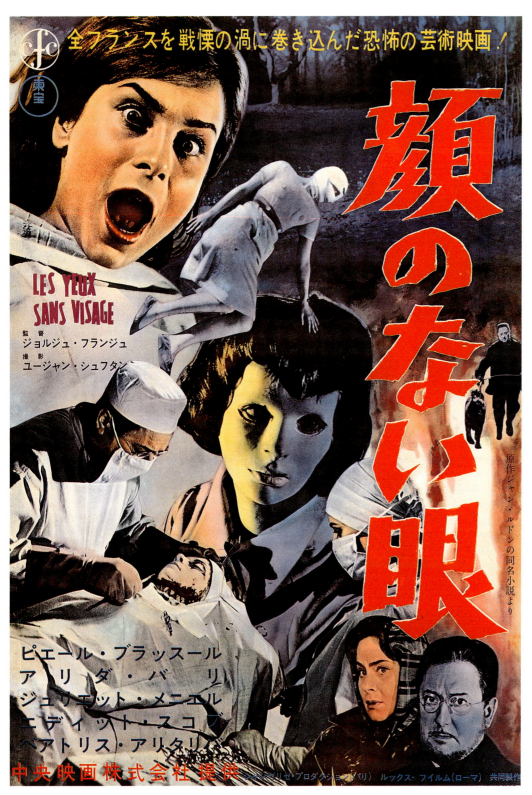

Les Yeux Sans Visage (Eyes Without A Face) (1959)
Japanese 30 × 20 in. (76 × 51 cm)
Courtesy of The Nouvelle Vague Collection

Les Yeux Sans Visage is a poetic and beautiful horror film concerned with the consequences of mutilation. Directed by Georges Franju, the film was part of the French New Wave that emerged in the late 50s and 60s. Although it is indeed horrific, the film is basically a study of how a man is slowly driven into madness through regret and guilt. When released in America under its original title, *Eyes Without A Face*, it failed to draw the crowds. It was subsequently re-released as *The Horror Chamber Of Dr Faustus* in order to appeal to the traditional horror market.

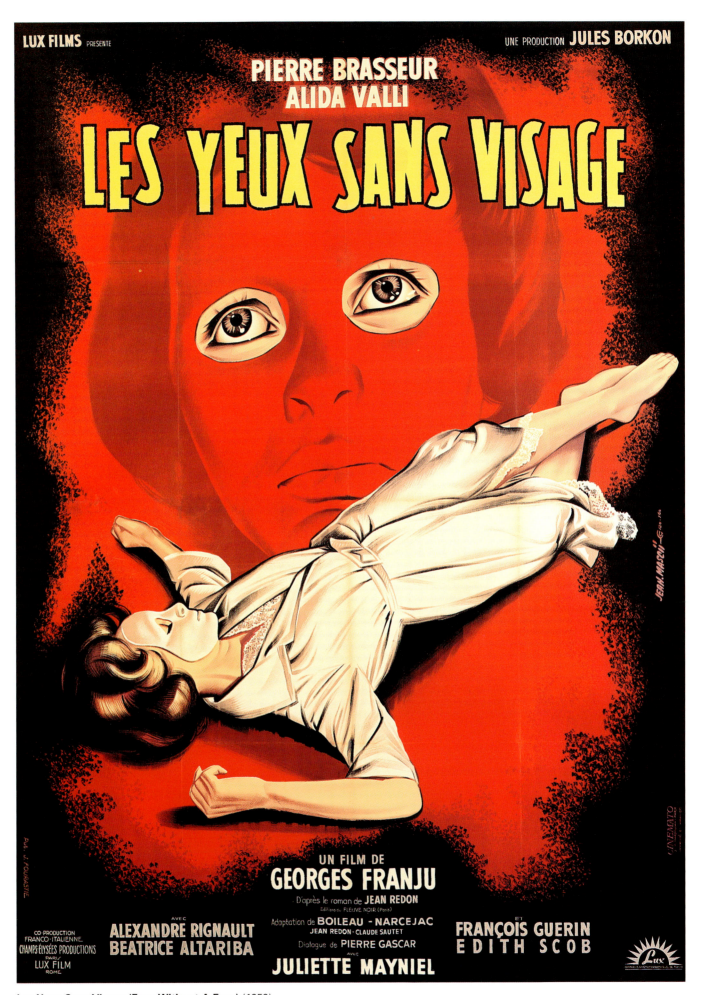

Les Yeux Sans Visage (Eyes Without A Face) (1959)
French 63 × 47 in. (160 × 119 cm)
Art by Jean Mascii
Courtesy of The Nouvelle Vague Collection

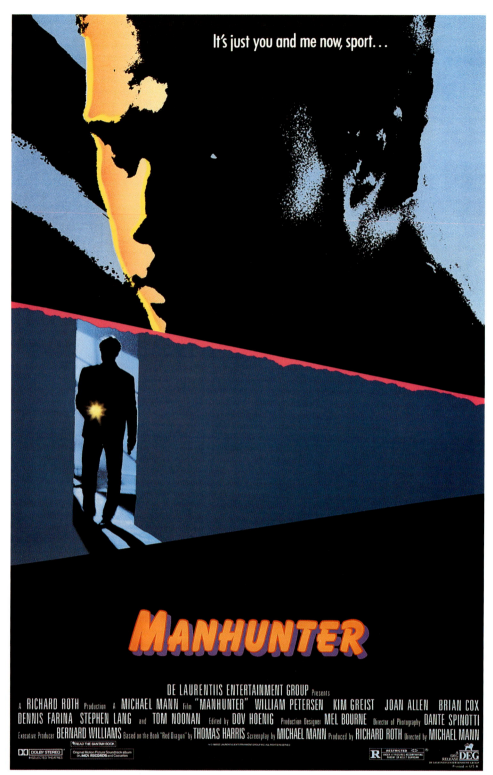

Manhunter (1986)
US 41 × 27 in. (104 × 69 cm)
Courtesy of The Reel Poster Gallery

Although they are often thought of as a twentieth-century phenomenon, there is nothing new about serial killers. There are written records from the fifteenth century that describe the murderous rampage of Gilles de Rais – a Breton nobleman who raped and killed over 140 peasant children. There is also the tale of Countess Elizabeth Bathory, history's most prolific female serial killer, who is thought to have killed over 600 women. She earned the moniker 'Blood Countess', and apparently believed that the blood of her victims was the source of eternal youth. Even the word 'sadism' originates from the eighteenth-century Marquis de Sade whose writings record his obsessive career of sexual torture.

This said, it *is* widely accepted that the public's fascination with apparently motiveless serial killing began in the nineteenth century, partly, no doubt, due to the growth of the popular press and partly because people were no longer willing to accept supernatural explanations for such behaviour. Certainly the first half of the twentieth century saw a steady rise in the number of serial killers who achieved widespread notoriety: Ted Bundy and Ed Gein are just two examples from an endless list.

Murderers who seem to be motivated solely by the pursuit of a perverted pleasure inspire a particular horror, for the obvious reason that no one can feel free from the threat of a killer who chooses his victims at random, leaving people with the feeling that the worst could 'happen to anyone, anywhere.' The movies are never slow to exploit such morbid interest and a whole stream of films have been dedicated to exploring the world of the modern-day serial killer: from Fritz Lang's *M* through *Silence Of The Lambs* and *American Psycho*, serial-killer films have proven their commercial potential.

In 1981, the world was introduced to the infamous cannibal serial killer, Hannibal Lecter, in Thomas Harris' novel, *Red Dragon*, which became a worldwide bestseller. Within five years, the story had been adapted for the screen under the title *Manhunter*. Two years later Harris' continued the story of Hannibal in *Silence Of The Lambs*, and this, too, was adapted for film. Menacing and disturbing, the movie is a masterpiece and is one of only three films to win all five major Academy Awards. The poster showing the moth superimposed on Anthony Hopkins' face is an iconic cinematic image from the 90s. The moth is made-up of a photograph of eight naked women forming the shape of a skull. The photograph, called *In Voluptate Mors*, is by Philippe Halsman and is based on a drawing by Salvadore Dalí.

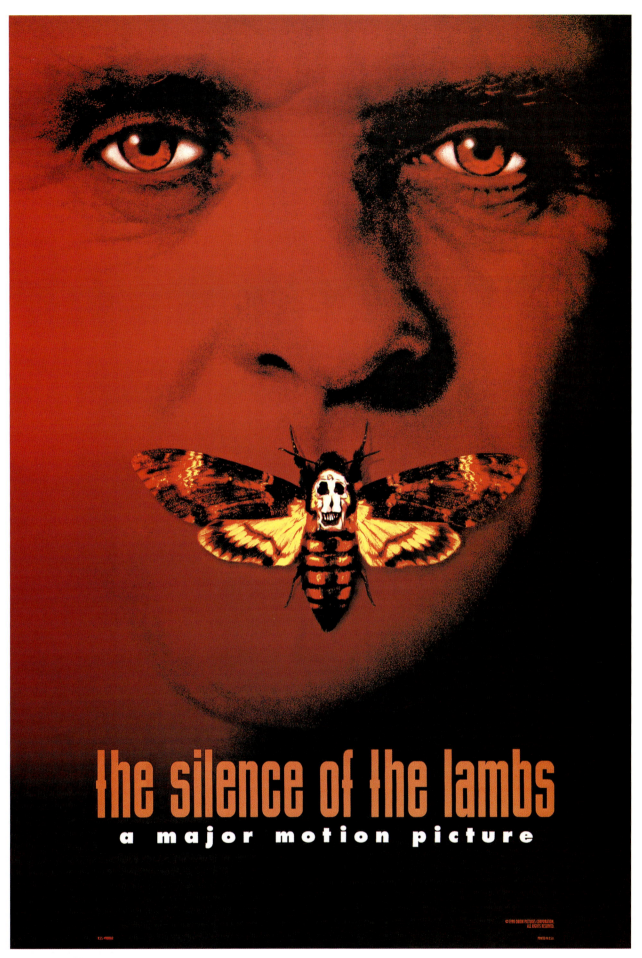

The Silence Of The Lambs (1991)
US 41 × 27 in. (104 × 69 cm)
(Advance – Hopkins)
Photo by Kevin Stapleton, Lee Varis & Ken Regan
Art direction and design by Dawn Teitelbaum
Courtesy of the Martin Bridgewater Collection

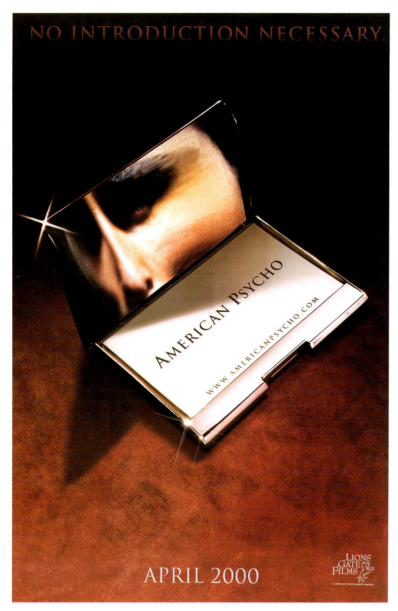

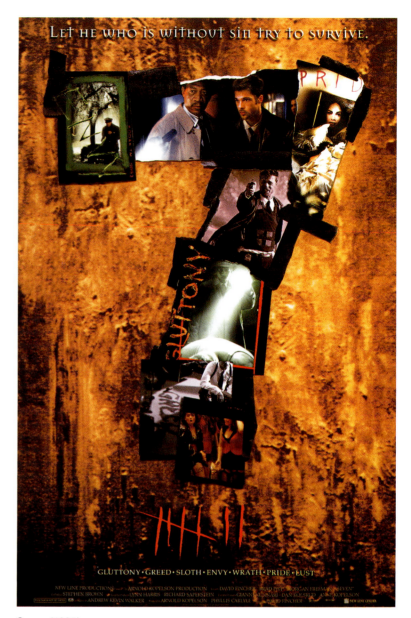

American Psycho (2000)
US 41 × 27 in. (104 × 69 cm)
(Advance)

Seven (1995)
US 41 × 27 in. (104 × 69 cm)
(Advance)
Photo by Peter Sorel
Design by De-La Erickson
Creative direction by Steve Reaves, Chris Pula,
Aimee Petta & Anthony Goldschmidt

Joe Coleman (b. 1955) is both a performance artist and a painter. His work is dark and grotesque and has proved too extreme for many in the art world. Yet, for the more discerning, Coleman's disturbing view of the world is exhilarating and powerful and he has gained international recognition. His childhood and upbringing provide the backbone for the themes that pervade his work: morality, violence and suffering. Being raised an Irish Catholic and living over the road from a graveyard led to an unhealthy fascination with the Bible from an early age. Growing up with abusive parents meant that violence and suffering were a central force in Coleman's life and from the age of eight he was drawing the Stations of the Cross, including sketches of stabbings and burnings.

Coleman says he is influenced most heavily by Medieval and early Renaissance art, especially by the dark visions of Hieronymus Bosch, and it is his skill at combining tradition with popular culture that gives his work its uniqueness. His paintings all have a strong narrative theme and are packed with detail; to achieve the latter he frequently paints with a jeweller's loupe using a single-hair brush. He always finishes his paintings with borders, quotations and charms to protect himself from their power.

Although Coleman's unnerving artwork for *Henry: Portrait Of A Serial Killer* is a wonderful and hypnotic example of his work, it was hardly a surprise when it was pulled from circulation. The film itself – a stark and shocking portrayal of real-life serial killer Henry Lucas – almost met a similar fate; its makers struggled for over three years to find a distributor. The MPAA were unwilling to award it anything less than an 'X' certificate for 'unacceptable' moral content but it was finally rescued from the shelf by filmmaker Errol Morris, who sponsored it at the Telluride Film Festival in 1989.

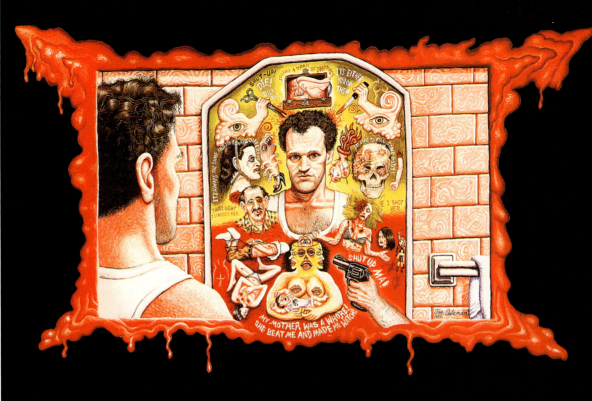

Henry: Portrait Of A Serial Killer (1986)
US 41 × 27 in. (104 × 69 cm)
(Unused)
Art by Joe Coleman
Courtesy of the Andy Johnson Collection

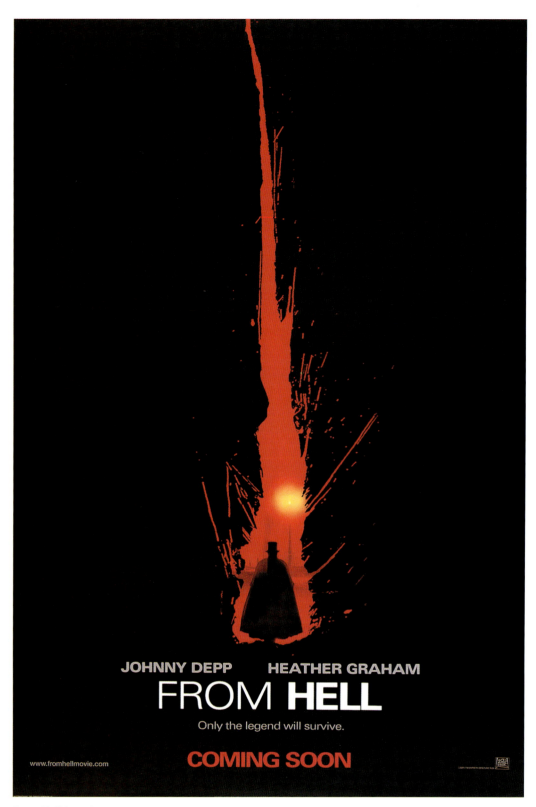

JOHNNY DEPP HEATHER GRAHAM

FROM HELL

Only the legend will survive.

www.fromhellmovie.com

COMING SOON

From Hell (2001)
US 41 × 27 in. (104 × 69 cm)
(Advance)

Jack The Ripper is the most infamous serial killer in history. There have, allegedly, been more books written about the Ripper than all the American presidents combined and a new word, 'Ripperologist', was even coined to describe the thousands who study him all over the world. A number of films have been made about the man, of which *The Lodger* and *From Hell* are just two. The continuing attraction of the subject is that the murders remain a mystery. Although there are many credible theories, featuring royal cover-ups, madmen and doctors, there has never been enough evidence to conclusively prove any of them.

Jack The Ripper has been called 'the first modern-day serial killer' because he was the first mass murderer who captured the attention of the public on a national, indeed an international, scale. By the 1880s, the vast majority of the population were literate, the telegraph had made rapid global communications a reality and the press was a power to be reckoned with. These developments, combined with the particularly brutal nature of the crimes, led to a massive public interest in the case. However, although the police followed several leads and devoted time and energy to the task, the killer never was, and never has been, identified.

Born Roger Jacquier, **Roger Rojac** (1913–1997) had a prolific career in film poster design. The French artist worked on a variety of French, German and American projects, creating dynamic and striking images that remain some of the most memorable from the 40s and 50s.

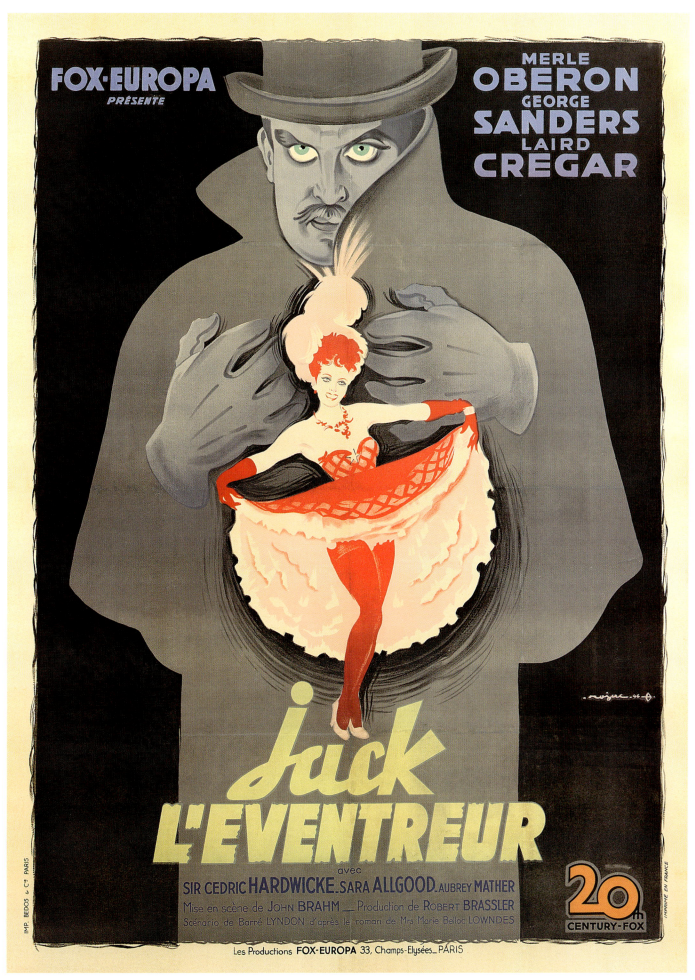

The Lodger (Jack L'Eventreur) (1944)
French 63 × 47 in. (160 × 119 cm)
Art by Roger Rojac
Courtesy of The Reel Poster Gallery

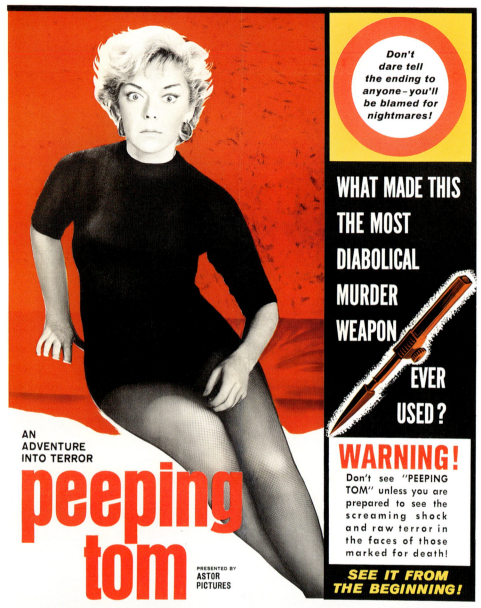

Peeping Tom (1960)
US 41 × 27 in. (104 × 69 cm)
Courtesy of The Reel Poster Gallery

The Peeping Tom of the title is a psychotic cameraman who murders his victims then watches their death on film. A landmark work of genius by director Michael Powell, it is an exploration of sex, voyeurism, obsession and violence. Scholars of the cinema now place it alongside *Psycho* as one of the definitive films of the genre. Its initial reception, however, was far from favourable, with critics rejecting it as a violent, sex-filled exploitation movie; this was apparently a view shared by the film's American distributor whose poster was clearly aimed at the exploitation market. Powell's own career was virtually destroyed in the wake of *Peeping Tom*'s release and it was only years later that the film began to receive the critical attention it deserves.

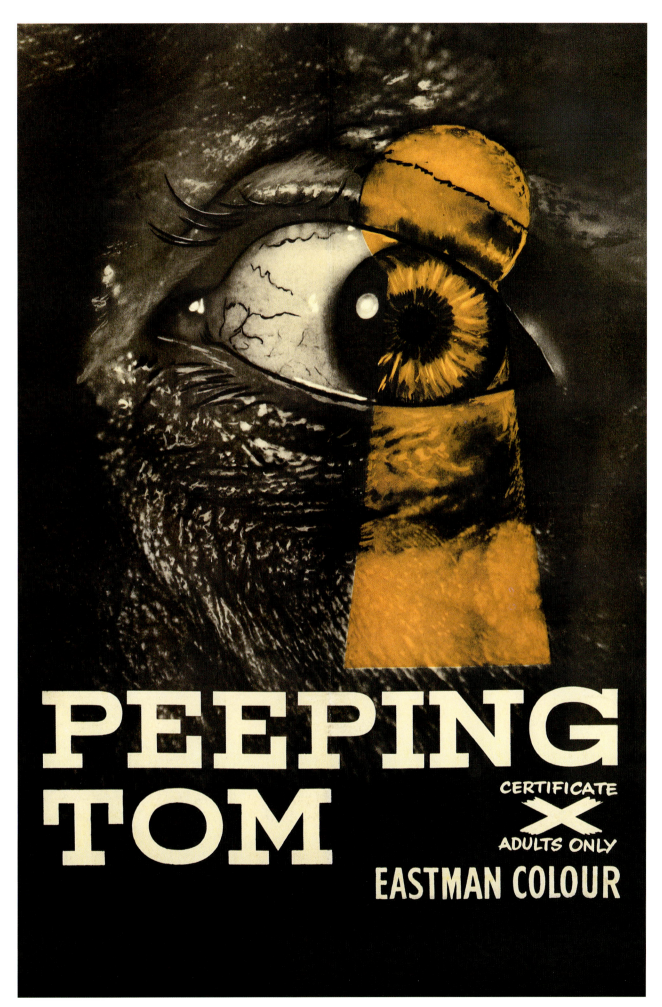

Peeping Tom (1960)
British 30 × 20 in. (76 × 51 cm)
Courtesy of the Tony Nourmand Collection

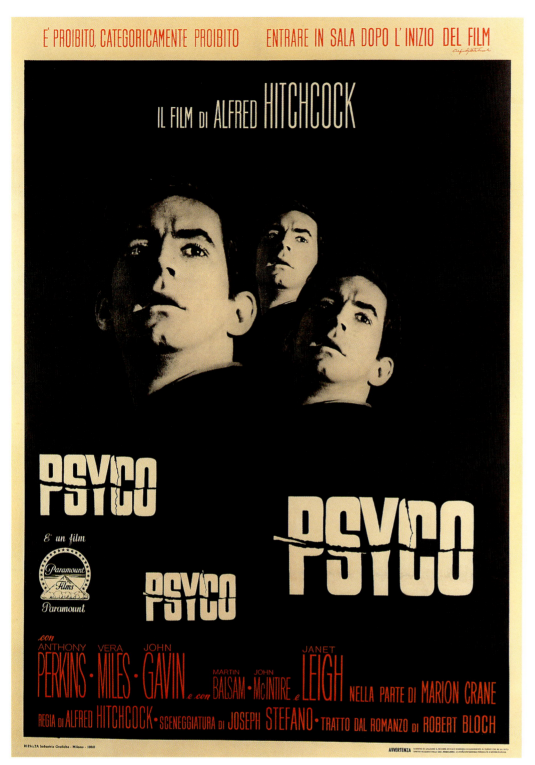

Psycho (Psyco) (1960)
Italian 55 × 39 in. (140 × 99 cm)

Psycho was not only Hitchcock's biggest grossing film, but was a phenomenon in its own right. Made on a budget of less than one million dollars and filmed in black and white – Hitchcock thought it would be too gory in colour – the film is a *magnum opus* of the horror genre and its immediate impact and enduring influence cannot be over-emphasised. The shower scene is one of the most studied and analysed sequences in cinema history and has achieved a notoriety that exceeds that of the film itself. It took 70 cameras to create the 45 seconds of footage and the chilling sound effects were created by stabbing a knife into a melon.

Hitchcock's marketing plan for the film was also a triumph. He insisted on keeping the ending secret– even screenwriter Joseph Stefano saw it for the first time in a movie theatre – and no-one was allowed into the cinema after the start of the film, a gimmick that was played up on specially made American and British posters.

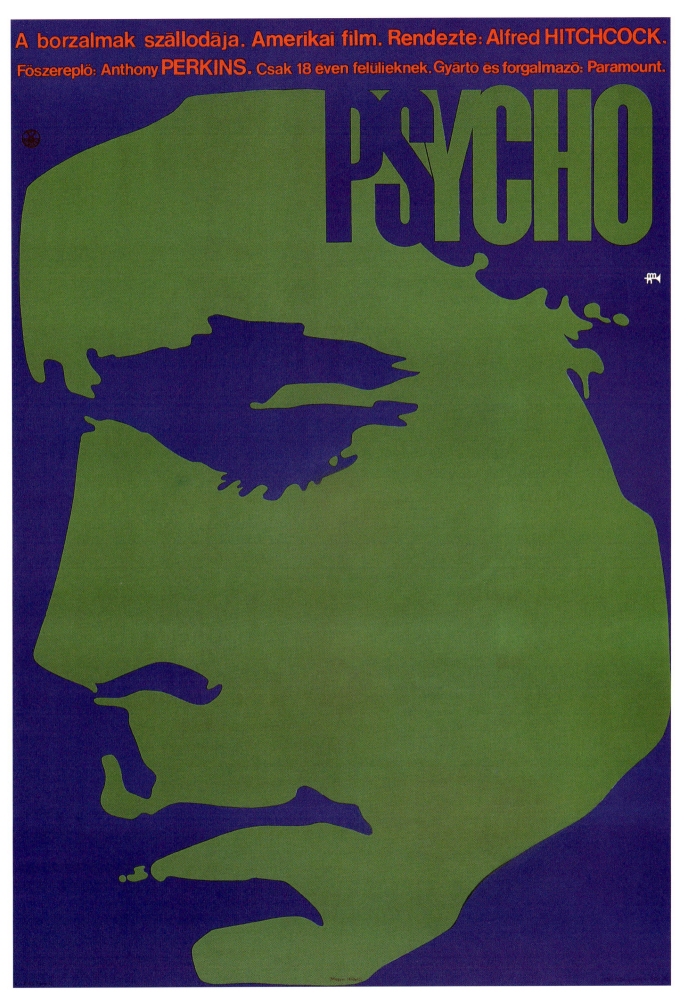

A borzalmak szállodája. Amerikai film. Rendezte: Alfred HITCHCOCK.
Föszereplö: Anthony PERKINS. Csak 18 éven felülieknek. Gyártó és forgalmazó: Paramount.

PSYCHO

Psycho (1960)
Romanian 33 × 23 in. (84 × 58 cm)
Courtesy of the Stephen Durbridge Collection

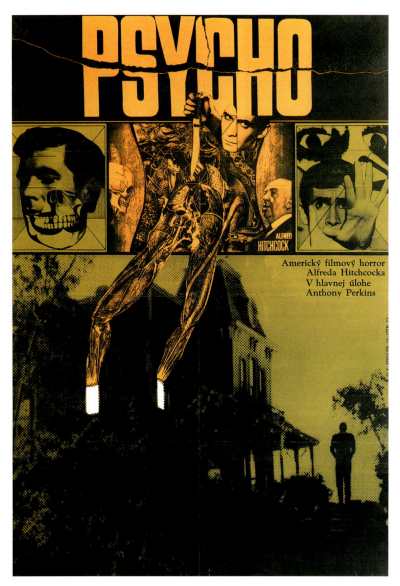

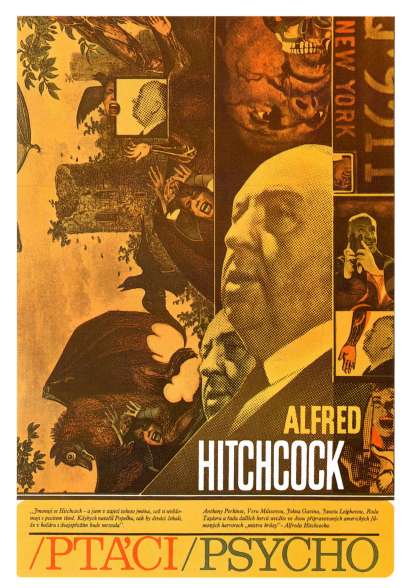

Psycho (1960)
Czechoslovakian 33 × 23 in. (84 × 58 cm)
(Poster dated 1970 – First Czechoslovakian release)
Art by Zdenek Ziegler
Courtesy of The Reel Poster Gallery

The Birds and Psycho (Pta'ci/Psycho) (1960)
Czechoslovakian 33 × 23 in. (84 × 58 cm)
(Double Bill Poster)
(Poster dated 1970 – First Czechoslovakian release)
Art by Zdenek Ziegler

Alfred Hitchcock (1899–1980) is one of cinema's most acclaimed and celebrated directors. He studied art at the University of London and this training gave him his foothold in the movies. By 1919, he was designing title cards for silent films at Paramount's famous Players-Lasky studio, based in London. Six years later, he directed his first feature, *The Pleasure Garden*; other works followed, but it was his direction of *The Man Who Knew Too Much* in 1934 that first attracted international recognition and set him on the road to fame. With *Rebecca* in 1940 he confirmed his mastery of psychological drama, the genre with which his name will be forever associated. In the 50s and 60s he produced his finest work, perfecting the art of suspense in a series of masterpieces – *Dial M For Murder, Rear Window, Vertigo, North By Northwest, Psycho* and *The Birds* – which are still studied and imitated today.

Josef Vyleťal (1940–1989) has been an influential force in Czechoslovakian poster design. He has created 115 film posters and has exhibited his work worldwide. Two of his most famous posters were for *Beauty And The Beast* in 1979 and for Hitchcock's *The Birds*. The latter perfectly illustrates his style; a surrealist focus combined with traditional painting and modern photomontage. The results were always unusual and striking.

A contemporary of Josef Vyleťal, **Zdenek Ziegler** (b. 1932) has been an equally important influence on the development of Czechoslovakian poster design. He combines photomontage with a strong use of colour and pattern to create striking and memorable images. He has won several awards for his work which has been exhibited around the world. He is currently rector of the Poster and Graphic Design department at the Academy of Arts, Architecture and Design in Prague.

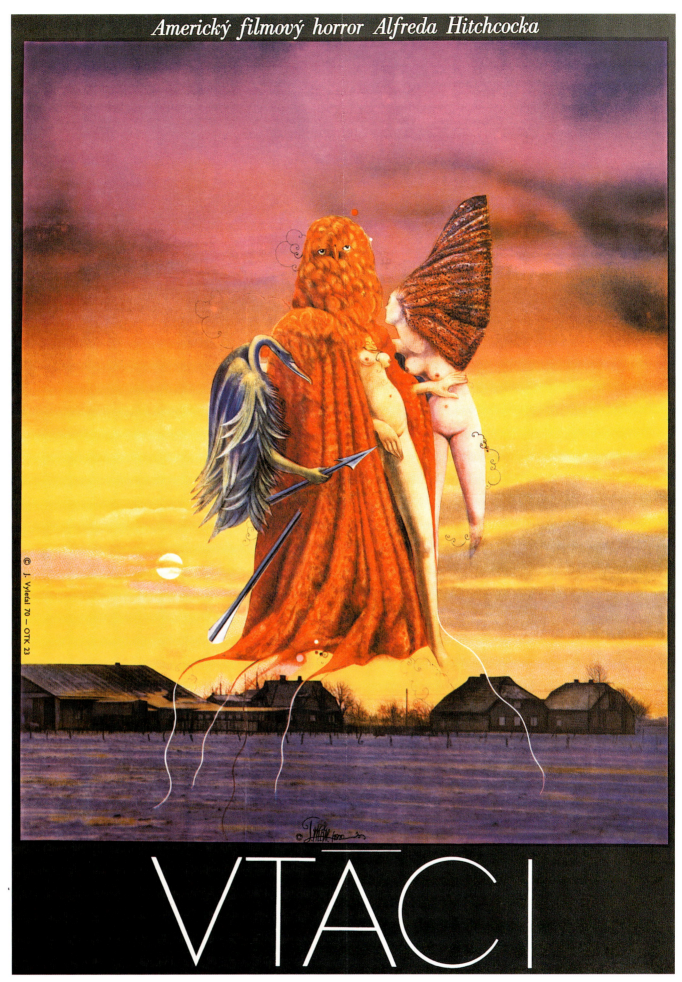

The Birds (Vtáci) (1963)
Czechoslovakian 33 × 23 in. (84 × 58 cm)
(Poster dated 1971 – First Czechoslovakian release)
Art by Josef Vyleťal

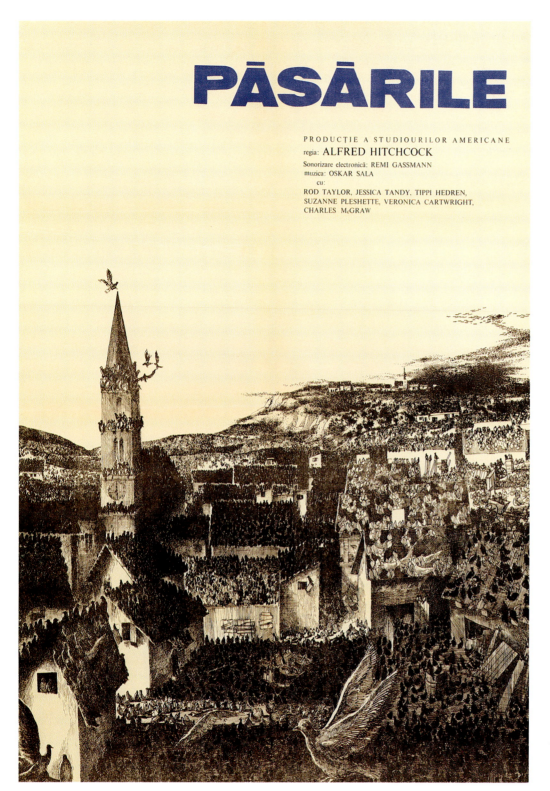

PĀSĀRILE

PRODUCȚIE A STUDIOURILOR AMERICANE
regia: ALFRED HITCHCOCK

Sonorizare electronică: REMI GASSMANN
muzica: OSKAR SALA
cu:

ROD TAYLOR, JESSICA TANDY, TIPPI HEDREN,
SUZANNE PLESHETTE, VERONICA CARTWRIGHT,
CHARLES McGRAW

The Birds (Pāsārile) (1963)
Romanian 33 × 23 in. (84 × 58 cm)
Courtesy of the Andy Johnson Collection

The artist **Bronislaw Zelek** (b. 1935) has been an important influence on Polish poster art. After studying under Henryk Tomaszewski, one of the founders of the Polish school of poster design, Zelek became part of a new group of Polish artists who incorporated photographic elements into their work. His style is further characterized by clean, simple graphics that are frequently composed of just two colours.

The Birds (Pta'ki) (1963)
Polish 33 × 23 in. (84 × 58 cm)
Art by Bronislaw Zelek
Courtesy of the Tony Nourmand Collection.

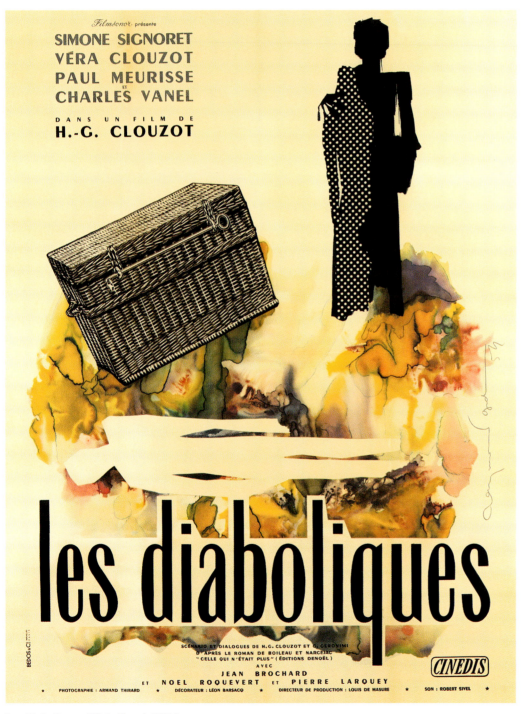

Les Diaboliques (Diabolique) (1955)
French 31 × 24 in. (79 × 61 cm)
Art by Raymond Gid
Courtesy of The Reel Poster Gallery

Raymond Gid (1905–2000) was a French typographer who worked in book and poster design. Some of his most notable works were for Bally shoes, Club Méditerranée and Amnesty International. Gid was also a film enthusiast and designed many movie posters. Three of his most famous are *Vampyr*, *Le Silence De La Mer* and Clouzot's *Les Diaboliques*. His posters for the latter remain two of the most outstanding French posters from the 50s.

Henri Georges Clouzot (1907–1977) was known as the 'French Hitchcock' and was a maestro of the suspense thriller. *Les Diaboliques* is a perfect example of his style with a tension that mounts in a slow crescendo until the shocking conclusion. Indeed, when Hitchcock saw *Le Salair De La Peur (Wages Of Fear)* and *Les Diaboliques*, he invited Clouzot to Hollywood to write for him. The director turned the offer down.

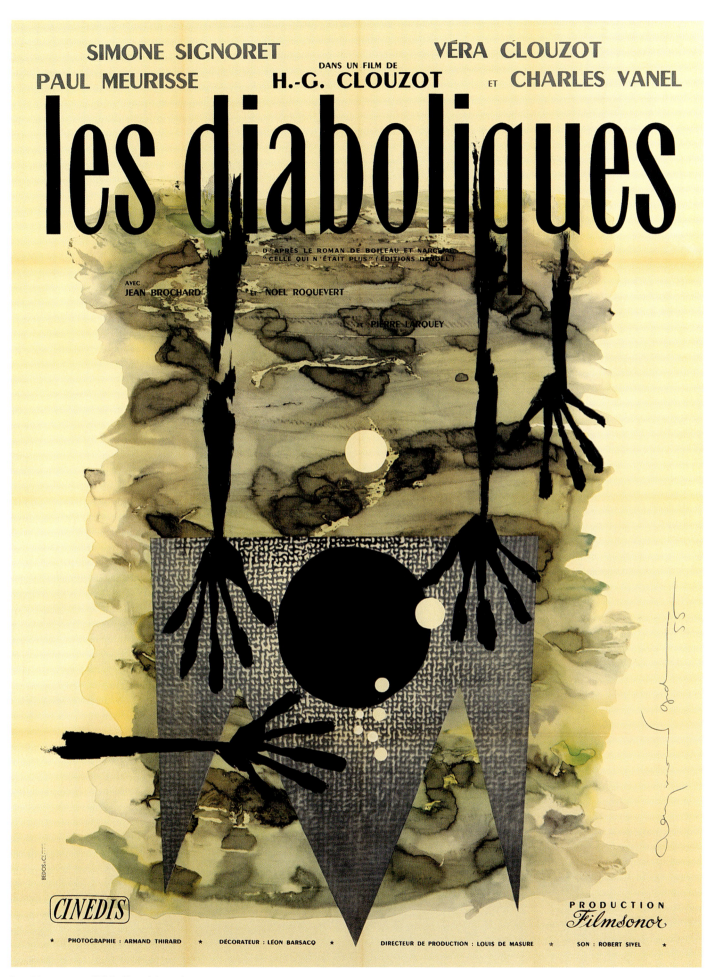

Les Diaboliques (Diabolique) (1955)
French 63 × 47 in. (160 × 119 cm)
(Style B)
Art by Raymond Gid
Courtesy of the Andrew MacDonald Collection

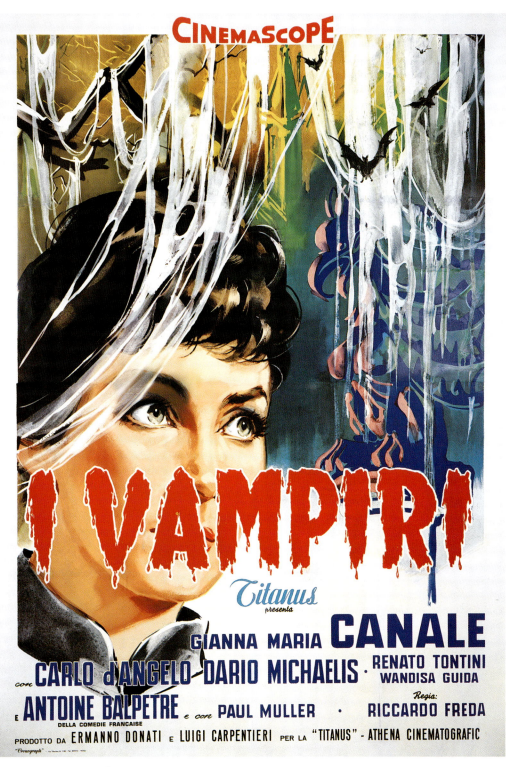

I Vampiri (The Devil's Commandment) (1957)
Italian 79 × 55 in. (201 × 140 cm)

Isolated from the mainstream of Hollywood and the British film industry, Italian horror cinema developed its own unique style and has emerged as an important force in the history of the genre. Only recently given the attention and credit they deserve, the masters of Italian horror, most notably Mario Bava and Dario Argento, are finally enjoying a renaissance of their work. The first Italian horror film was made in 1956 by Riccardo Freda and was called *I Vampiri*. Plagued with problems from the start – Freda left after ten days of shooting, leaving cameraman Mario Bava to take over for the final couple of days – it was a box-office flop. The next film to emerge, *La Maschera Del Demonio*, marked Bava's full directorial debut and it was this film that gave birth to an entire sub-genre of horror and shot the director to fame.

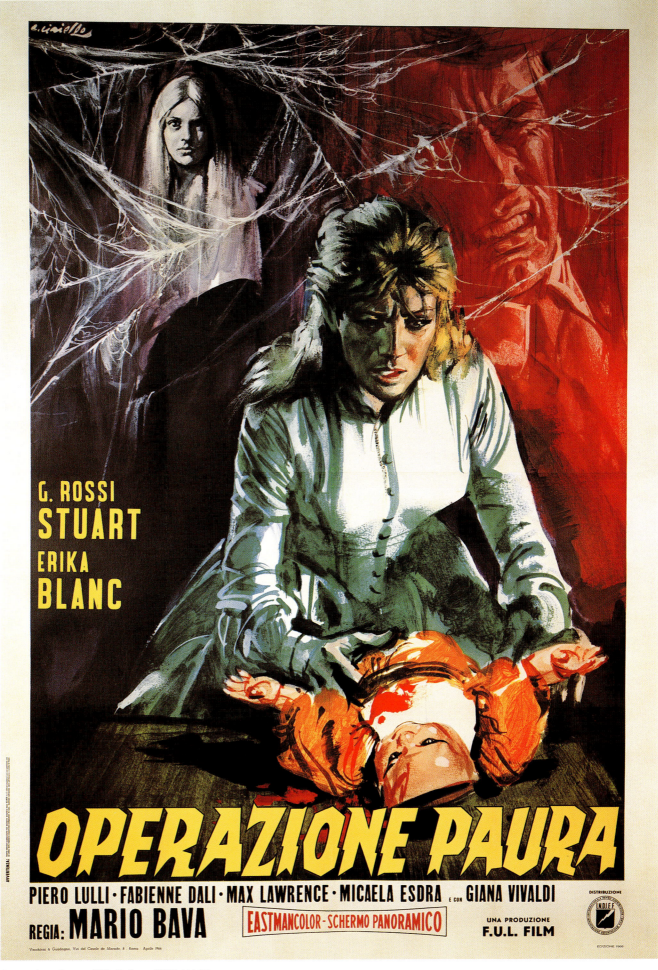

Operazione Paura (Kill, Baby... Kill!) (1969)
Italian 79 × 55 in. (201 × 140 cm)
Art by Averardo Ciriello
Courtesy of the Steve Smith Collection

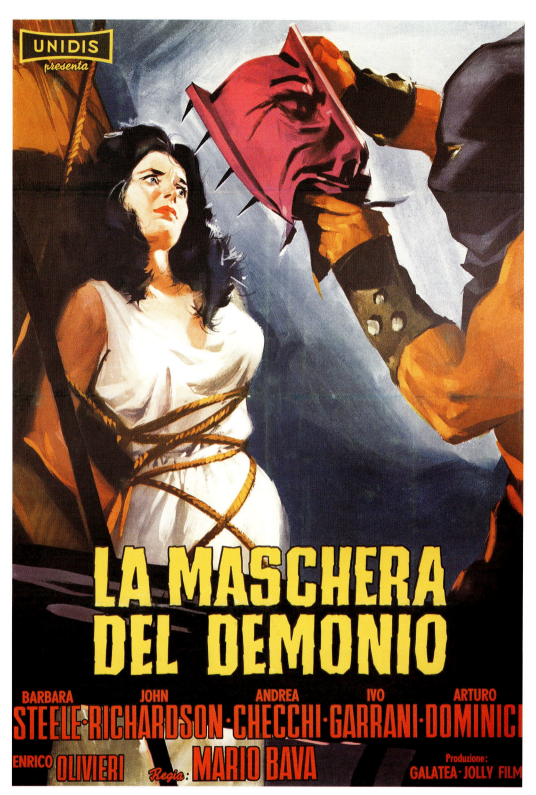

La Maschera Del Demonio (Black Sunday) (1960)
Italian 55 × 39 in. (140 × 99 cm)
Art by Guiliano Nistri
Courtesy of the Steve Smith Collection

Mario Bava (1914–1980) has been called the 'Italian Hitchcock' and was a master of special effects. His father was a cinematographer and he started his own career in movies as a cameraman. Visually spectacular and dreamlike, all his films are infused with a strong awareness of lighting and shadow. *La Maschera Del Demonio* is obscenely violent, yet seductively beautiful. Many consider *Operazione Paura* to be his masterpiece.

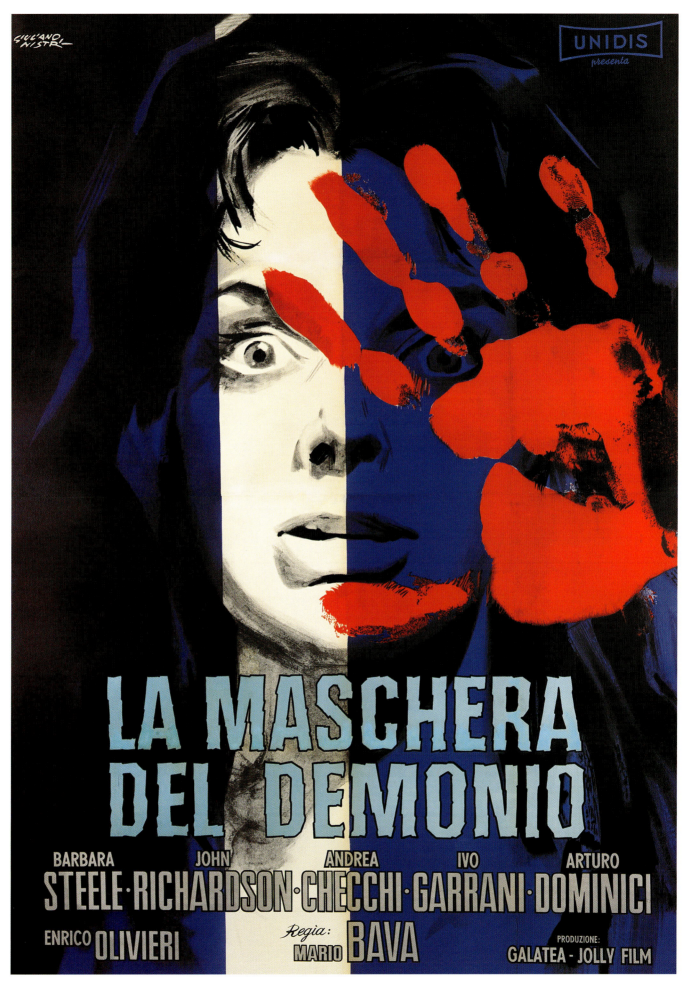

La Maschera Del Demonio (Black Sunday) (1960)
Italian 79 × 55 in. (201 × 140 cm)
Art by Guiliano Nistri
Courtesy of The Reel Poster Gallery

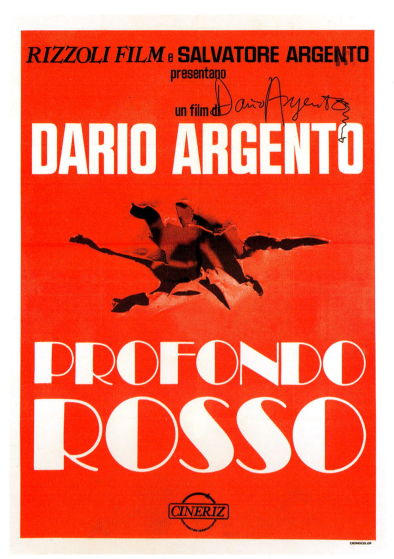

Profondo Rosso (Deep Red) (1975)
Italian 55 × 39 in. (140 × 99 cm)
(Advance)
Signed in felt by Dario Argento.
Courtesy of The Reel Poster Gallery

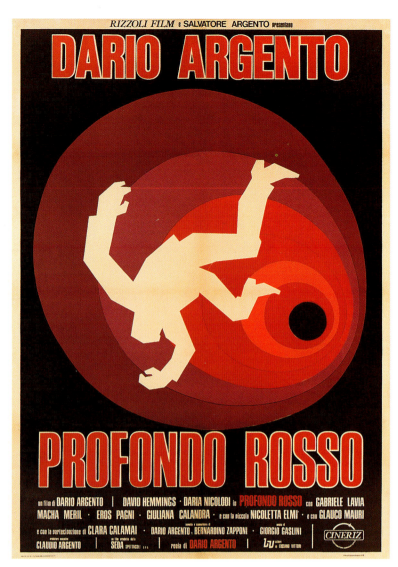

Profondo Rosso (Deep Red) (1975)
Italian 55 × 39 in. (140 × 99 cm)
Courtesy of The Reel Poster Gallery

Dario Argento (b. 1940) was fascinated by film from a young age.
His father, Salvadore Argento, was a famous movie producer and
Argento knew he wanted to enter this world as soon as he was
able. After writing film criticism for various magazines and
newspapers while at university, he became a screenwriter and his
big break came with a Bertolucci / Leone collaboration, *Once Upon
A Time In America*. He made his directorial debut in 1969 with
Bird With A Crystal Plumage. This film was known as a 'giallo'
horror, after the lurid, yellow-covered paperback horror stories
that sold like hot cakes in Italy. His *Profondo Rosso* in 1975 was a
masterpiece; a beautifully violent work that set an international
standard for the genre and proved hugely influential. His
hallucinogenic *Suspiria* in 1977 was equally successful. His work,
like Bava's, has a dark, fairy-tale twist to it, and reflects the
influence of the Brothers Grimm and Hans Christian Andersen.
In 1994, Dario Argento was awarded a Lifetime Achievement Award
at the 2nd Montreal Festival International Cinema Fantastique.

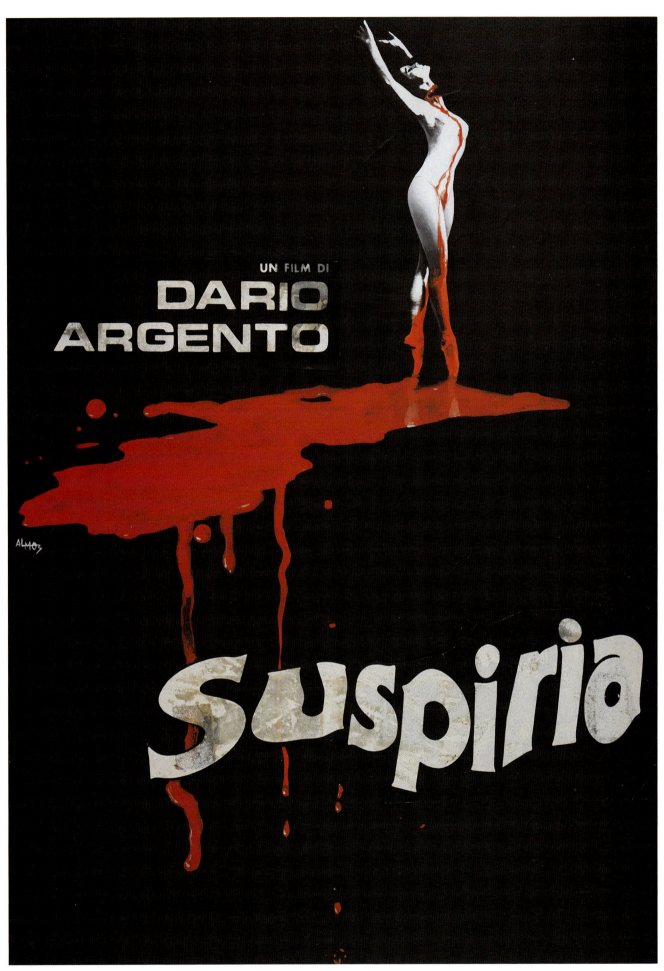

Suspiria (1977)
Italian 20 × 15 in. (51 × 38 cm)
Original Artwork. Gouache on board.
Art by Antonio Mos ('Almos')
Courtesy of the Helmut Hamm Collection

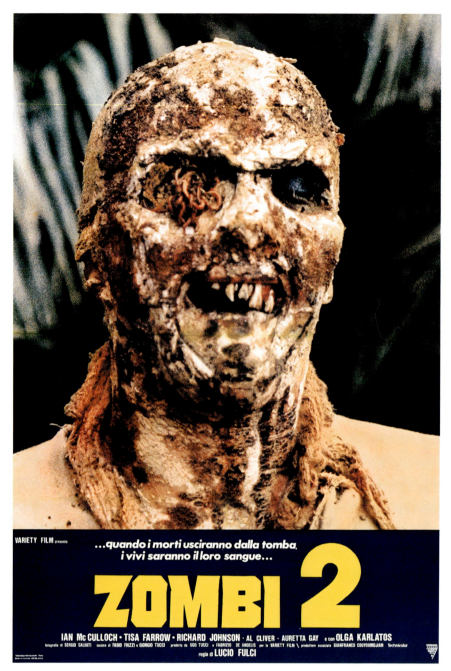

Zombie (Zombi 2) (1979)
Italian 39 × 27 in. (99 × 69 cm)

il nuovo film di LUCIO FULCI

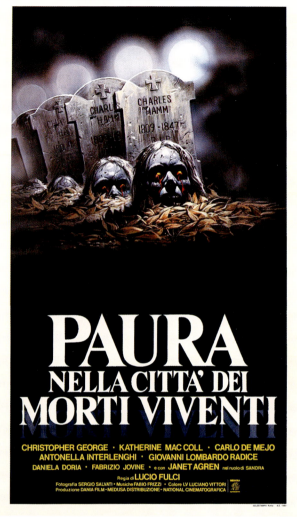

Paura Nella Citta Dei Morti Viventi
(City Of The Living Dead) (1980)
Italian 28 × 13 in. (71 × 33 cm)

Critics are divided over both the talents and the morals of **Lucio Fulci** (1927–1996), one of the most controversial directors of horror films. Many of his films are shockingly violent and brutal, yet their gory surface often conceals intelligent commentaries on social or religious issues. His supporters argue that he is a skilled craftsman who creates great works on a tight budget. Whether he should be viewed as a genius or just a cheap sensationalist, Fulci has a loyal fan base and has undeniably had a unique and important influence on the horror genre.

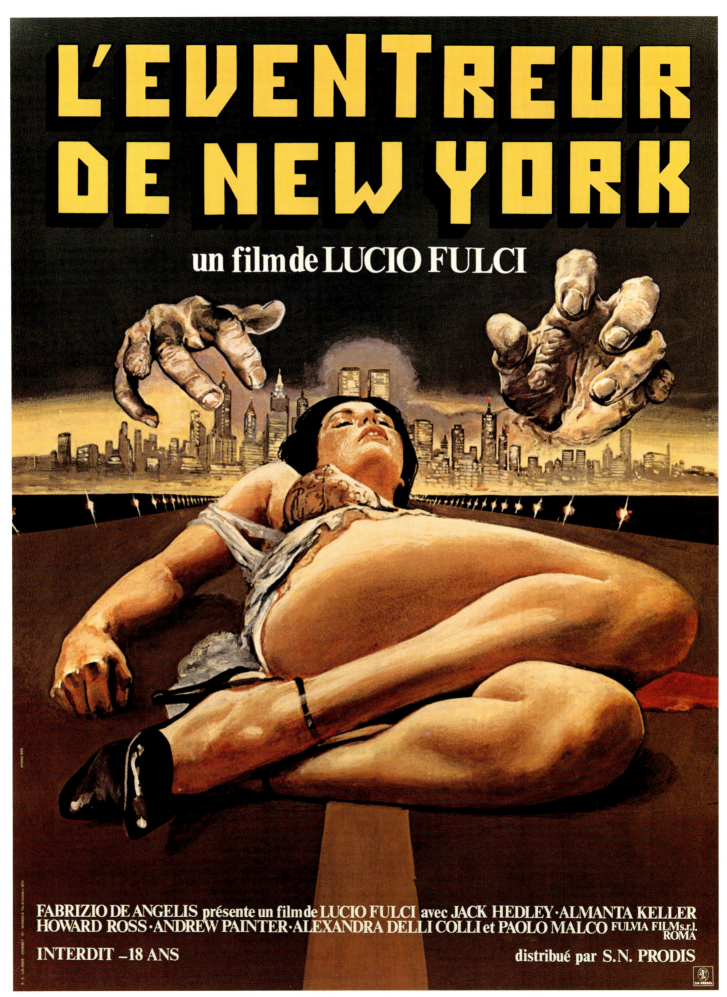

Lo Squartatore Di New York
(The New York Ripper / L'Eventreur De New York) (1982)
French 63 × 47 in. (160 × 119 cm)

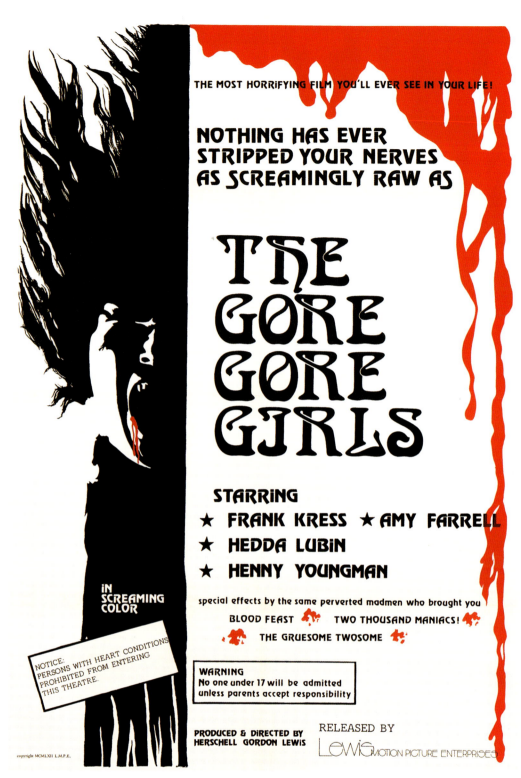

The Gore Gore Girls (1972)
US 41 × 27 in. (104 × 69 cm)

Known as 'The Godfather of Gore', **Herschell Gordon Lewis** (b. 1926) pioneered the 'gorror' film. After a spell spent teaching English, journalism and advertising, Lewis moved into advertising and TV commercials. From here, it was a short leap to setting up his own production company and he went into business with exploitation maestro David F. Friedman. An intelligent and savvy businessman, Lewis realised that the only way to survive as an independent company was to be innovative. This was the early 60s, and Lewis reckoned that the secret of success lay in combining soft-core porn with hard-core violence. He made his films so over-the-top, so exaggerated the sex and violence that the public's curiosity was aroused and popularity was guaranteed. Lewis is the first to admit that his films are nothing more than trash, but he spotted a gap in the market and exploited it to its full, profitable potential. His *Gore Gore Girls* in 1972 was full of black humour and gained the honour of being the first film to receive an 'X' certificate for violence alone. He helped re-define the borders of acceptable on-screen violence and was an important influence on the gore and slasher films of the 70s and 80s. During the 80s, the attitude towards films that had previously been seen as crude works of exploitation underwent a sea change and Lewis' films have recently enjoyed something of a revival, gaining new respectability as expressions of popular culture.

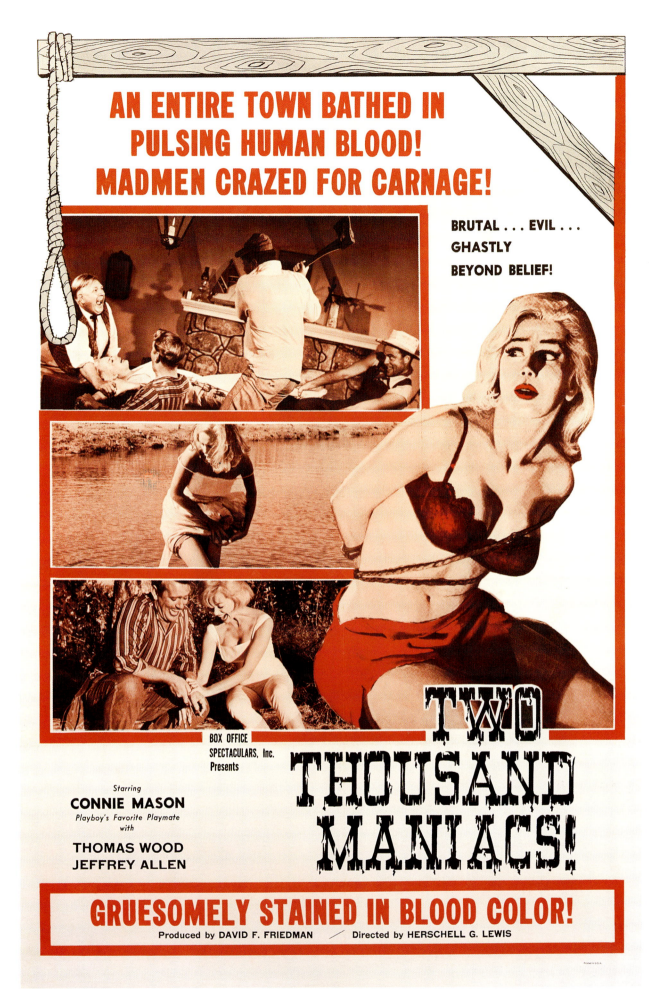

Two Thousand Maniacs (1964)
US 41 × 27 in. (104 × 69 cm)
Courtesy of The Reel Poster Gallery

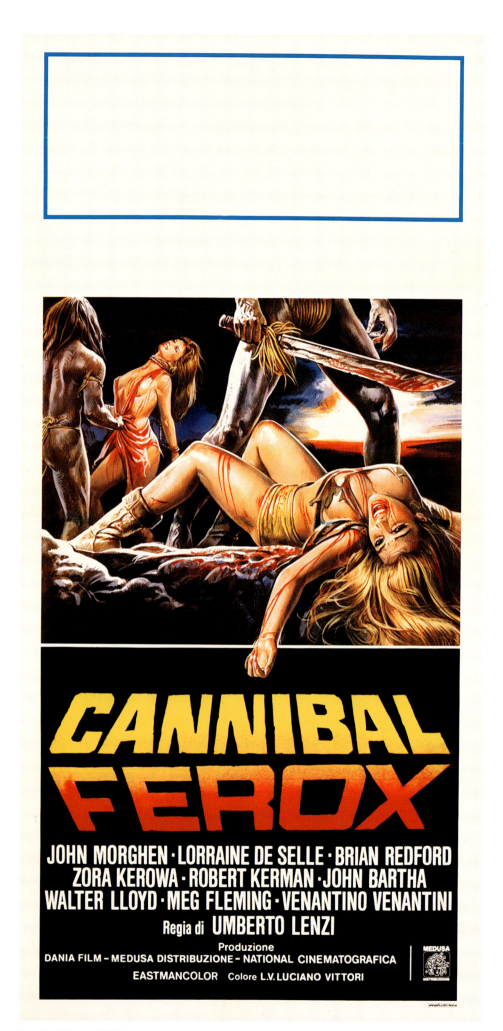

Cannibal Ferox (1980)
Italian 28 × 13 in. (71 × 33 cm)

When Italian director Umberto Lenzi made *Il Paese Del Sesso Selvaggio (Deep River Sacrifices)* in 1972, he created a new sub-genre of extreme and sickening cannibal horror films. Eight years later, Ruggero Deodata directed the most famous and popular film in this field, *Cannibal Holocaust*. Lenzi's *Cannibal Ferox*, made just a year later, was the last film in this gruesome category.

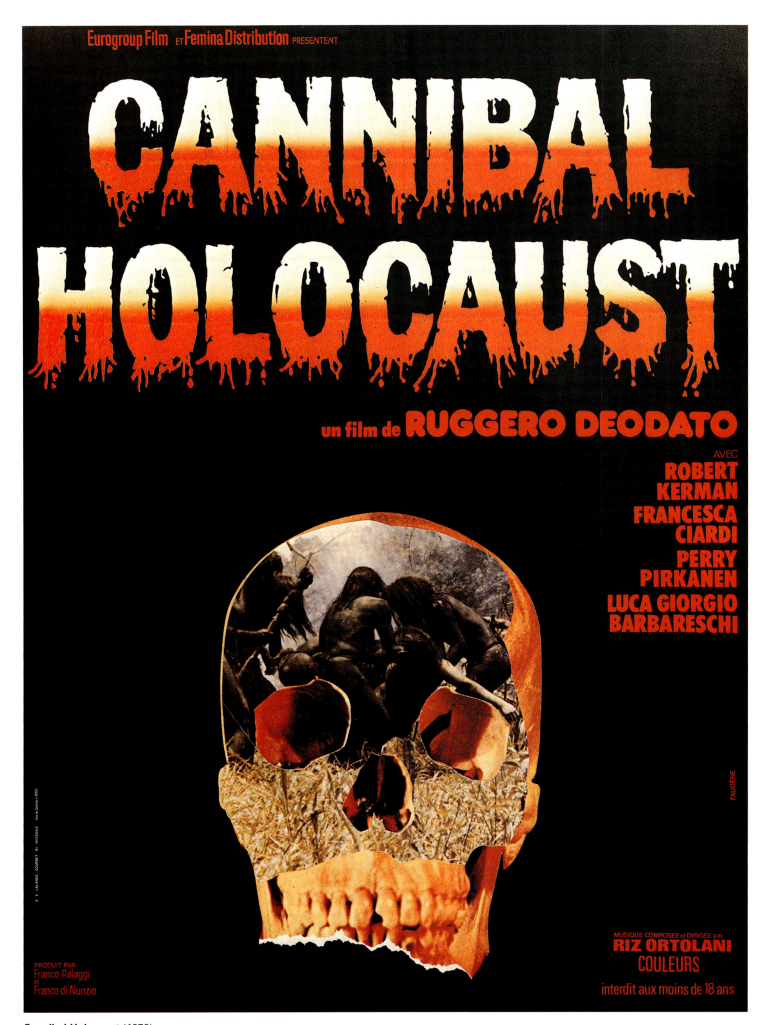

Cannibal Holocaust (1979)
French 63 × 47 (160 × 114 cm)

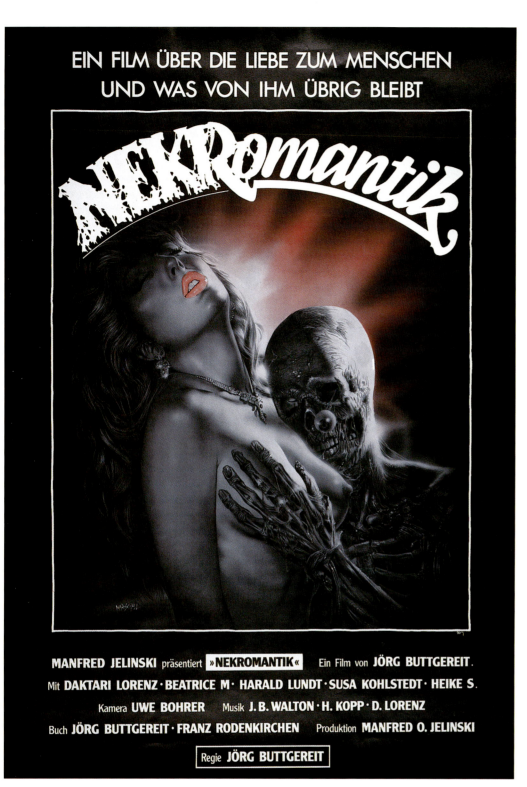

Nekromantik (1987)
German 33 × 23 in. (84 × 58 cm)
Courtesy of the Helmut Hamm Collection

A combination of X-rated thrills and nauseating horror, *Nekromantik* is an extreme example of the arthouse film that pushes moral boundaries to the limit. However, exploitative and revolting though it is, this outrageous film is also a poetic and philosophical examination of the power of relationships, sex and death. With no expectations of the sort of success that would justify a large print run, the original posters for *Nekromantik* were carried from theatre to theatre, given to anyone who was prepared to show the film. Eventually, three small print runs were done, and the majority were pasted on walls across Germany. Very few of the original posters survive. Ultimately more light-hearted, *Orgy Of The Dead* is another X-rated horror flick written by the infamous Ed Wood Jr.

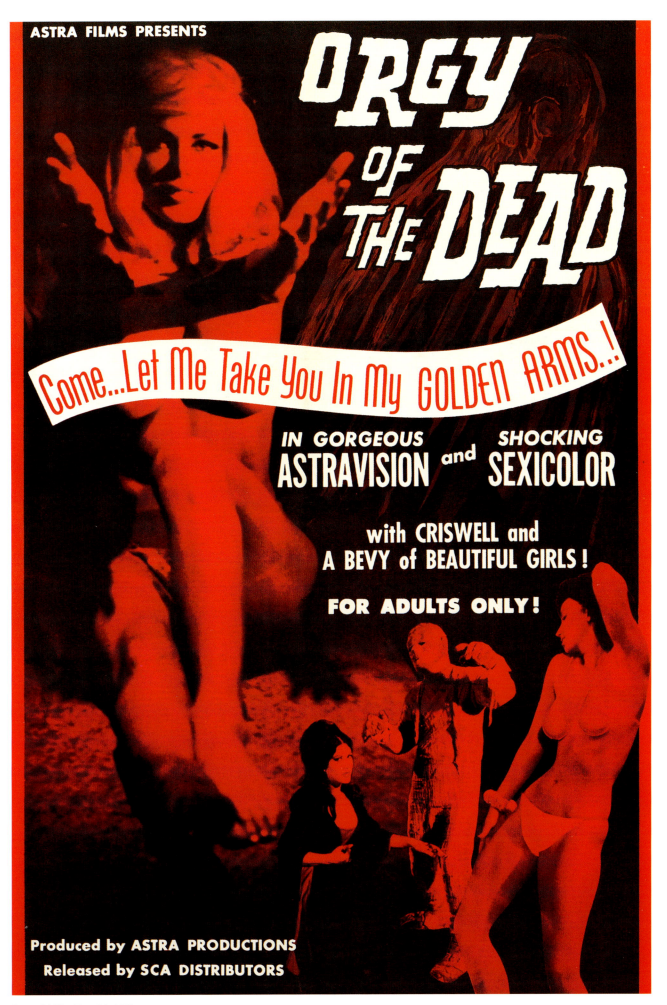

Orgy Of The Dead (1965)
US 41 × 27 in. (104 × 69 cm)
Courtesy of The X-rated Collection

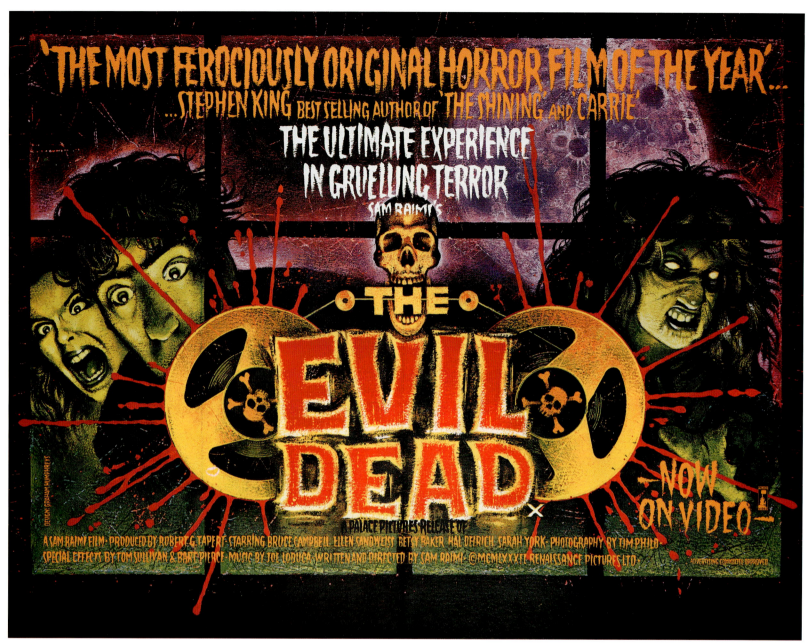

The Evil Dead (1981)
British 30 × 40 in. (76 × 102 cm)
Courtesy of The Reel Poster Gallery

The early 80s was a difficult time for cinema with attendances falling because of the thriving video market (both legitimate and pirate). Palace Pictures, the British distributors of *The Evil Dead*, therefore sought an innovative approach to the film's marketing and released it in cinemas and on video at the same time. It was a huge success. *The Evil Dead* was the highest-selling video in 1983 and put Palace Pictures well and truly on the map. It also led to several court cases, with the company being accused of distributing 'obscene material'. Although never prosecuted, *The Evil Dead* was banned in Britain until the early 90s – another victim of the infamous 'video nasties' years – and was only released uncut in 2001.

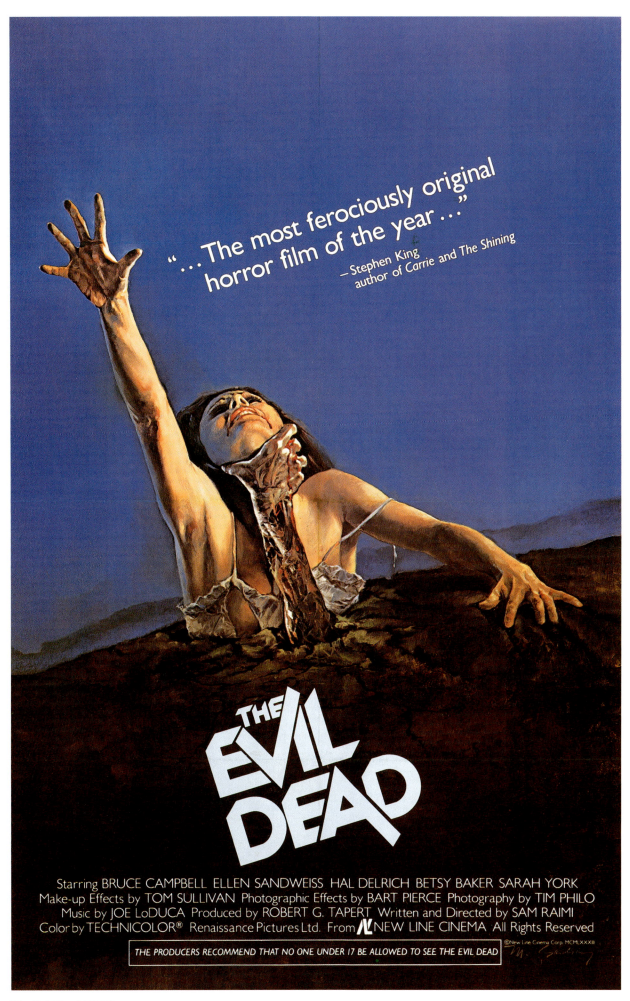

The Evil Dead (1981)
US 41 × 27 in. (104 × 69 cm)

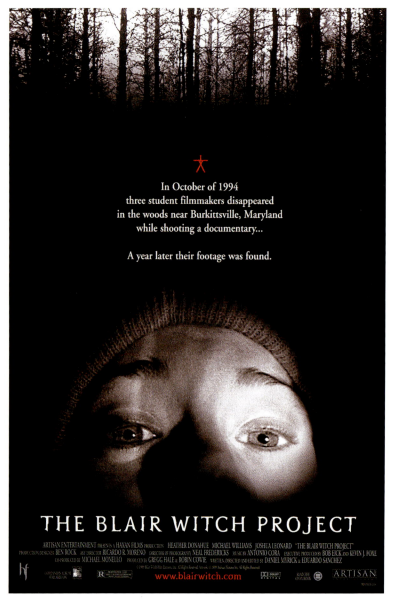

The Blair Witch Project (1999)
US 41 × 27 in. (104 × 69 cm)
Courtesy of The Reel Poster Gallery

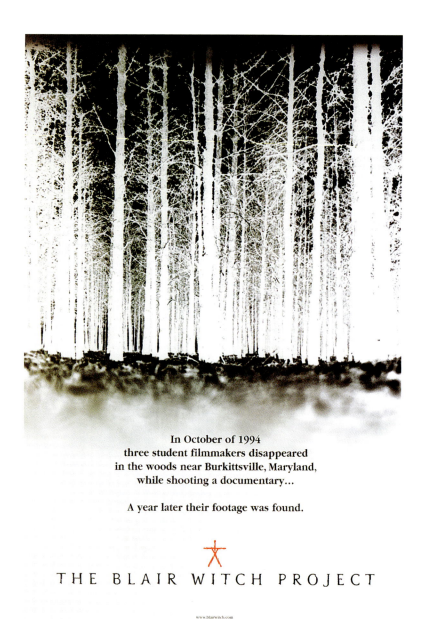

The Blair Witch Project (1999)
US 41 × 27 in. (104 × 69 cm)
(Advance)
Courtesy of The Reel Poster Gallery

Häxan is a blend of documentary and fiction. Made by the Danish filmmaker, Benjamin Christensen in 1922, it tells the story of witchcraft through the ages using a non-linear narrative and featuring scenes and subject matter unprecedented at the time. Its striking lighting effects and black and white photography have influenced a whole swathe of filmmakers right up to the present day. Perhaps the greatest influence has been on *The Blair Witch Project*, another 'mockumentary' about witchcraft. Indeed the film's makers even named their production company Haxan in tribute to the original work.

Made by two film school graduates on a budget of $50,000, *The Blair Witch Project* grossed over $100 million. It was a contemporary phenomenon and a victory for independent filmmakers everywhere. The key to its success was marketing. The film was presented as a true story, a real-life documentary that was filmed on a Hi-8 video camera, 16mm black and white film and a DAT recorder. Once the website for the movie was launched upon a geek generation, the hype generated itself. Everything on the site was presented as truth, with testimonies and photographs detailing the 'disappearance' of three college students. Nowhere on the site was it mentioned that the whole incident was made up (but, on the other hand, nowhere did it say it was true). The buzz developed because everyone was kept guessing as to whether the 'information' on the site was real or just part of an ingenious advertisement. The film premiered at the midnight movie section of the 1999 Sundance Film Festival and swept round the world shortly afterwards. The posters produced for the film kept up the suspense, with a short summary of what had supposedly occurred 'in the woods near Burkittesville'. *The Blair Witch Project* represented a watershed in movie marketing and was a true 21st-century success story.

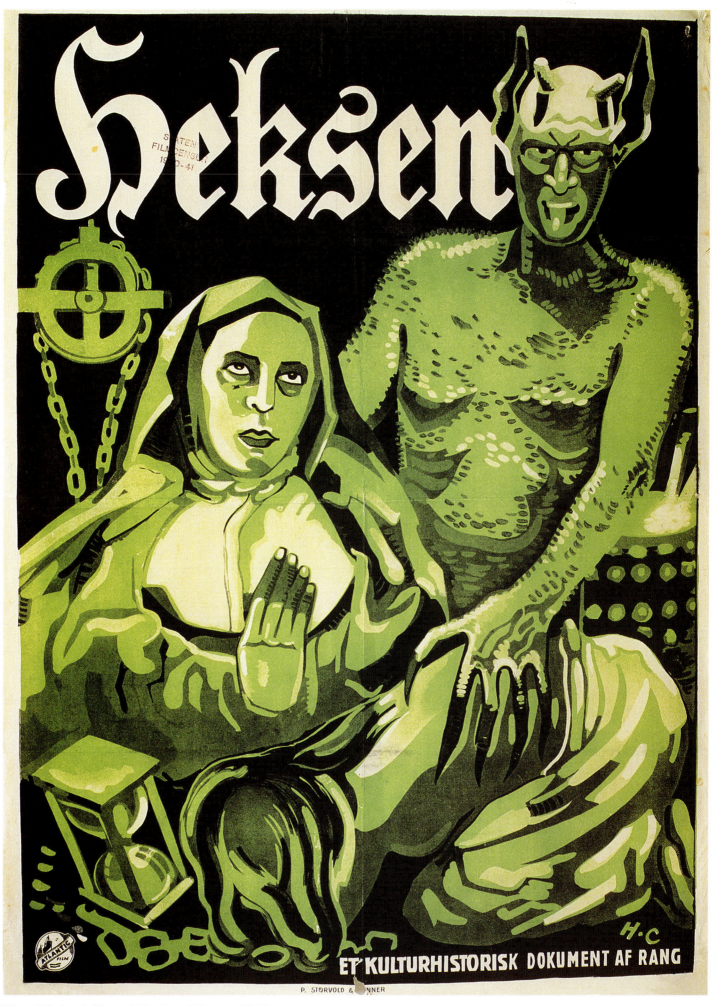

Häxan (Witchcraft Through The Ages / Heksen) (1922)
Danish 33 × 24 in. (84 × 61 cm)

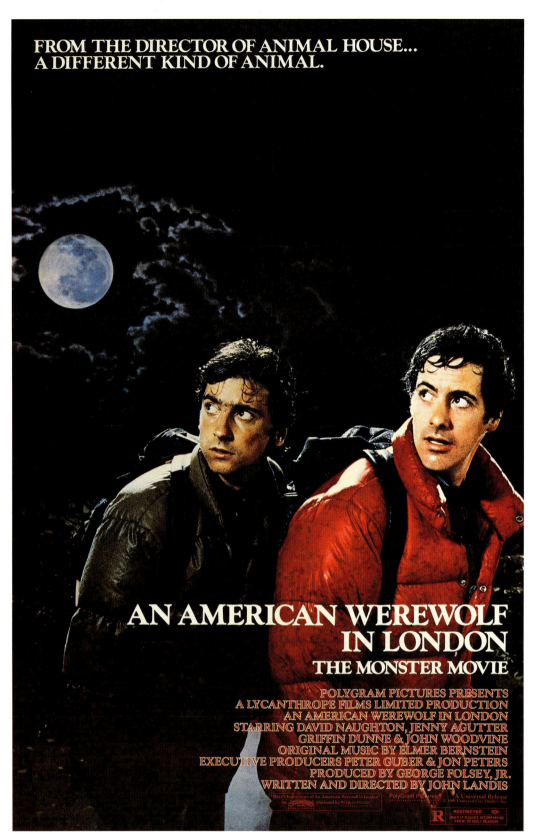

An American Werewolf In London (1981)
US 41 × 27 in. (104 × 69 cm)
Courtesy of the Martin Bridgewater Collectiom

A great combination of tongue-in-cheek humour and genuinely scary sequences, *An American Werewolf In London* was an 80s hit. It had outstanding special effects by Rick Baker – the werewolf transformation sequences are amazing and set a new standard for the industry. The American International poster has an interesting design and, unusually for a modern American poster, shows no characters or scenes from the film. The artist was fittingly given complete creative freedom.

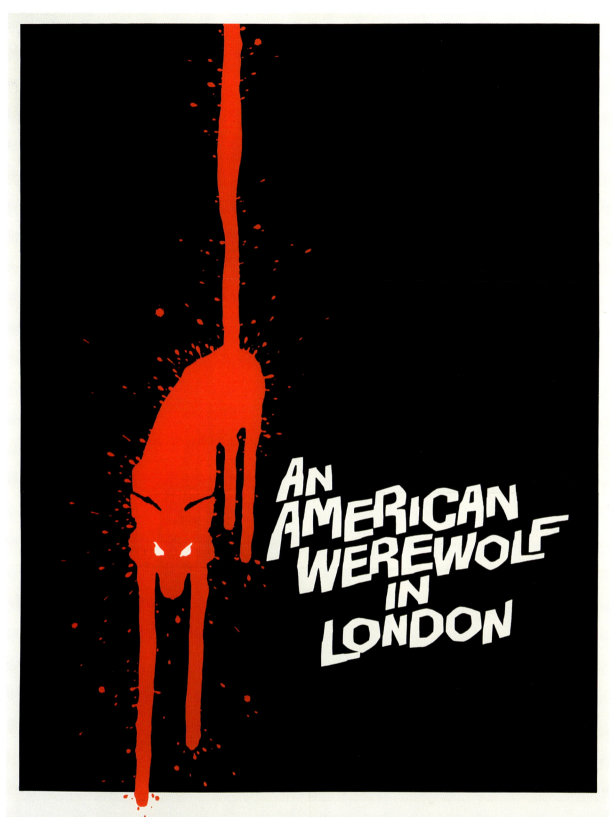

An American Werewolf In London (1981)
US 40 × 25 in. (102 × 64 cm)
(International)
Courtesy of the Martin Bridgewater Collection

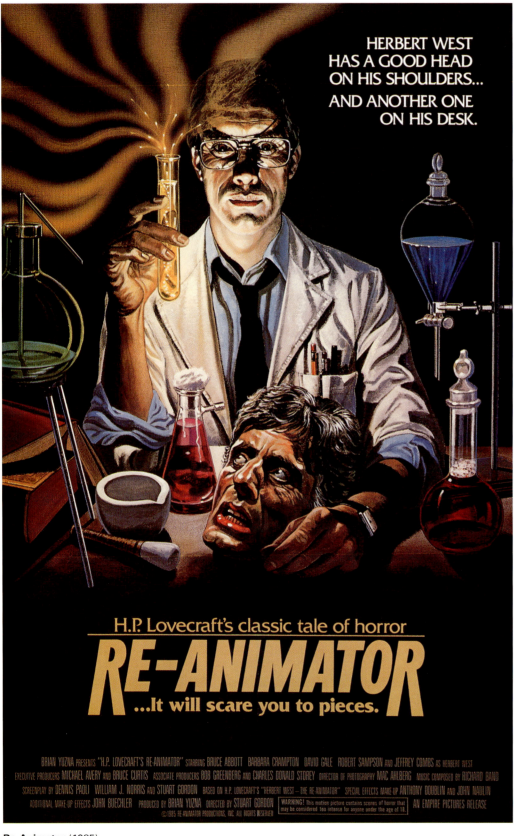

Re-Animator (1985)
US 41 × 27 in. (104 × 69 cm)
Courtesy of the Andy Johnson Collection

Re-Animator is a horror spoof based on one of the many weird tales by H. P. Lovecraft. The blend of horror and humour was a popular one in the 80s and the combination was again successful in *Creepshow*. Inspired by EC Comics horror stories from the 50s and 60s, *Creepshow* is filmed like a comic book – scenes are framed with borders and the colours are garish and deliberately cartoon-like. Indeed, the alterative, style B, poster for the film was designed by **Jack Kamen** (b. 1920), who had worked as an artist for EC in the 50s. Kamen had studied at the Art Students League and Grand Central Art School before moving into comic art in the 40s and 50s. At the time, he was EC's most prolific artist, illustrating 138 stories. His style was characterized by a strong use of light and shadow and the use of atypical angles. Kamen left comics in the mid-fifties and moved instead into advertising illustration. His 1982 poster for *Creepshow* saw him make a brief return to his comic-book roots. Interestingly, the artwork also cross-references other poster art and depictions of *The Shining*, *Dawn Of The Dead* and *Carrie* posters can be seen in the background of the boy's bedroom.

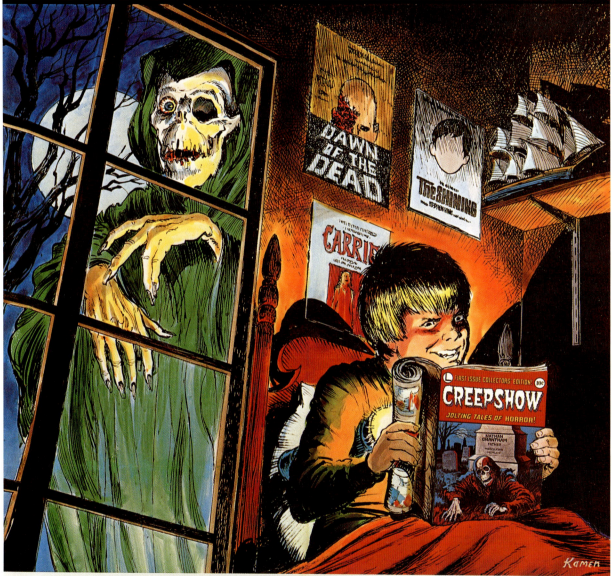

Creepshow (1982)
US 41 × 27 in. (104 × 69 cm)
(Style B)
Art by Jack Kamen

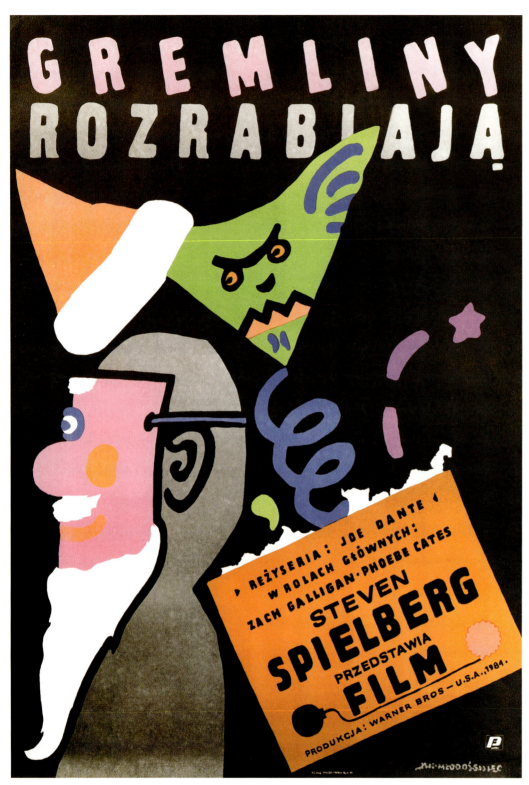

Gremlins (Gremliny Rozrablaja) (1984)
Polish 38 × 27 in. (97 × 69 cm)
Art by Jan Młodożeniec
Courtesy of The Reel Poster Gallery

Jan Młodożeniec (1929–2000) was
responsible for over 400 poster designs
and was one of the most prolific and
celebrated Polish poster artists of the
twentieth century. A contemporary of
Jan Lenica, he studied under Henryk
Tomaszewski, one of the original and
leading influences on the development
of Polish film poster art. Młodożeniec
has won several awards for his work and
his artwork for *Gremlins* is a perfect
illustration of his inimitable style.

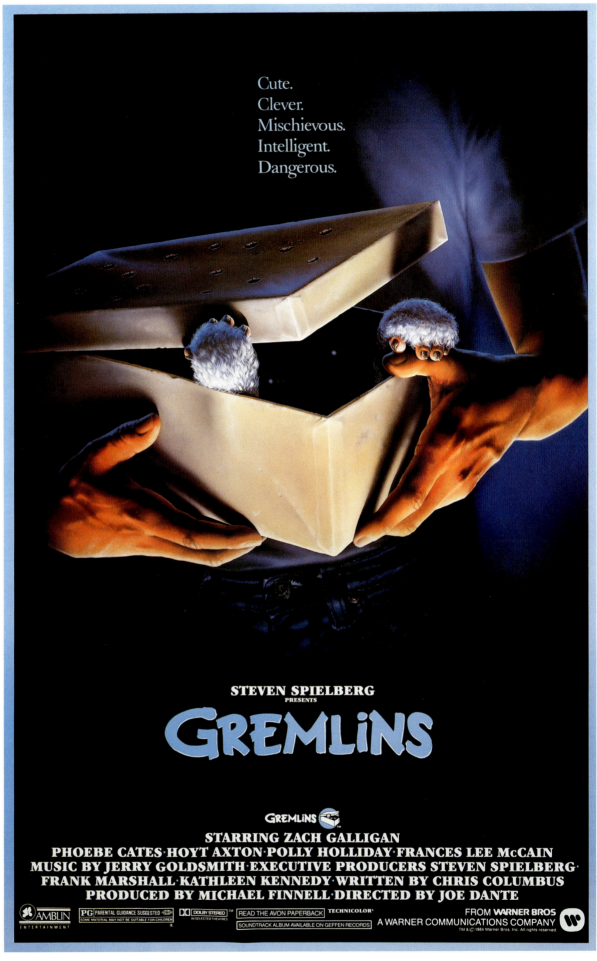

Gremlins (1984)
US 41 × 27 in. (104 × 69 cm)
Art by John Alvin
Art direction by Anthony Goldschmidt
Courtesy of the Martin Bridgewater Collection

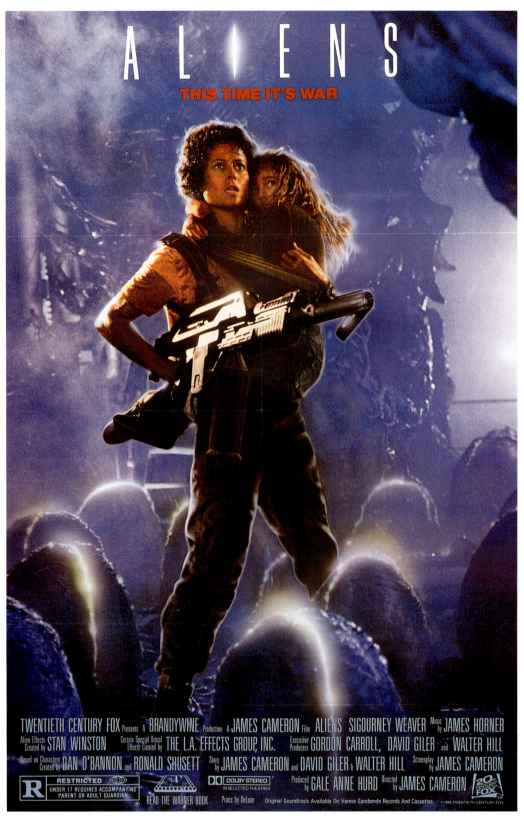

Aliens (1986)
US 41 × 27 in. (104 × 69 cm)
(Style A – Withdrawn)
Art by Terry Lamb
Design by Mike Salisbury
Courtesy of The Reel Poster Gallery

The original American poster for *Aliens* was banned because the image gave away the ending of the film and ruined the suspense for the audience. However, fifteen years later, John Alvin's anniversary poster for the original *Alien* could exploit the suspense for all it was worth and the image of the monster was so well known, that it was used as the main selling point.

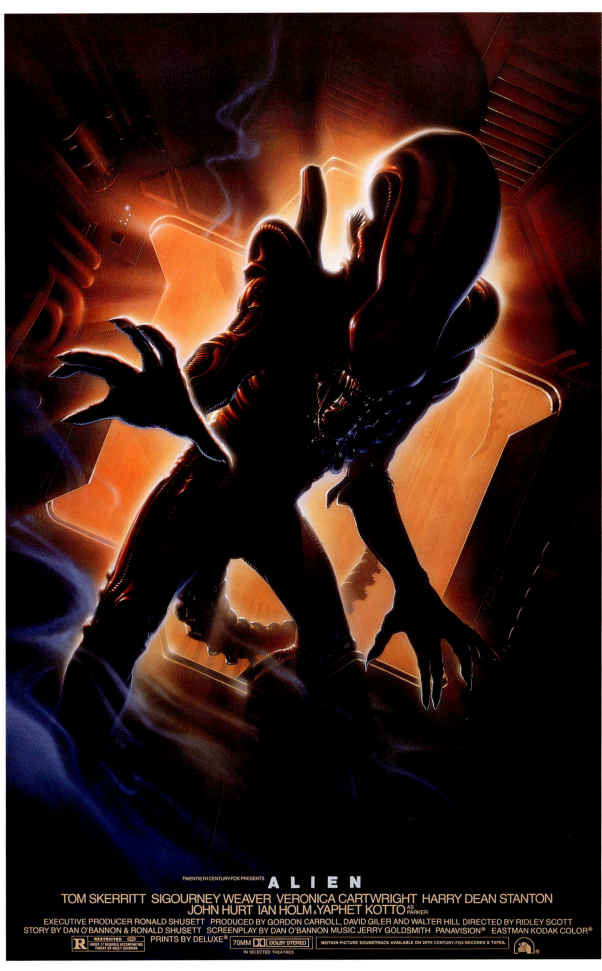

Alien (1979)
US 41 × 27 in. (104 × 69 cm)
(15th Anniversary)
Art by John Alvin
Courtesy of The Reel Poster Gallery

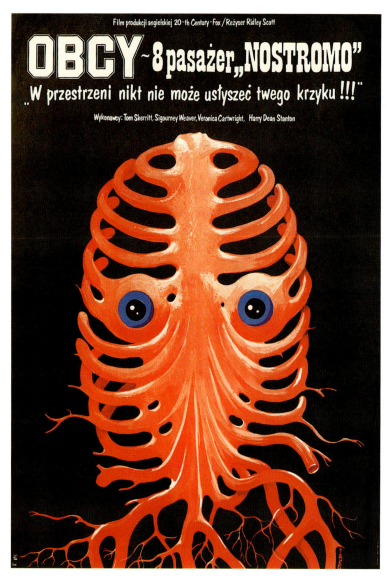

Alien (Obcy) (1979)
Polish 37 × 26 in. (94 × 66 cm)
Art by Jakub Erol
Courtesy of The Reel Poster Gallery

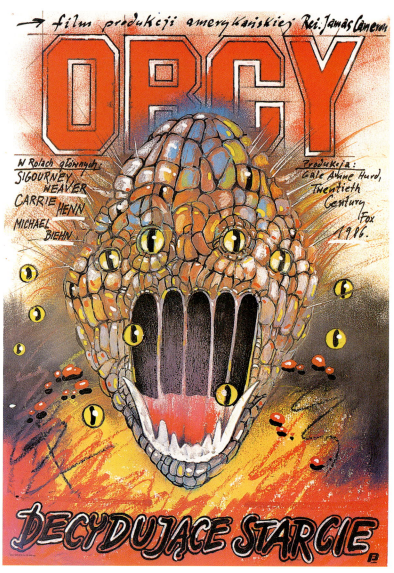

Aliens (Obcy: Decydujace Starcie) (1986)
Polish 38 × 26 in. (97 × 66 cm)
Art by Andrzej Pagowski
Courtesy of the Martin Bridgewater Collection

Eastern European film poster artists are famous
for their abstract and conceptual designs. Often
the artists were given only a title and brief
summary to work from and this, combined with
a great deal of artistic freedom, has led to the
creation of some of the most interesting and
unusual film posters on record. The Polish
posters for *Alien* and *Aliens* and the Hungarian
Alien poster are three examples of this tradition.

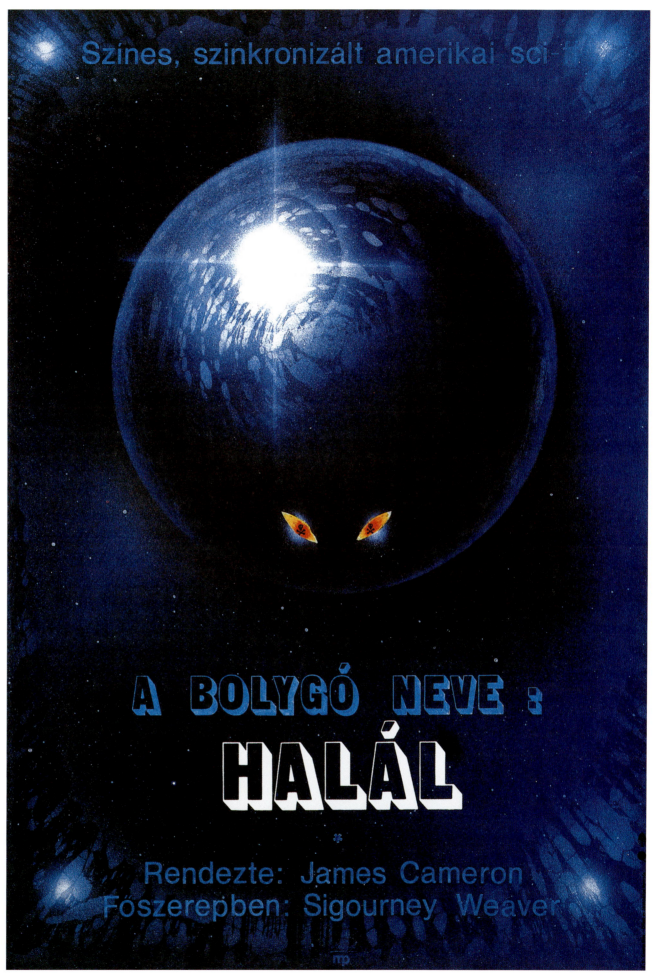

Alien (Halál) (1979)
Hungarian 33 × 23 in. (84 × 58 cm)
Courtesy of The Reel Poster Gallery

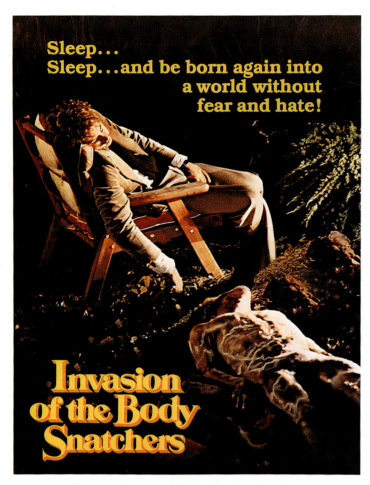

Invasion Of The Body Snatchers (1979)
US 41 × 27 in. (104 × 69 cm)
(International Style B)

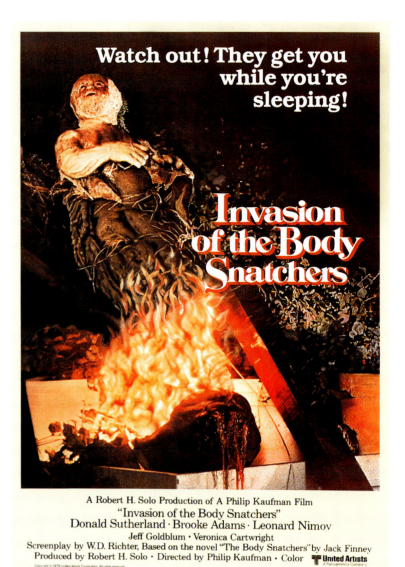

Invasion Of The Body Snatchers (1979)
US 41 × 27 in. (104 × 69 cm)
(International Style A)

Every generation has a different take on Albert Finney's famous science fiction classic, *The Invasion Of The Body Snatchers*. The original 50s hit used the story as a thinly veiled metaphor for both the struggle against communism and the suffocating conformity of McCarthy's America. In contrast, Philip Kaufman's version was more light entertainment than social commentary – though it does include several references to the spiritual and psychological excesses of the 70s. This version was also much more 'horrific' than the original, with the developments in special effects adding a shocking new dimension to the classic tale. Abel Ferrara's *Body Snatchers* was again a scary, special effects-fuelled romp but also a critique of the breakdown of the family unit in modern America.

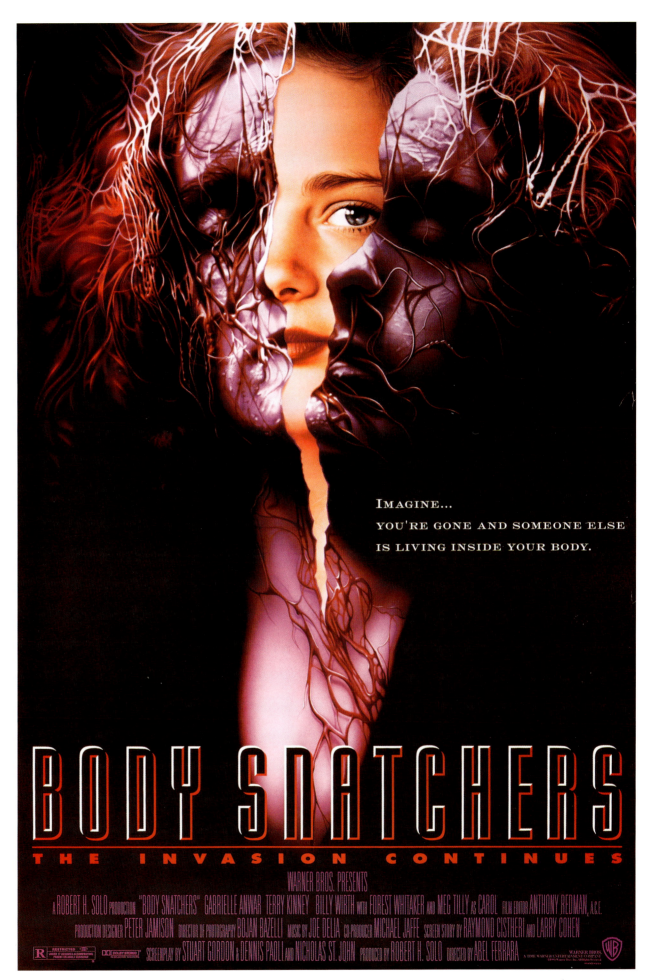

Body Snatchers (1994)
US 41 × 27 in. (104 × 69 cm)
Photo and illustration by Mike Bryan
Art direction and design by Rob Biro
Courtesy of The Reel Poster Gallery

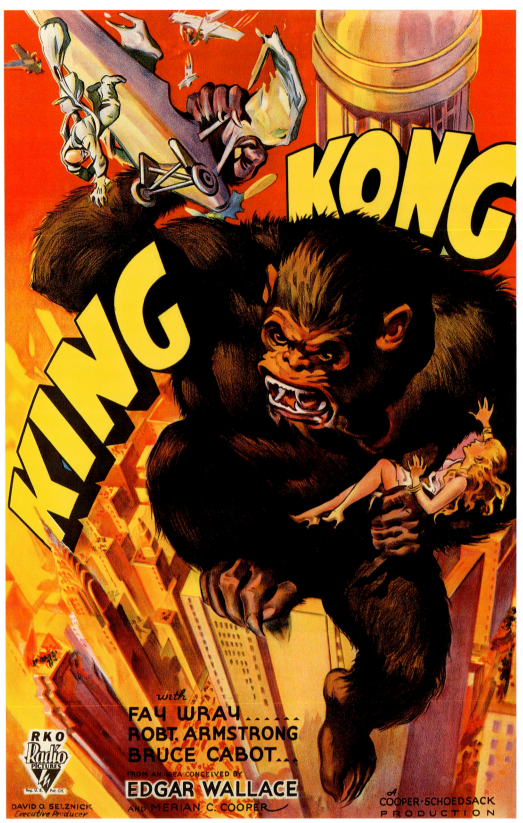

King Kong (1933)
US 41 × 27 in. (104 × 69 cm)
(Style A)
Art by S. Barret McCormick & Bob Sisk
Courtesy of the Andrew Cohen Collection

A perfect blend of adventure, science fiction and horror, *King Kong* is the ultimate monster movie. Willis O'Brien's use of stop-motion effects was groundbreaking for the time and remains legendary. The film blew audiences away and broke all previous box-office records. The painting of Kong on top of the Empire State Building is iconic and one of cinema's most celebrated images.

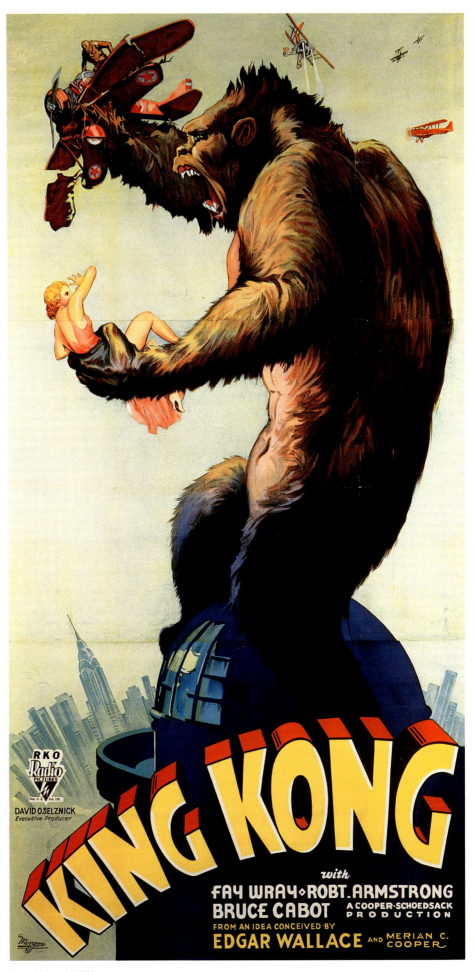

King Kong (1933)
US 81 × 41 in. (104 × 69 cm)
(Style A)
Art by S. Barret McCormick & Bob Sisk
Courtesy of The Reel Poster Gallery

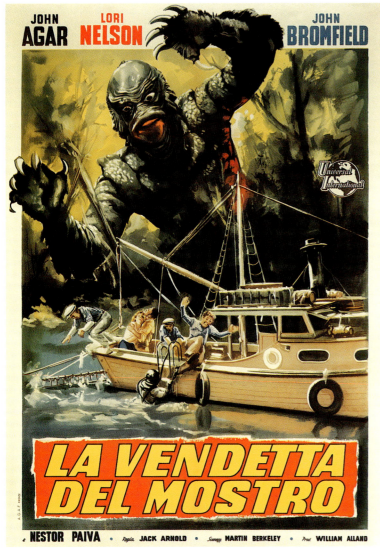

Revenge Of The Creature (La Vendetta Del Monstro) (1955)
Italian 55 × 39 in. (140 × 99 cm)

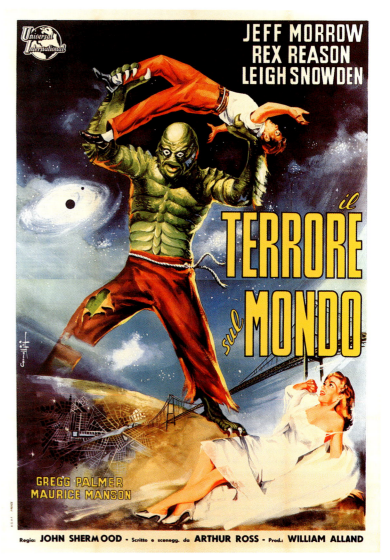

The Creature Walks Among Us (Il Terrore Sul Mondo) (1956)
Italian 79 × 55 in. (201 × 140 cm)
Art by Carmellini

The Creature From The Black Lagoon and its sequels are examples of the many 50s B-movies that straddled the science-fiction and horror genres. They followed a simple formula to attract their, mostly teenage, audience – beautiful screaming maidens confronted by ugly lumbering monsters. It was a winning combination. The Italian posters for the films are in the traditional painterly style and show classic 50s imagery. In contrast to Reynold Brown's American posters for the films, the Italian artists focused more on the horrific elements of the movies and the posters are more frightening than their American counterparts.

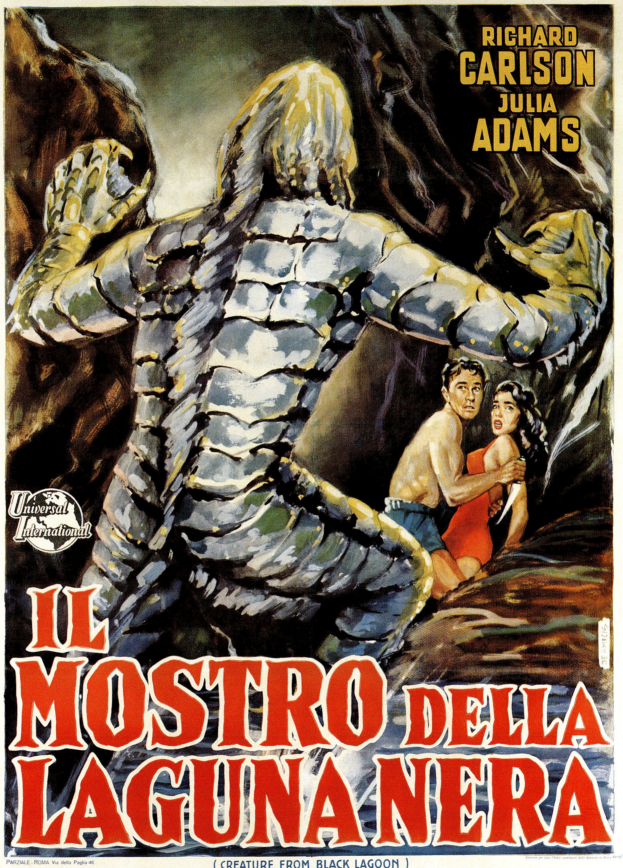

Creature From The Black Lagoon (Il Mostro Della Laguna Nera) (1954)
Italian 55 × 39 in. (140 × 99 cm)
Art by Aldo De Amicis

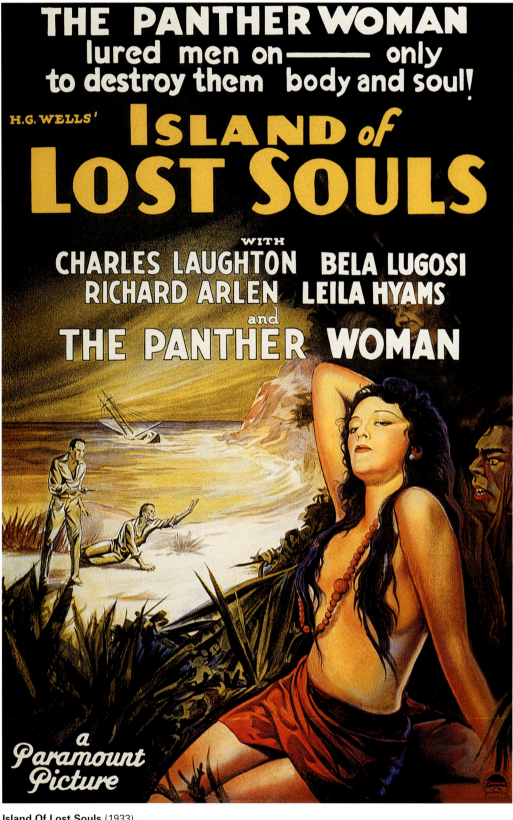

THE PANTHER WOMAN
lured men on—————— only
to destroy them body and soul!

H.G. WELLS' ISLAND of LOST SOULS

WITH
CHARLES LAUGHTON BELA LUGOSI
RICHARD ARLEN LEILA HYAMS
and
THE PANTHER WOMAN

a Paramount Picture

Island Of Lost Souls (1933)
US 41 × 27 in. (104 × 69 cm)

As a young man, **H. G. Wells** (1866–1946) had studied at the Normal School of Science in London, under the tutelage of the noted biologist Thomas H. Huxley. The influence that this experience had on Wells' science-fiction stories is obvious, not least in the case of *The Island Of Dr Moreau*. The story is set on an island where an evil scientist manipulates nature, creating 'manimals' – animals that have been turned into humans. Wells was much concerned with the moral implications of the advancement of science and mankind's role in a world of rapid technological change. Like much of Wells' other work, *The Island Of Dr Moreau* explored the future implications of contemporary scientific ideas, in this case with notable prescience it would seem, in the light of the modern developments in genetic engineering.

The tale has been adapted for the screen several times. The first adaptation was *Island Of Lost Souls* in 1933; starring Bela Lugosi and Charles Laughton, it was banned in Britain until the late 60s. *The Island Of Dr Moreau* is one of the latest adaptations, proving the lasting appeal of a classic adventure story.

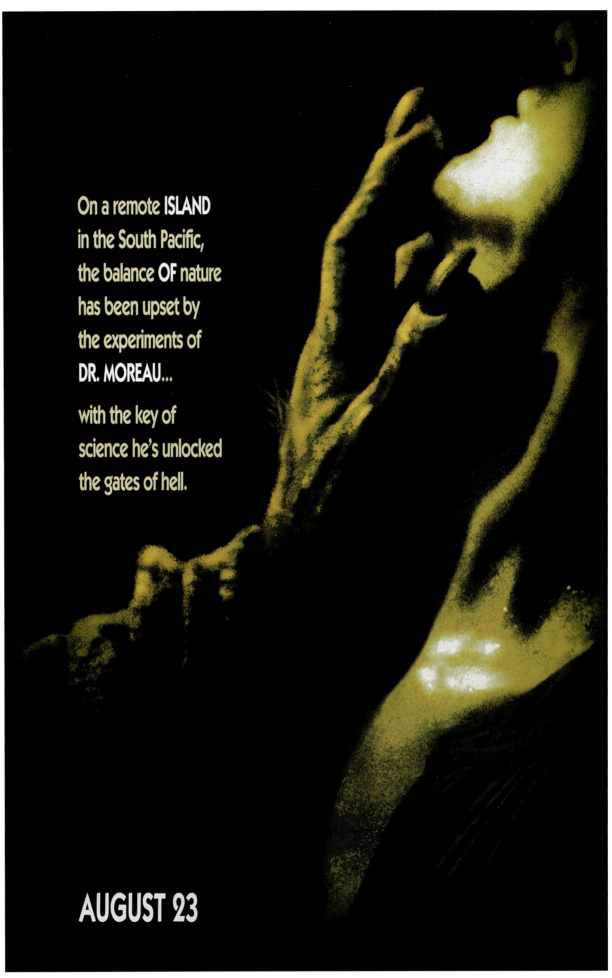

On a remote **ISLAND** in the South Pacific, the balance **OF** nature has been upset by the experiments of **DR. MOREAU...**

with the key of science he's unlocked the gates of hell.

AUGUST 23

The Island Of Dr. Moreau (1996)
US 41 × 27 in. (104 × 69 cm)
(Advance)
Art direction by Pat Garling-Ellis

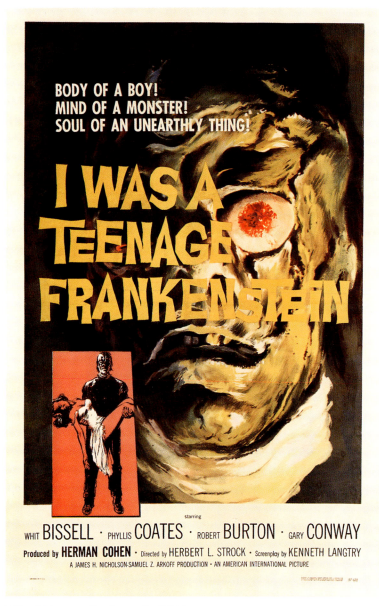

I Was A Teenage Frankenstein (1957)
US 41 × 27 in. (104 × 69 cm)

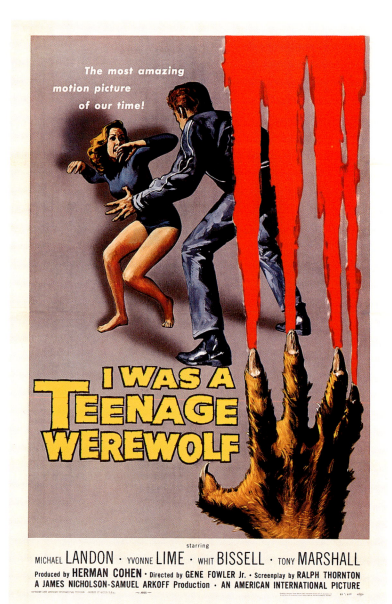

I Was A Teenage Werewolf (1957)
US 41 × 27 in. (104 × 69 cm)
Art by Reynold Brown
Courtesy of The Reel Poster Gallery

The United States emerged from World War II a superpower and the post-war years saw the nation enter a new period of unprecedented economic strength and growth. With just six percent of the world's population, America's GDP was as big as that of all the other countries combined. Such affluence was reflected in a new consumer culture and the American public went on a spending spree that was the envy of the world. While parents were stocking their homes with televisions and washing machines, their children were rushing to the cinema creating a new audience which found the cheap thrills of science fiction and horror very much to its taste.

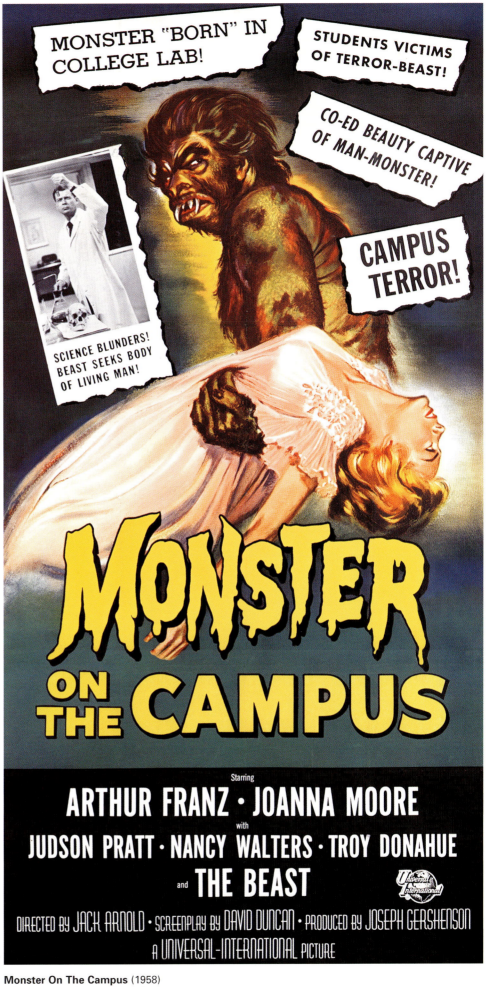

Monster On The Campus (1958)
US 81 × 41 in. (206 × 104 cm)
Art by Reynold Brown
Courtesy of The Reel Poster Gallery

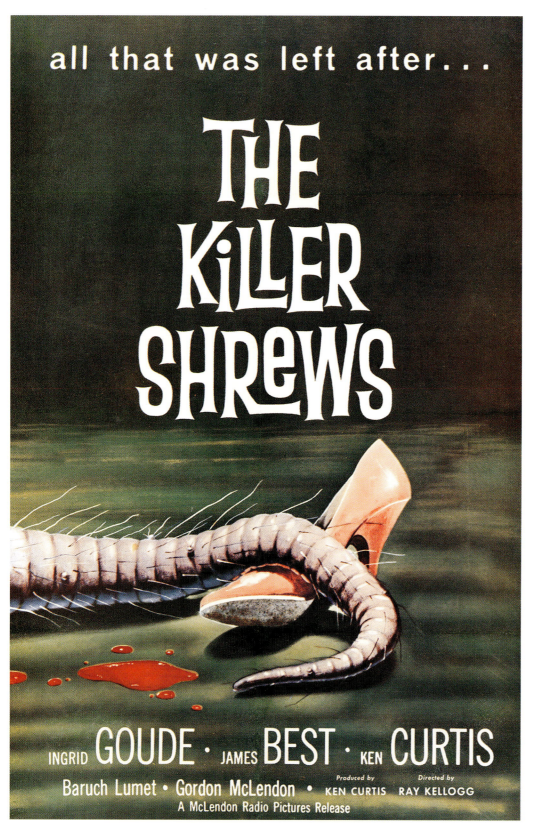

all that was left after...

THE Killer Shrews

INGRID **GOUDE** · JAMES **BEST** · KEN **CURTIS**

Baruch Lumet · Gordon McLendon ·
Produced by KEN CURTIS
Directed by RAY KELLOGG
A McLendon Radio Pictures Release

The Killer Shrews (1959)
US 41 × 27 in. (104 × 69 cm)

Like many films produced by American International Pictures, *How To Make A Monster* was sold to distributors on the back of its title alone – the scriptwriting was almost an afterthought. The film was a near sequel to *I Was A Teenage Werewolf* and *I Was A Teenage Frankenstein* and the poster invited audiences to 'See the ghastly ghouls in flaming color!' The promise of 'flaming color' was probably made because of the need to compete with the bigger-budget Technicolor hits of the time, not least the popular Hammer horrors, but it was perhaps slightly misleading – only eight minutes of the film were in fact shot in colour, the rest remaining in inexpensive black and white.

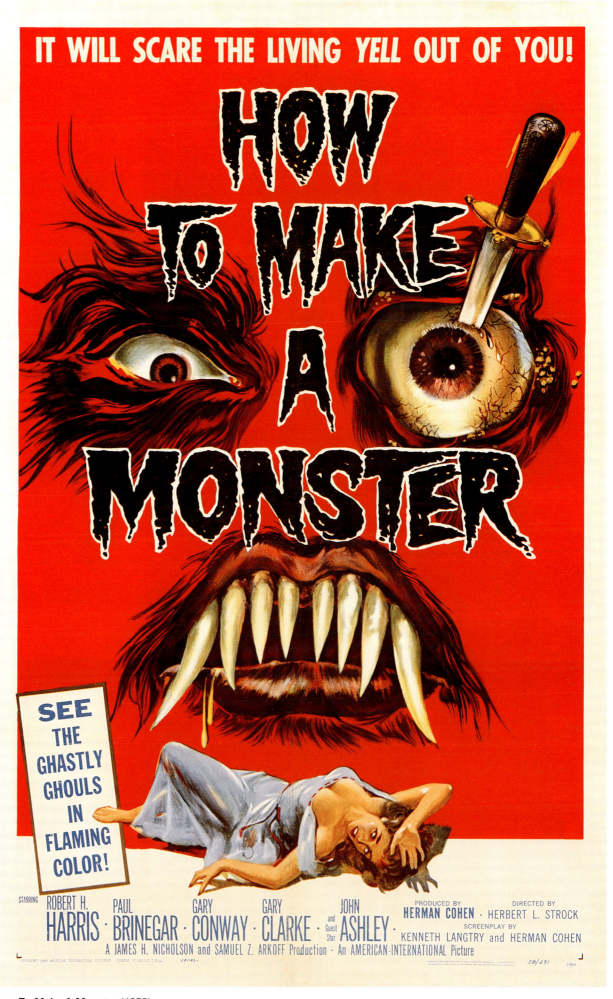

How To Make A Monster (1958)
US 41 × 27 in. (104 × 69 cm)

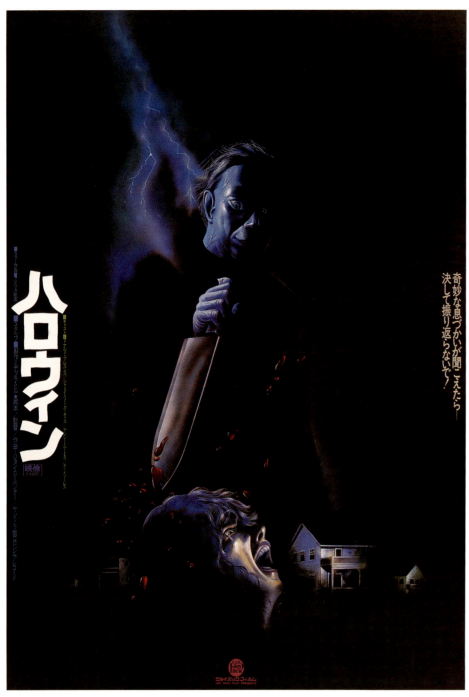

ハロウィン

奇妙な息づかいが聞こえたら──
決して振り返らないで！

Halloween (1978)
Japanese 30 × 20 in. (76 × 51 cm)
Courtesy of The Reel Poster Gallery

Slasher films are firmly grounded in the culture of the 80s. Poised somewhere between popular culture and counterculture, they were, and still are, massively popular. Most follow a simple general formula – a maniac killer (usually male) with a knife, a group of attractive teenagers, a lone girl who survives the mayhem (usually by abstaining from sex) and a camera that follows the action from the killer's point of view. With minor variations these elements feature in every slasher film. Although *Halloween* is recognized as the first slasher flick, earlier films such as *Psycho*, *Peeping Tom*, Tobe Hooper's *The Texas Chainsaw Massacre* and the gory *Blood Feast*, can be seen as precursors of the genre. In the 80s improvements in special effects, allowing the killings to be much more realistic, the rise of the video market, and the relaxation of censorship, which allowed greater violence to appear in mainstream cinema, all contributed to the success of the slasher genre.

Halloween was not only the first but also the definitive slasher flick. Shot in just twenty days on a budget of $300,000, it is one of the most successful independent films of all time, grossing over $70 million worldwide on its first release and shooting all of those involved to stardom.

The title played a large part in the film's success – unbelievably, the word 'halloween' had never featured in a film title before. As mentioned above, the film was influenced by earlier works, most notably *Psycho*, and the figure of the killer owes something to the robotic villain in *Westworld*. The iconic mask, influenced by that in *Les Yeux Sans Visage*, is horrific because of its sinister featureless expression but was in fact nothing more than a two-dollar Captain Kirk mask with the eye-holes enlarged and spray-painted. It was simple, cheap and yet chillingly effective.

With such a small budget, and a limited number of prints, the film could not be released nationwide simultaneously, and its success grew by word of mouth. It was not until the Chicago Film Festival later in the year that the movie became the huge, critically acclaimed hit that it has remained. The American poster for the film is an iconic image from the 70s and the design kept up the suspense and mystery of the plot. However, by the time it was released around the world, the film was so well known that the killer's face could be used as a main selling point.

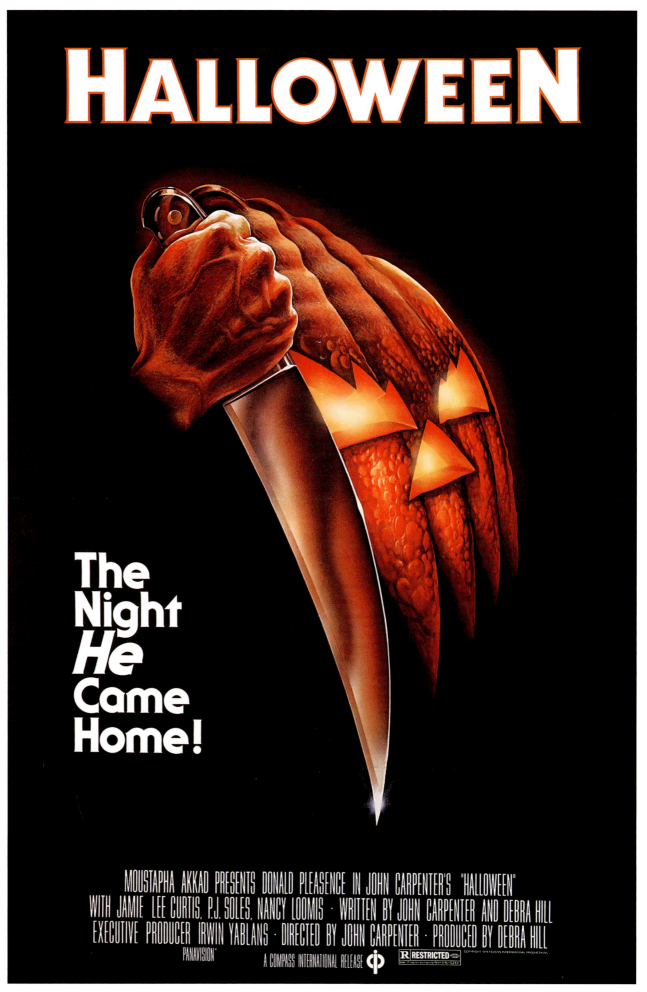

Halloween (1978)
US 41 × 27 in. (104 × 69 cm)
Courtesy of The Reel Poster Gallery

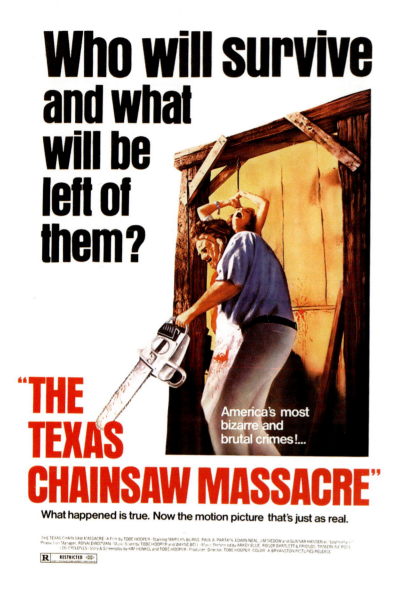

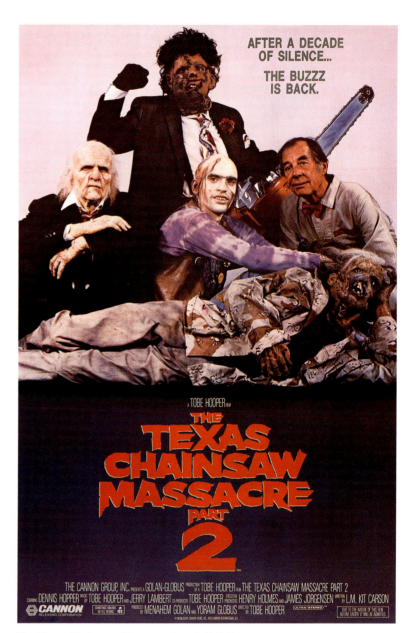

The Texas Chainsaw Massacre (1974)
US 41 × 27 in. (104 × 69 cm)

The Texas Chainsaw Massacre Part 2 (1986)
US 41 × 27 in. (104 × 69 cm)
(Family portrait – Withdrawn)
Courtesy of the Andy Johnson Collection

Describing *The Texas Chainsaw Massacre*, film historian and writer Forrest Ackerman said that 'it brought a new dimension of reality to horror films.' The British *News of the World* called it the 'sickest carnival of slaughter ever seen'. It is certainly true that the film brought nauseating, forceful horror to the screen with a realism that was new to mainstream cinema. Relentlessly violent and desolate, the movie reflected the bleak nihilism of the 70s when economic unrest, unemployment, the Vietnam War and Watergate all seemed to threaten a breakdown of established social and political norms.

The story is based on that of the real-life killer Ed Gein, and the director, Tobe Hooper, still remembers being told stories of the mass murderer as a child. More direct inspiration came from an incident when he found himself forced to stand in line at a hardware store in front of a row of chainsaws, though it is also possible that something was owed to the climactic showdown in Wes Craven's *The Last House On The Left* which takes the form of a duel with chainsaws.

Although *The Texas Chainsaw Massacre* was widely criticized when it first appeared, and indeed provoked a national debate on violence in the movies, it has subsequently gained the status of a cult classic; so much so that a print of the film was added to the permanent collection of the Museum of Modern Art in New York. It helped usher in the era of slasher movies and influenced a number of other films.

The 'Family Portrait' poster for *The Texas Chainsaw Massacre Part 2* was a deliberate spoof of *The Breakfast Club*, which had been released the previous year. The poster was rapidly withdrawn because of breach of copyright.

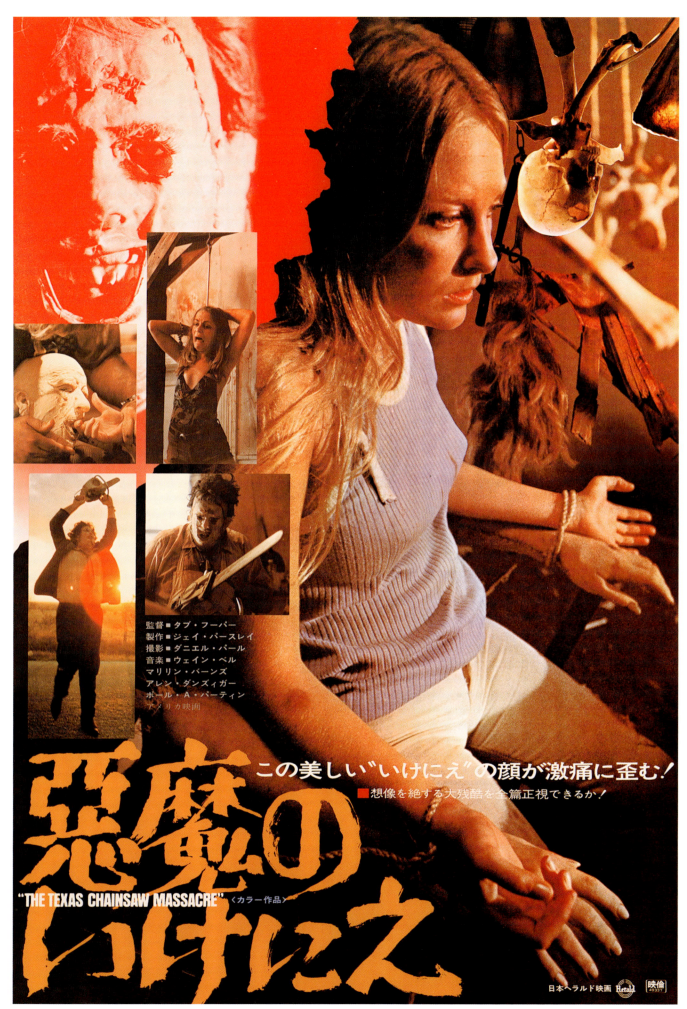

この美しい"いけにえ"の顔が激痛に歪む！
想像を絶する大残酷を全篇正視できるか！

監督■タブ・フーパー
製作■ジェイ・パースレイ
撮影■ダニエル・パール
音楽■ウェイン・ベル
マリリン・バーンズ
アレン・ダンズィガー
ポール・A・パーティン
アメリカ映画

惡魔の
"THE TEXAS CHAINSAW MASSACRE" 〈カラー作品〉
いけにえ

日本ヘラルド映画 Herald 映倫

The Texas Chainsaw Massacre (1974)
Japanese 30 × 20 in. (76 × 51 cm)

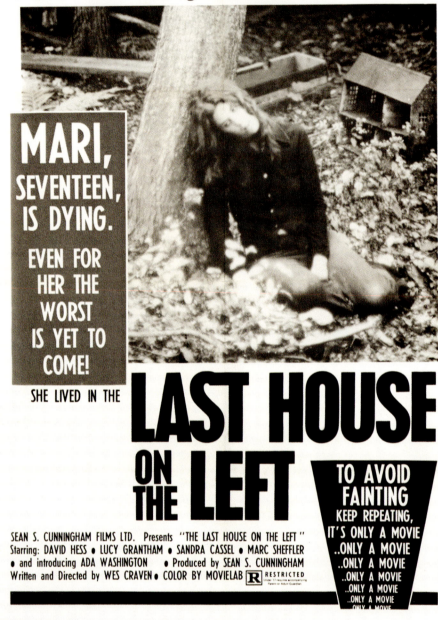

It rests on 13 acres of earth over the very center of hell..!

MARI, SEVENTEEN, IS DYING.

EVEN FOR HER THE WORST IS YET TO COME!

SHE LIVED IN THE

LAST HOUSE ON THE LEFT

TO AVOID FAINTING KEEP REPEATING, IT'S ONLY A MOVIE ..ONLY A MOVIE ..ONLY A MOVIE ..ONLY A MOVIE ..ONLY A MOVIE ..ONLY A MOVIE ..ONLY A MOVIE

SEAN S. CUNNINGHAM FILMS LTD. Presents "THE LAST HOUSE ON THE LEFT" Starring: DAVID HESS • LUCY GRANTHAM • SANDRA CASSEL • MARC SHEFFLER • and introducing ADA WASHINGTON • Produced by SEAN S. CUNNINGHAM Written and Directed by WES CRAVEN • COLOR BY MOVIELAB [R] RESTRICTED

The Last House On The Left (1972)
US 41 × 27 in. (104 × 69 cm)

Wes Craven (b. 1939) is by nature a gentle, quiet man and is the surprising genius behind many of the twentieth century's most popular horror films. Raised in a family of Baptist fundamentalists, the only films he was ever allowed to watch as a child were Disney movies. It was only after moving to university to follow his dreams of becoming a writer that his obsession with the movies was born. His first film as director was *The Last House On The Left*, a crude horror opus that was one of the earliest 'rape-revenge' movies. Craven's ambition was to horrify rather than titillate and the shockingly graphic violence led to the film being banned in the UK for over thirty years. Influenced by Peckinpah, the film went further than most had been willing to go, and set a new benchmark for horror. *The Last House On The Left* would in its turn influence many works, including Tobe Hooper's *The Texas Chainsaw Massacre*. The film balances the violence of the initial rape and murder scenes with the later revenge sequences, forcing the audience to question whether one type of violence is as bad as another, or whether revenge can be justified.

It is these same themes that are explored in Craven's second picture, *The Hills Have Eyes*. It was inspired by the story of Sawney Bean and his family – seventeenth-century Scots who preyed on unsuspecting travellers and ate them. When the family were finally caught by the authorities, their punishment was to be executed in a most grotesque fashion. Craven's film tells the story of a normal family who are attacked in the desert by savage cannibals who kill many of them before the survivors decide to exact revenge. The moral lines are blurred and, by the film's conclusion, it is unclear who are supposed to be seen as the real victims or the real criminals.

Although initially reluctant to make a second horror picture, the director gave in to massive pressure and agreed to shoot the low budget movie that would become a cult classic and consolidate his reputation as a master of horror. Shot on 16mm film with a crew of sixteen, the film was raw and menacing. It was initially given an 'X' certificate and underwent huge editing cuts to bring it down to an 'R'. It did well at the cinema but was eclipsed by *Smokey And The Bandit* that was unfortunately released in the same month.

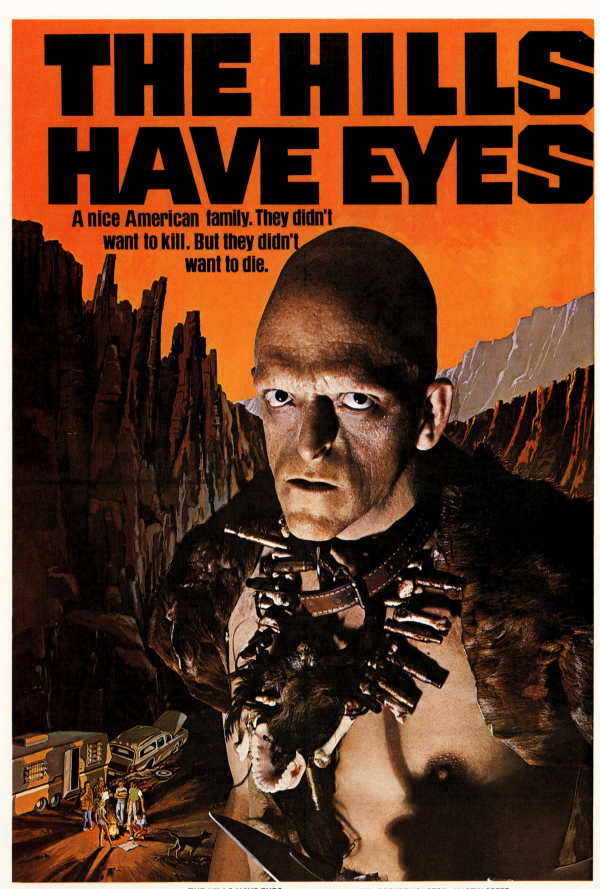

The Hills Have Eyes (1977)
US 41 × 27 in. (104 × 69 cm)

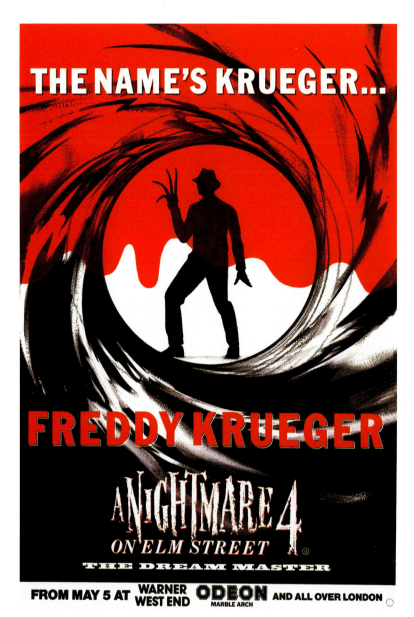

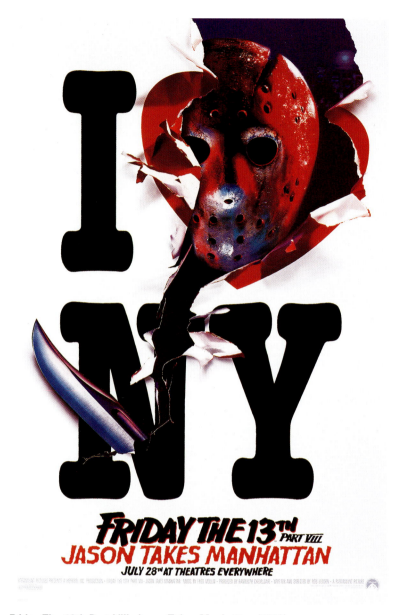

A Nightmare On Elm Street 4: The Dream Master (1988)
British 30 × 20 in. (76 × 51 cm)
(Withdrawn)
Courtesy of the Andy Johnson Collection

Friday The 13th Part VIII: Jason Takes Manhattan (1989)
US 41 × 27 in. (104 × 69 cm)
(Advance – Withdrawn)

Freddy Krueger – Freddy after a bully who used to pick on Craven as a kid, Krueger after Krug, the baddie in *The Last House On The Left* – is the epitome of the slasher-movie villain and has become one of the cinema's most evil and best-loved personalities. His image, the burned face with its grotesque grin topped by a porkpie hat, the striped red sweater and the bladed fingers, became an icon of 80s culture.

The story of *A Nightmare On Elm Street* was inspired by a report in the *Los Angeles Times* about people who had appalling nightmares after which they were terrified to go back to sleep – when they did, they died. Wes Craven had in fact written a research paper on dreams at university and used to keep a dream diary of his own. This interest in the subject, coupled with his proven mastery in the field of horror, made him the perfect candidate to direct this most popular of slasher films.

The British poster for *A Nightmare On Elm Street 4: The Dream Master* disappeared from hoardings across London within hours of EON Productions sending a strong warning that they considered it an infringement of the Bond copyright. Likewise the poster for *Friday The 13th: Jason Takes Manhattan* was pulled in America for illegal use of the 'I Love NY' trademark.

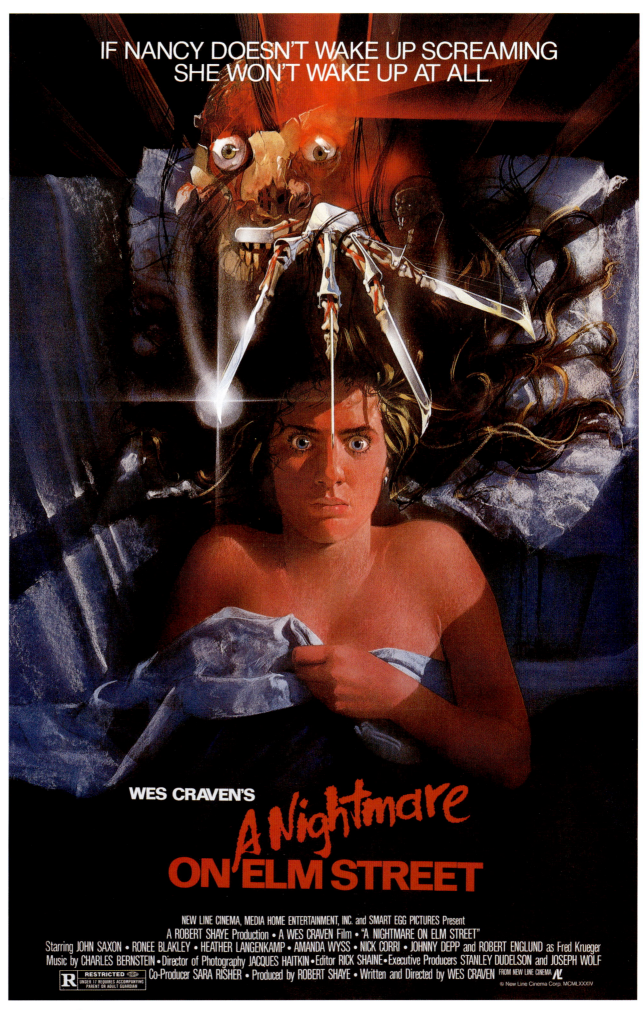

A Nightmare On Elm Street (1984)
US 41 × 27 in. (104 × 69 cm)
Art by Matthew William Peak

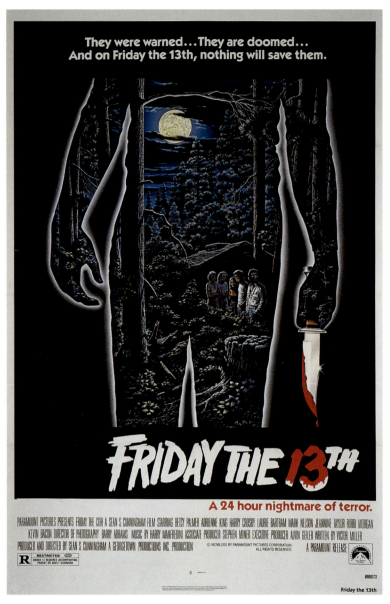

Friday The 13th (1980)
US 41 × 27 in. (104 × 69 cm)
Art by Alex Ebel

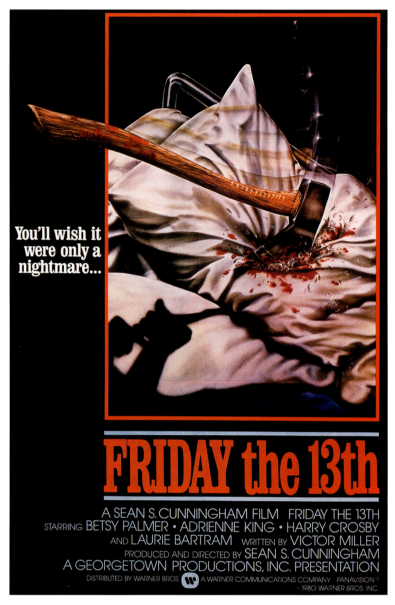

Friday The 13th (1980)
US 41 × 27 in. (104 × 69 cm)
(International)
Art by Joann
Courtesy of The Reel Poster Gallery

Inspired by Mario Bava's *Twitch Of The Dead Nerve* in 1971, *Friday The 13th* is a classic slasher film. Director Sean Cunningham had the title for the film way before he had a script, cast or crew and he used it to make an advertisement for the non-existent film that drummed up sufficient publicity to raise the $500,000 he needed to start production. Further interest was then fuelled by a bidding war between Paramount, Warner Brothers and United Artists. But, even so, the film was very much a surprise hit that had not been expected to have much success, especially as it was up against the two summer blockbusters of 1980, *The Empire Strikes Back* and *The Shining*. Before the first run was over, *Friday The 13th* had taken nearly $40 million, consolidating the genre as the 80s' favourite.

Scream is a post-modern slasher movie. It is both a tribute to, and a clever satire, of the genre. Wes Craven was so taken with Kevin Williamson's script that he agreed to direct the feature, after initially turning it down. It proved as successful as the 80s movies it emulates.

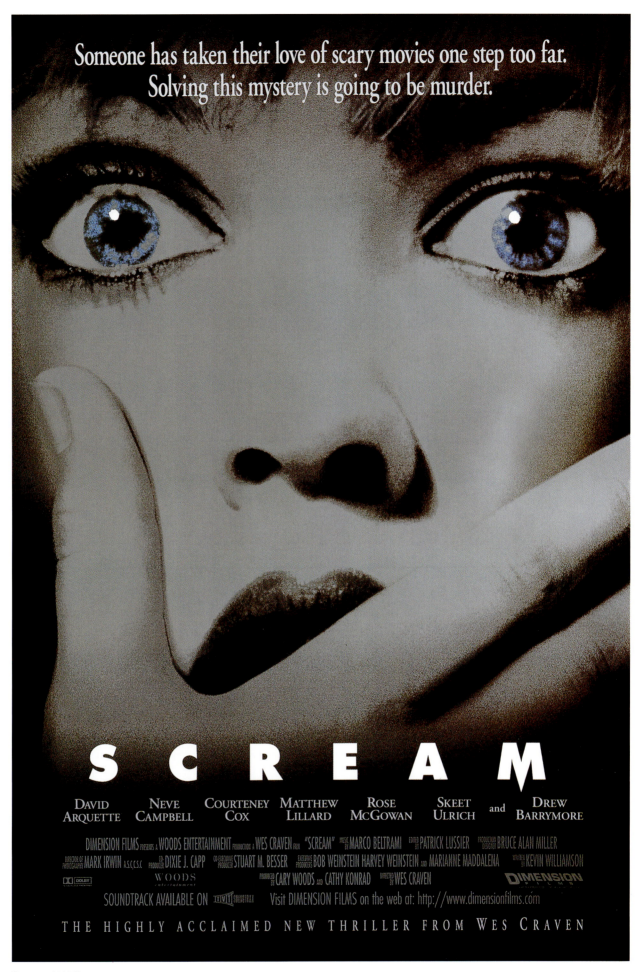

Scream (1996)
US 41 × 27 in. (104 × 69 cm)
Photo by Susan Schashter
Design by David Pearson
Creative direction by Tod Tarhan

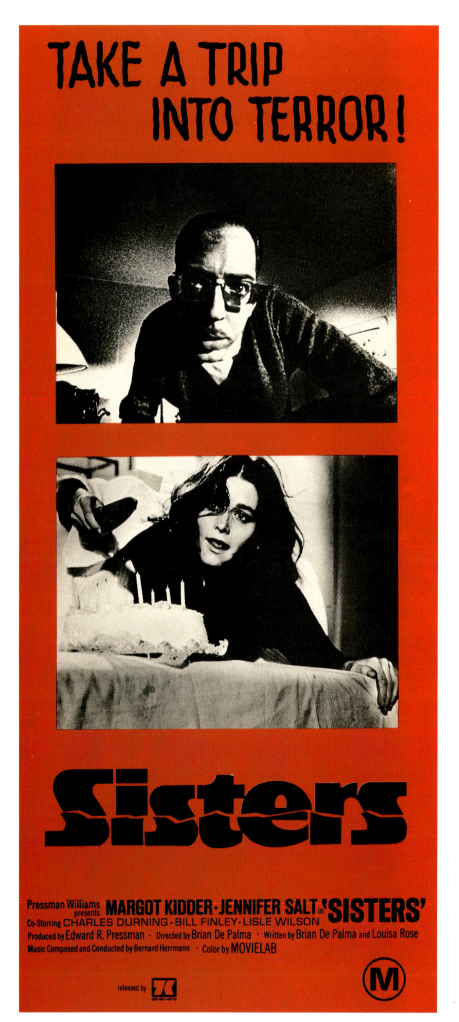

Sisters (1973)
Australian 30 × 13 in. (76 × 33 cm)

Brian de Palma (b. 1940) is the son of an orthopaedic surgeon and was fascinated by all things bloody and gruesome from an early age. Widely acclaimed as a director, he has repeatedly worked in the horror genre. After directing several independent productions, he released *Sisters*, his first real hit, in 1973. The film owes a great deal to Alfred Hitchcock's style and pays intelligent homage to the director while still remaining a unique and visionary work in its own right. De Palma continued this love affair with Hitchcock in many of his subsequent films, adopting a voyeuristic style characterized by split-screen shots and false endings and regularly featuring *doppelgangers* or *femme fatales*. When *Carrie* was released in 1976 it was his biggest success thus far.

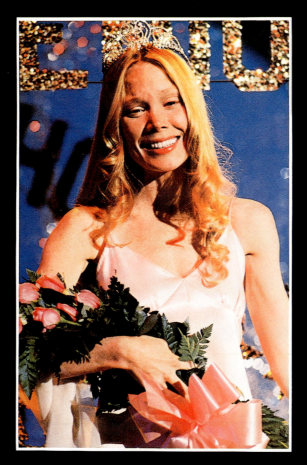
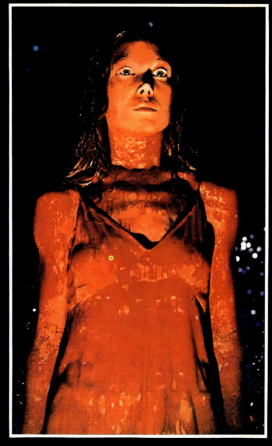
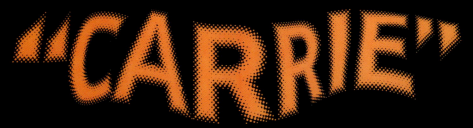

Carrie (1976)
US 41 × 27 in. (104 × 69 cm)

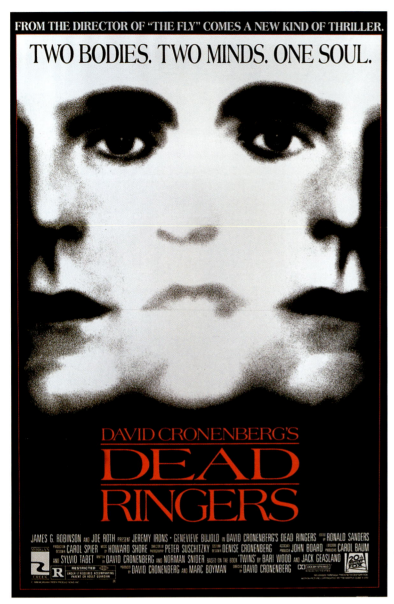

Dead Ringers (1988)
US 41 × 27 in. (104 × 69 cm)
Art direction and design by Nathan Grant

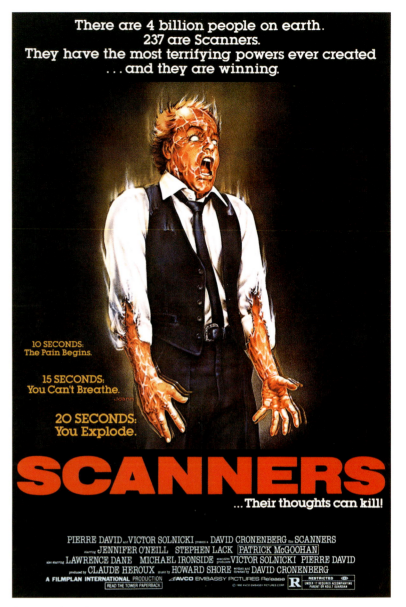

Scanners (1981)
US 41 × 27 in. (104 × 69 cm)
Courtesy of the Martin Bridgewater Collection

David Cronenberg (b. 1943) was a writer and musician from a young age. He studied science at the University of Toronto, before switching to take a degree in literature and it was at university that his interest in film began. After making some low-budget horror films that earned him a reputation, he made his first mainstream film, *Scanners*, in 1981. His background in science and his continuing fascination with the subject is evident in all his work which is much concerned with themes such as mutation, parasites and the perversion of biology. *The Fly* is a perfect example of his work and highlights the dangers of trying to control and exploit nature. Both touching and gruesome, it displays the intelligence and intellectual provocation that characterizes all of Cronenberg's work.

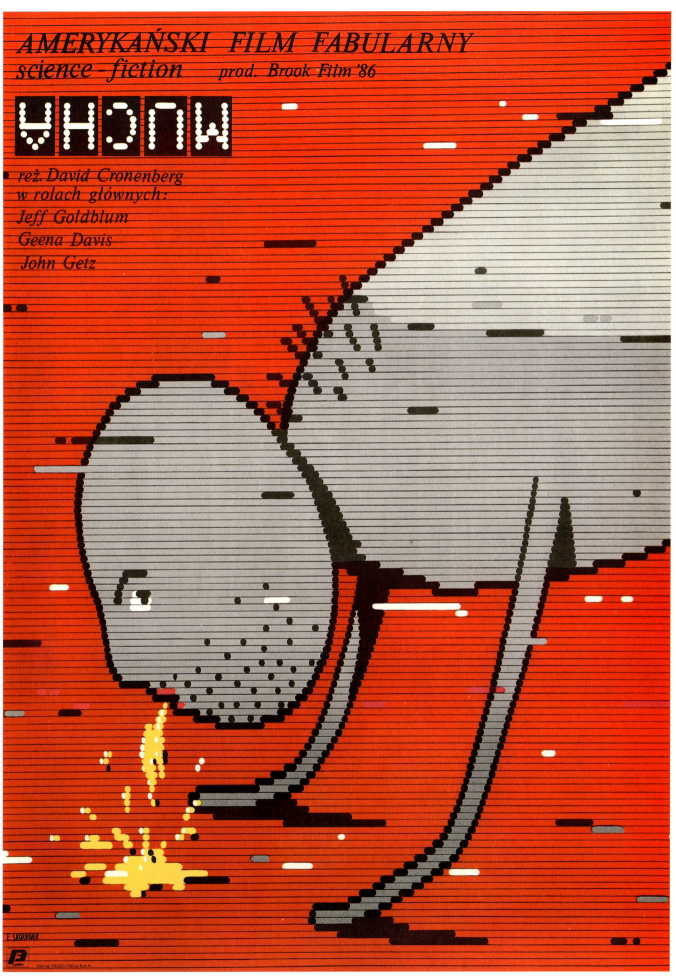

The Fly (Mucha) (1986)
Polish 38 × 27 in. (97 × 69 cm)
Art by Eugeniusz Skorwider
Courtesy of The Reel Poster Gallery

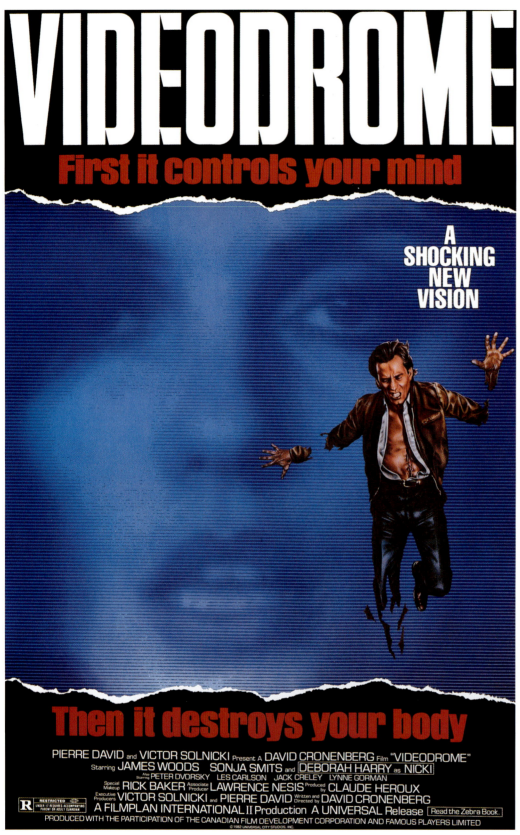

Videodrome (1982)
US 41 × 27 in. (104 × 69 cm)
Courtesy of the Martin Bridgewater Collection

Horror films in the 20s and 30s placed the ghouls in far-off lands, a safe distance from the audiences enjoying their escapist thrills. Horror in the 60s and 70s was often set closer to home, but was still safely removed from 'normal' life – the action was played out in remote hotels and empty countryside. In the 80s, however, a new and terrifying dimension was added to horror – it was brought into our own homes and everyday lives. The audiences leaving the cinemas would take home with them memories of killers creeping through bedroom windows and phones ringing endlessly through the night. In *Poltergeist*, the horror invades the familiar environment of a family home and plays on childhood fears of things that go bump in the night and shadows that hide under the bed.

Videodrome is an examination of our 'video age' and a disturbing exploration of the effects of technology. Cronenberg takes the humdrum and manipulates it into a dark world of danger and sexuality, mind control and technology gone awry.

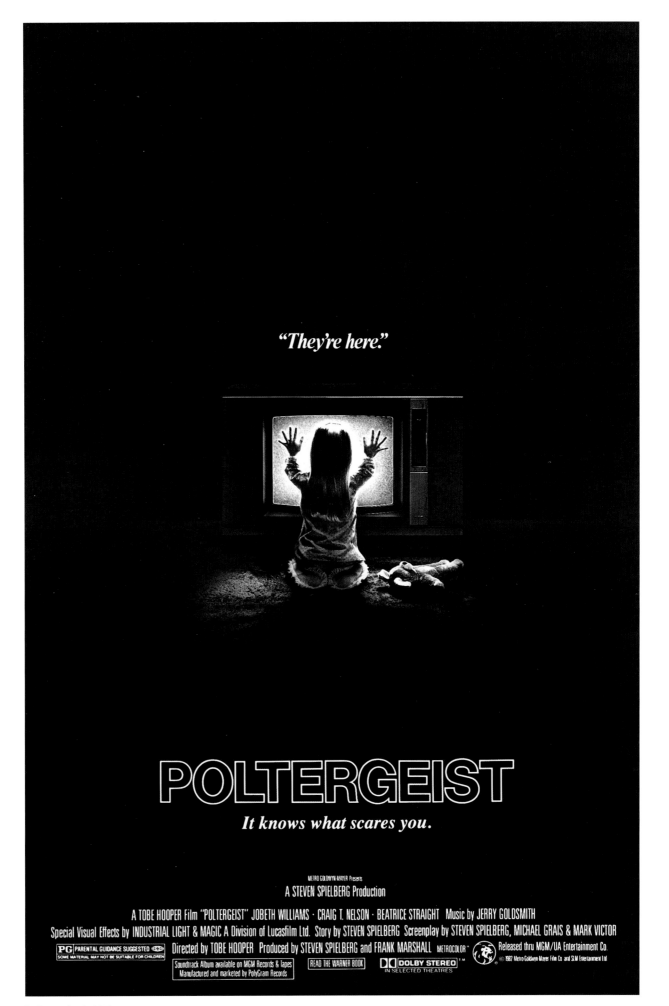

Poltergeist (1982)
US 41 × 27 in. (104 × 69 cm)
Courtesy of the Martin Bridgewater Collection

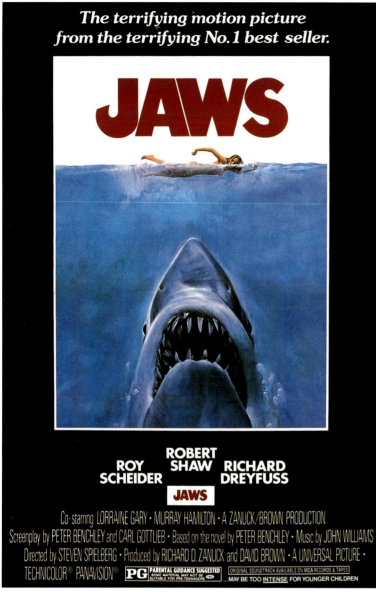

Jaws (1975)
US 41 × 27 in. (104 × 69 cm)
Art by Mick McGinty
Courtesy of The Reel Poster Gallery

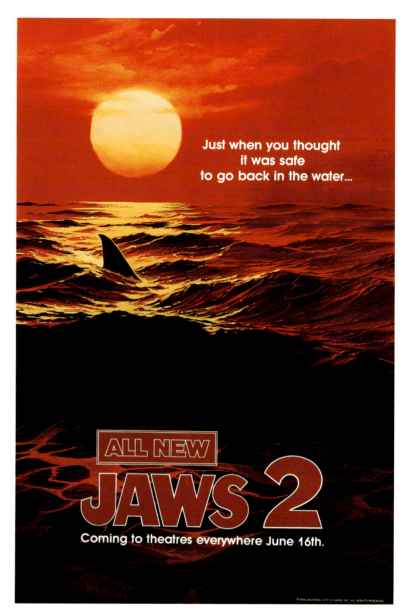

Jaws 2 (1978) US 41 × 27 in. (104 × 69 cm)
(Advance Style B)
Art by Mick McGinty

The work of Siouxland illustrator **Mick McGinty** is recognized around the world. His designs have featured on Superbowl programs and on beer bottles, but his most famous single work remains his poster design for *Jaws*. In addition to McGinty's artwork, a special, limited-edition 'Shark Facts' poster was released for the film that detailed fourteen gruesome and fascinating facts. It was authenticated by a leading shark research specialist, Professor Donald R. Nelson.

Jaws invented the summer blockbuster and was a massive hit that shattered box-office records. It was the film that propelled Spielberg to international fame and frightened a whole generation out of the water. Three years later, the sequel was also a massive hit. The phrase, 'Just when you thought it was safe …' has become an overused cliché in today's society. In fact, it was the *Jaws 2* poster that first introduced the saying into daily use back in 1978.

Sharkfacts:

Provided as a Public Service
by the Producers of
JAWS

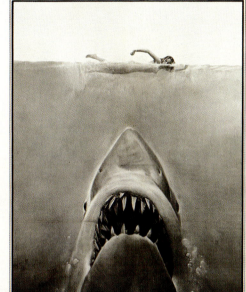

If you swim in the sea, anywhere in the world, you do not do so without risk. The shark is an ancient, wide-ranging, and ever present threat.

Sharks do not ordinarily feed on human beings. But as volumes will attest, they do attack. How and when and why is still unpredictable.

Therefore, if you must venture into the ocean, at least know your enemy. At present, there is much about the shark's behavior we do not fully comprehend. Some of the important things we do know are enumerated below.

You would be wise to study them.

1 All sharks, no matter what their size, should be treated with respect. There are over 300 species of sharks. Most are predators, born with a full set of teeth and the instinct to use them. Even a shark much smaller than a man has the ability to inflict fatal injuries.

2 The seas off our shore are aprowl with many killers. The proven maneaters include the Blue Shark, the Tiger Shark, the Bull Shark, the Mako, the Hammerhead, and most fearsome of all...the Great White.

3 Fresh water swimmers are not necessarily safe from sharks. A lake in Central America contains some of the most voracious sharks in the world. Experiments have proven that some sharks traverse 100 miles of river to get there. Three of the worst attacks in U.S. history occurred in a brackish New Jersey creek 20 miles from the open sea.

4 The shark is in many respects one of the most successful creatures on the planet. The first sharks appeared over 300 million years ago. They have changed relatively little in the past 60 million years. The sharks prey are many, his enemies few. He is a most efficient killing machine.

5 Shark attacks may be motivated by more than mere hunger. There is evidence that the shark has a "fighting instinct," that he attacks for reasons of true aggression —probably to protect territory, personal space, or status.

6 Some sharks can move in tremendous bursts of speed. The Mako, which can leap twenty feet out of the water has been reported to exceed 30 miles an hour.

7 A shark is a tooth making machine. And the teeth you see in a shark's gaping mouth aren't the half of it. Behind the front row lay at least four to six more rows. Razor sharp cutting and tearing tools, they are often serrated like a steak knife. When a tooth is lost, a new tooth replaces it. In one chomp, a shark can inflict a wound which is massive and almost surgically precise.

8 A major portion of a shark's brain is devoted to the sense of smell. An incredibly small concentration of blood in the water can arouse his feeding desire and bring him running to the source from far away. If you are bleeding, no matter how slightly, get out of the water.

9 A shark's vision is far from poor. Like a panther, his eyes are designed to be efficient in very dim light. In the dark, the shark has a special advantage over you. Never swim at night.

10 Sharks have been known to attack practically anything. Floating barrels. Life rafts. Whirling propellers. And boats. One hooked shark attacked a 35 foot fishing boat, tore planking from the bottom, and sank it.

11 Shark attacks occur in water of every depth. They have killed in the open sea and at the surf line. Some of the worst attacks occurred in water only knee deep.

12 A shark doesn't have to bite you to hurt you. His skin is extremely rough, covered with tiny denticle structures very similar to teeth. Rub him the wrong way, and he can severely abrade your skin.

13 Sharks are superbly equipped to detect low-frequency vibrations—the erratic noises made by wounded fish...and poor swimmers. He can home in on these peculiar sounds from hundreds of yards. Swim smoothly.

14 Of all the sharks in the sea, the Great White (*Carcharodon carcharias*) is unquestionably the most dangerous. The largest yet captured measured 21 feet and weighed over 3½ tons. They undoubtedly grow even larger.

The known food of the Great White Shark includes mackerel, tuna, porpoise, seal, other sharks, and on terrible occasions...man.

for of all large animals found in the sea, man is the easiest prey.

Authenticated by Donald R. Nelson (Ph.D.), Shark Research Specialist, Associate Professor of Biology California State University, Long Beach

Jaws (1975)
US 41 × 27 in. (104 × 69 cm)
(Shark Facts)
Courtesy of The Reel Poster Gallery

Eraserhead (1977)
Japanese 30 × 20 in. (76 × 51 cm)
Courtesy of the Martin Bridgewater Collection

Avant-garde filmmaker **David Lynch** (b. 1946) has gained an international reputation as an accomplished writer, director, television producer, photographer, artist and composer. The surreal worlds that he creates have a nightmare quality in which reality is supplanted by the bizarre landscapes of his imagination. Lynch attended various art schools, including one in an especially violent area of Philadelphia. He also became a father at 21. Both experiences had a major influence on *Eraserhead*, the opus on which he worked obsessively for over five years. Hypnotic and violent, the film tells the story of a child born a reptilian mutant. Almost too disturbing to be released, it was shown in arthouse theatres and was distributed by independent company Libra – the posters for the film thus differ from the standard American size. *Eraserhead* has since garnered a cult following and the threads and themes established in it are woven through many of Lynch's later works.

Eraserhead (1977)
US 22 × 17 in. (56 × 43 cm)
Courtesy of The Reel Poster Gallery

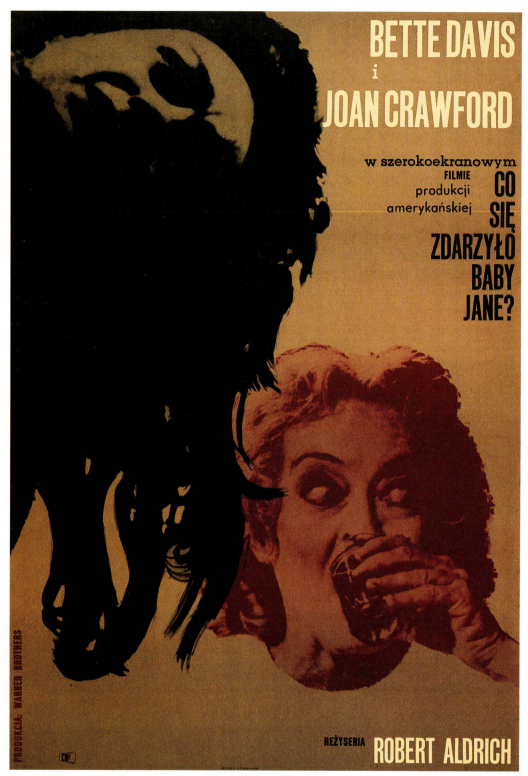

What Ever Happened To Baby Jane? (Co Sie Zdarzyło Baby Jane?) (1962)
Polish 33 × 23 in. (84 × 58 cm)
Courtesy of The Reel Poster Gallery

The cult classic *What Ever Happened To Baby Jane?* is an eccentric film about the twisted relationship between two sisters. The movie revitalized the dying careers of two aging screen legends, Bette Davis and Joan Crawford, and is infused with the same paranoid animosity that existed between its stars in real life.

Bette Davis and Joan Crawford

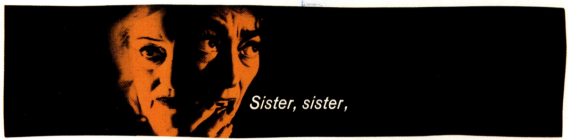

Sister, sister,

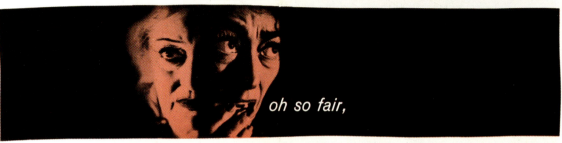

oh so fair,

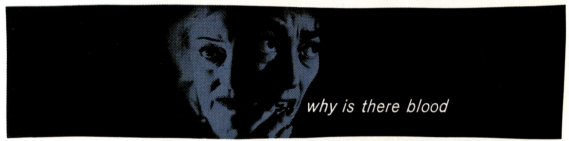

why is there blood

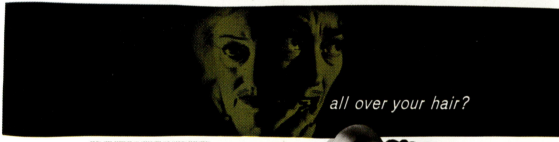

all over your hair?

SEVEN ARTS PRESENTS AN ASSOCIATES AND ALDRICH PRODUCTION

"WHAT EVER HAPPENED TO BABY JANE?"

Things you should know about this motion picture before buying a ticket:
❶ If you're long-standing fans of Miss Davis and Miss Crawford, we warn you this is quite unlike anything they've ever done. **❷** You are urged to see it from the beginning. **❸** Be prepared for the macabre and the terrifying. **❹** We ask your pledge to keep the shocking climax a secret. **❺** When the tension begins to build, try to remember it's just a movie.

INTRODUCING VICTOR BUONO PRODUCED AND DIRECTED BY ROBERT ALDRICH SCREEN PLAY BY LUKAS HELLER MUSIC BY FRANK DeVOL BASED ON THE NOVEL BY HENRY FARRELL RELEASED BY WARNER BROS.

What Ever Happened To Baby Jane? (1962)
US 41 × 27 in. (104 × 69 cm)
Courtesy of The Reel Poster Gallery

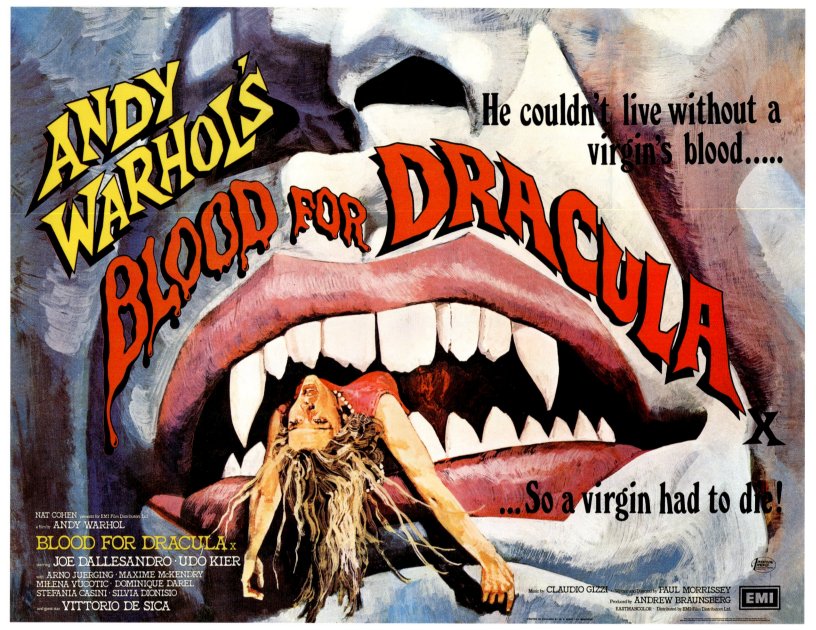

Andy Warhol's Dracula (Blood For Dracula) (1974)
British 30 × 40 in. (76 × 102 cm)
Courtesy of the Tomoaki 'Nigo' Nagao Collection

The father of Pop Art and one of the twentieth century's most important and influential artists, **Andy Warhol** (1928–1987) has become an American legend. By the mid-60s, he had firmly established himself as the most famous visual artist in New York. By 1962, he had founded his famous Factory, the chaotic art and performance studio where Pop Art was born. As well as his paintings, Warhol made over 300 experimental films (his first was called *Sleep* and simply showed a man sleeping for six hours). Influenced and inspired by notable underground directors, Warhol is credited with opening the way for the avant-garde film movement to break into the cinematic mainstream.

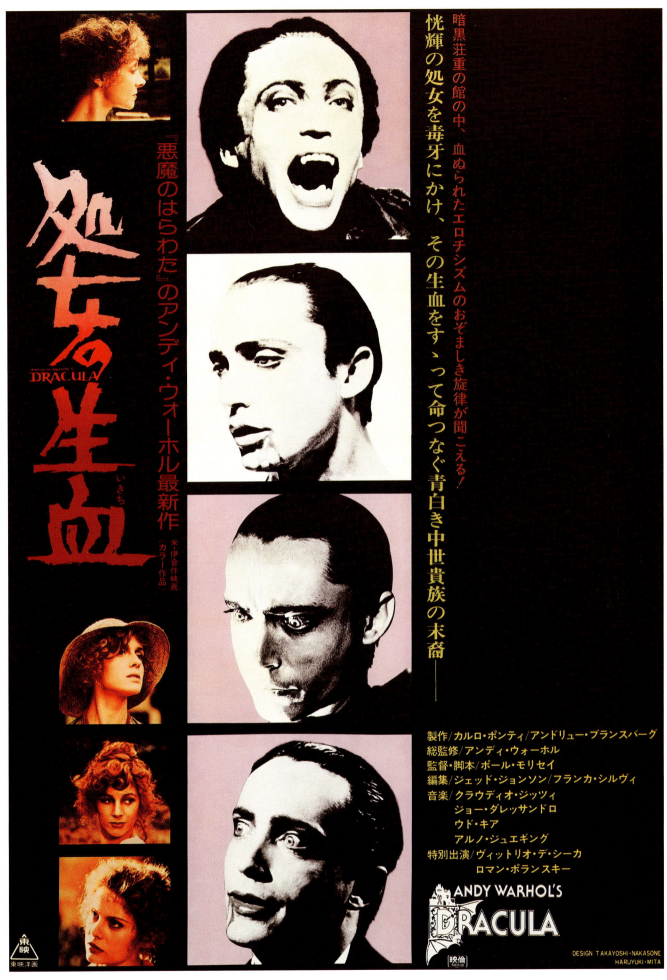

Andy Warhol's Dracula (Blood For Dracula) (1974)
Japanese 30 × 20 in. (76 × 51 cm)
Design by Takayoshi Nakasone & Haruyuki Mita
Courtesy of the Tomoaki 'Nigo' Nagao Collection

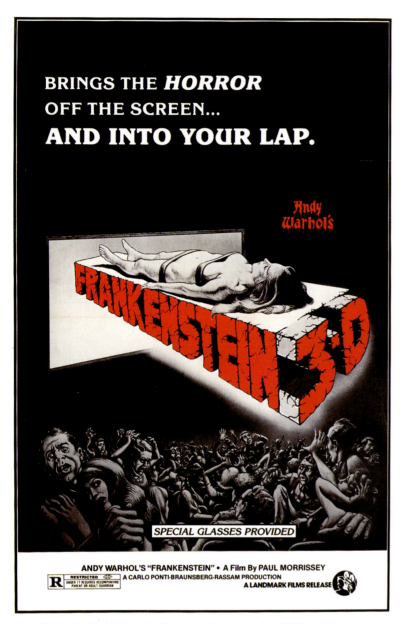

Andy Warhol's Frankenstein (Flesh For Frankenstein) (1974)
US 41 × 27 in. (104 × 69 cm)
(International 3-D)
Courtesy of the Tomoaki 'Nigo' Nagao Collection

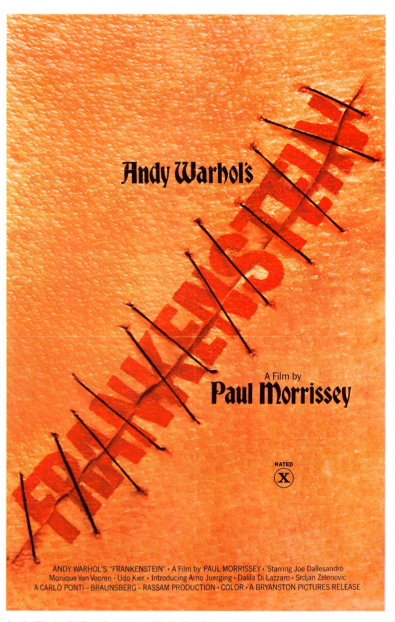

Andy Warhol's Frankenstein (Flesh For Frankenstein) (1974)
US 41 × 27 in. (104 × 69 cm)
Courtesy of The Reel Poster Gallery

Warhol's films were mostly shown in arthouse cinemas and continue to be a challenge to watch. His work is characterized by unconventional shots, innovative formats and non-linear narratives. Warhol continued to direct his own films until 1968, when he handed over the reigns to Paul Morissey. He was still involved, however, and continued to use his celebrated name to promote the movies.

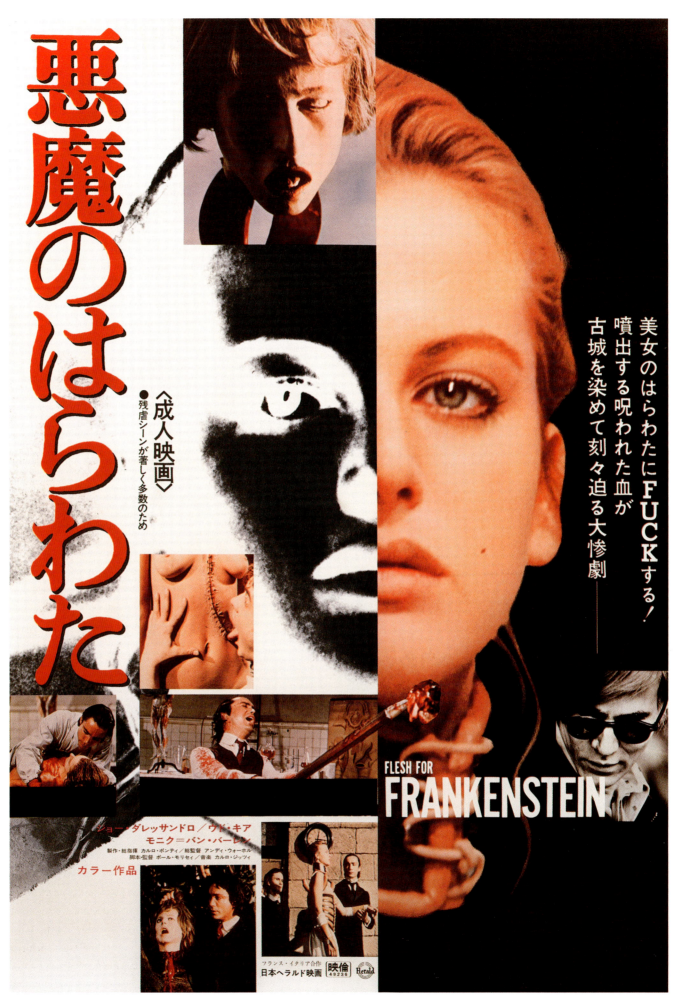

Andy Warhol's Frankenstein (Flesh For Frankenstein) (1974)
Japanese 30 × 20 in. (76 × 51 cm)
Courtesy of The Reel Poster Gallery

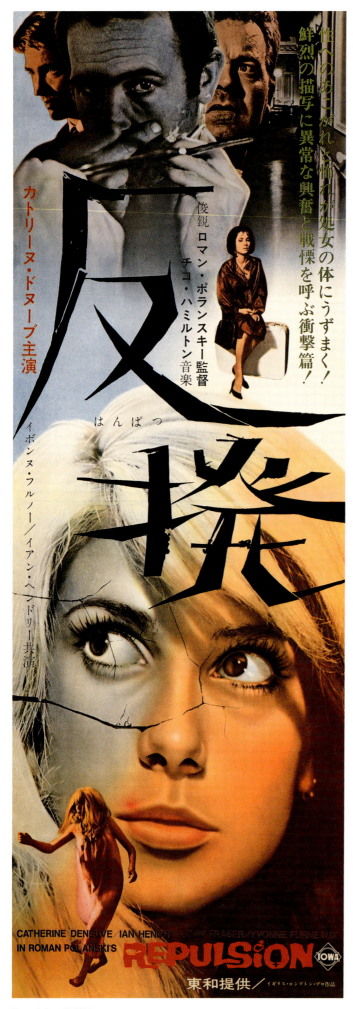

Repulsion (1965)
Japanese 60 × 20 in. (152 × 51 cm)

Roman Polanksi (b.1933) took up acting in the 50s before studying at the Lotz film school. In 1959, his short film, *Dwaj Ludzie Z Szafa (Two Men And A Wardrobe)* won several international awards and began to establish his reputation as a connoisseur of black humour and an intelligent observer of strange human relationships. His debut feature film, *Noz W Wodie (Knife In The Water)* was the first post-war Polish film that was not about the war. After this success, Polanski moved to Paris, where he befriended Gerard Brach, a notable scriptwriter. After moving to Britain, the friends collaborated on *Cul De Sac* and *Repulsion*. The latter formed the first part of a trilogy of Polanksi's psychological horrors. It was followed by *Rosemary's Baby* in 1968 (the first film Polanski made in Hollywood) and then by *The Tenant* in 1976.

Jan Lenica (1928–2001) is an accomplished cartoonist, illustrator, animated filmmaker and graphic designer. He has won numerous awards for his work in all of these disciplines, but most notably for his poster designs.

Polanski and Lenica had a mutual respect for each other's work and Polanski names Jan Lenica as his favourite Polish filmmaker. Their work is perhaps connected by a shared preoccupation with the bizarre and the absurd. Although he was creating far fewer posters by the 60s, Lenica designed the Polish poster for *Knife In The Water*. He has only designed two posters for British films, both of them directed by Polanksi – *Cul De Sac* and *Repulsion*.

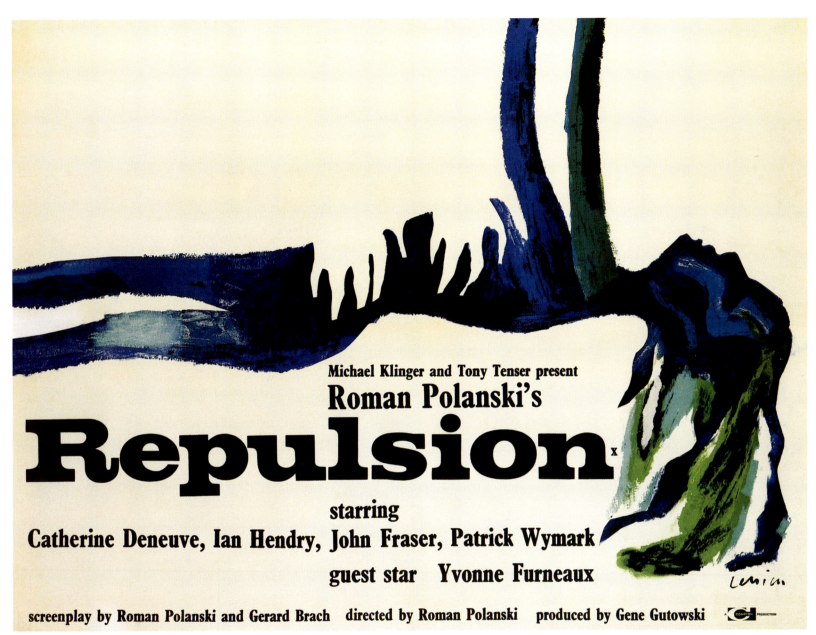

Repulsion (1965)
British 30 × 40 in. (76 × 102 cm)
Art by Jan Lenica
Courtesy of the Jonathan Wilkinson Collection

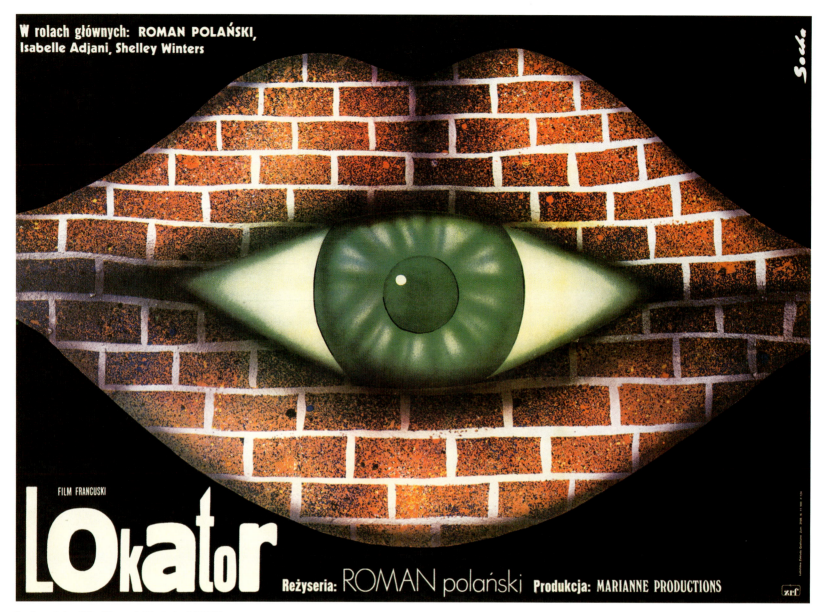

Le Locataire (The Tenant / Lokator) (1976)
Polish 23 × 33 in. (58 × 82 cm)
Art by Romuald Socha
Courtesy of The Reel Poster Gallery

In 1995, **Steve Frankfurt (b.1931)** was awarded the *Hollywood Reporter's* Key Art Lifetime Achievement Award. It was a fitting tribute to the man who began his career in the 60s as a top creative director in a leading advertising agency. The images which he created for his Madison Avenue clients became known across America. From this auspicious beginning, he moved into the world of film production where he proceeded to enhance his already legendary status. His advertising campaign for *Rosemary's Baby* in 1968 revolutionized the way in which movies were marketed: his inventive techniques included the sound of crying babies in film houses, stencilled sidewalks and matchbooks, birth announcements in the *New York Daily News* and a baby carriage poised on a rock in Central Park. It is this image that features on the American poster for the film.

Frankfurt has designed a number of film posters, including *Forrest Gump* in 1994 and *Alien* in 1979 which features the famous tagline 'In space, no-one can hear you scream.'

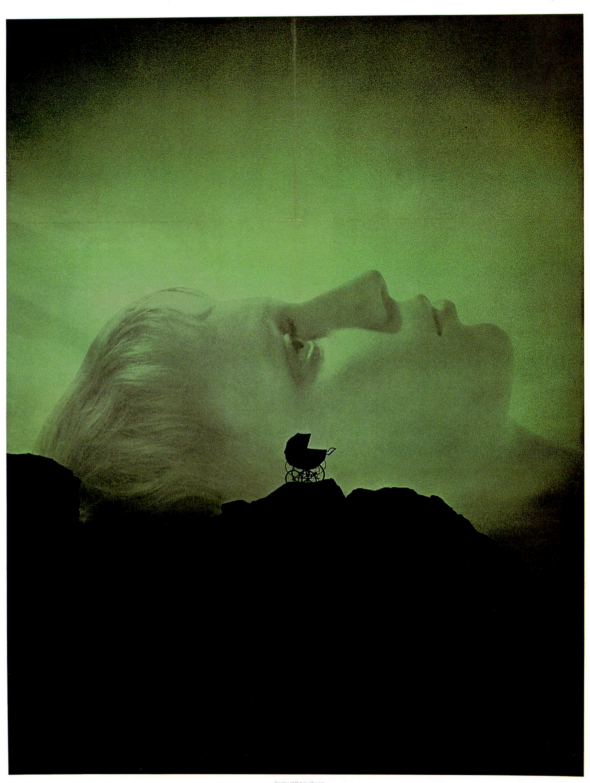

Rosemary's Baby (1968)
US 41 × 27 in. (104 × 69 cm)
Design by Steve Frankfurt
Courtesy of the Andrew MacDonald Collection

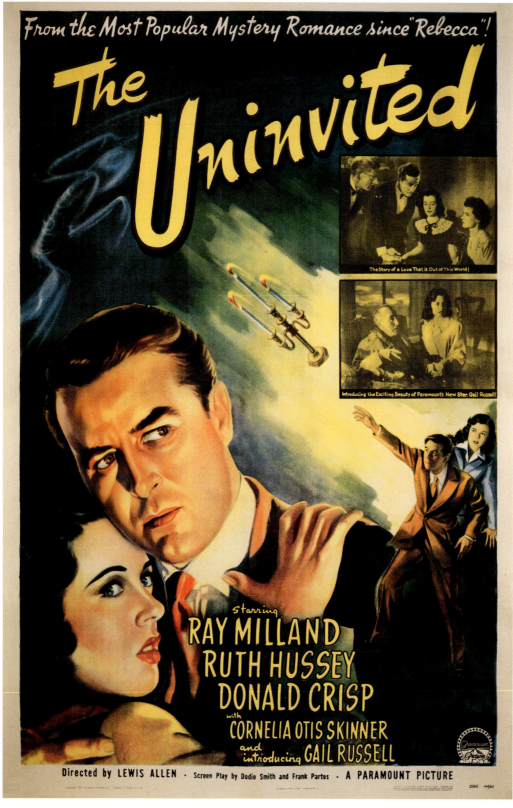

The Old Dark House and The Uninvited are two examples of the haunted house sub-genre of horror movies that also includes classics like The Amityville Horror and The Changeling. The Old Dark House is a gothic horror, directed by James Whale and starring a creepy Boris Karloff. The plot centres on a group of people who take shelter from a storm in an old mansion inhabited by a family who display disconcerting characteristics. The Uninvited, made twelve years later, was a classic romantic ghost story and one of the spookiest haunted house movies ever made.

The Uninvited (1944)
US 41 × 27 in. (104 × 69 cm)

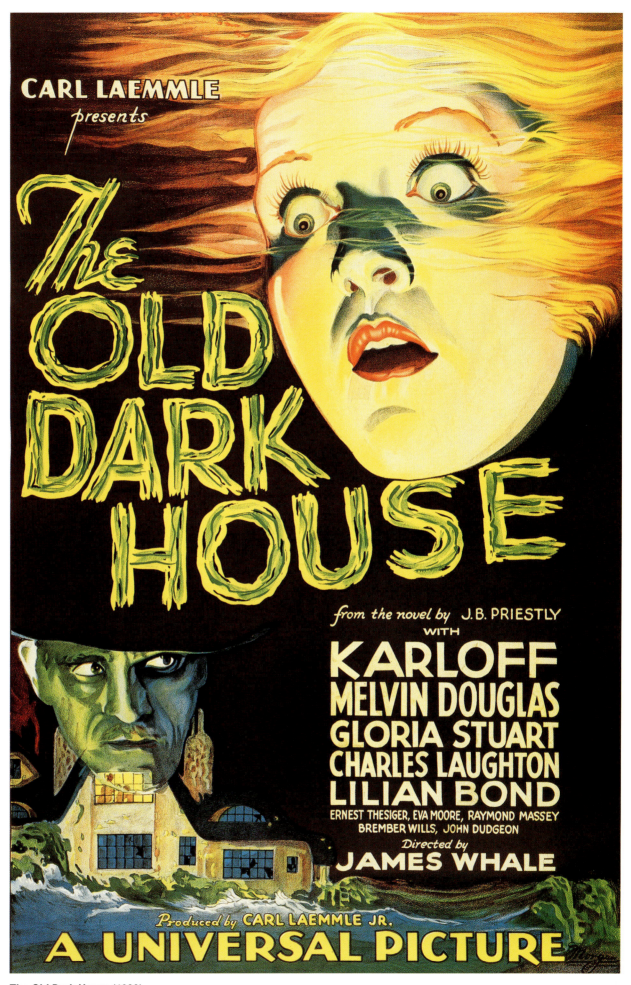

The Old Dark House (1932)
US 41 × 27 in. (104 × 69 cm)
Art by Karoly Grosz
Courtesy of the Kirk Hammett Collection

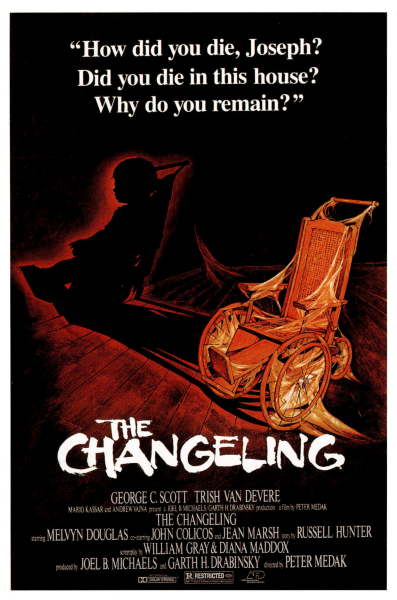

The Changeling (1980)
US 41 × 27 in. (104 × 69 cm)

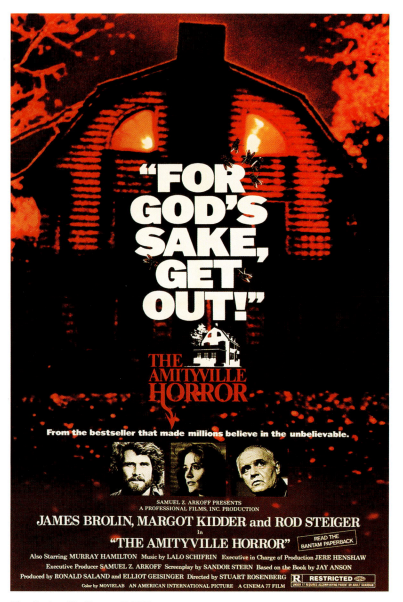

The Amityville Horror (1979)
US 41 × 27 in. (104 × 69 cm)

The Exorcist was a phenomenon and remains one of the highest earning horror films of all time. When it was first released on an unsuspecting public there were reports of people fainting or throwing up in movie theatres, walking out or even seeking psychiatric help. Never before had a movie had such an effect. The plot was based on a novel by William Peter Blatty about the last known exorcism in the United States to be officially sanctioned by the Catholic Church. The film's special effects, music and intelligence all combined to make it a classic and its influence cannot be overstated. It spawned a wave of demonic possession films that continues unabated today. *The Changeling* and *The Amityville Horror* are two further examples of this sub-genre.

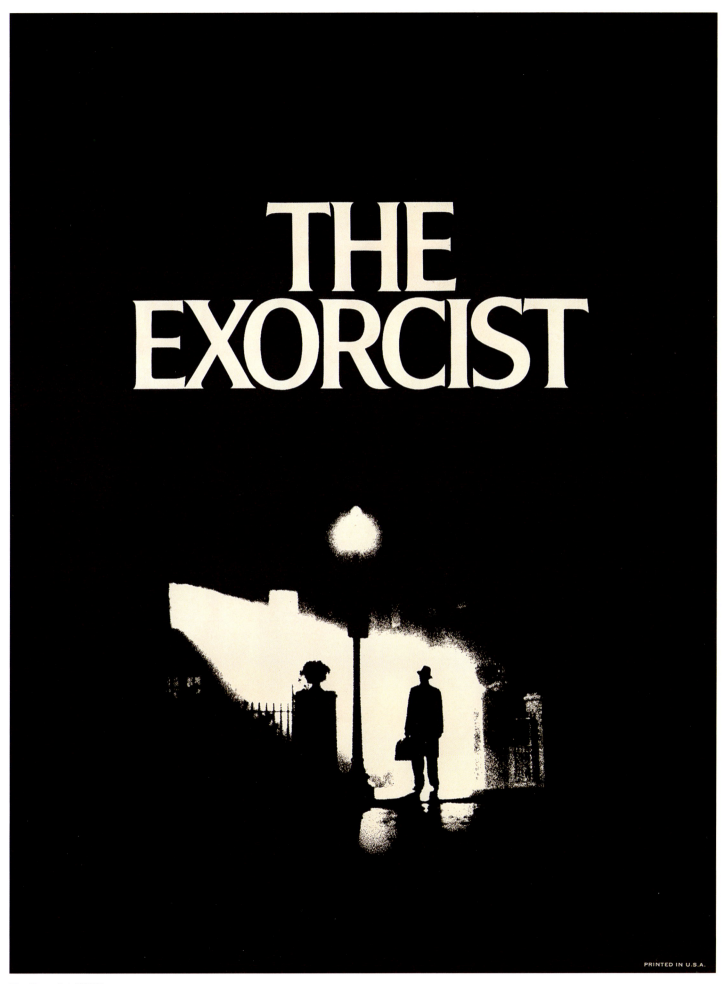

The Exorcist (1973)
US 25 × 19 in. (64 × 48 cm)
(Special)
Courtesy of the Hastings Collection

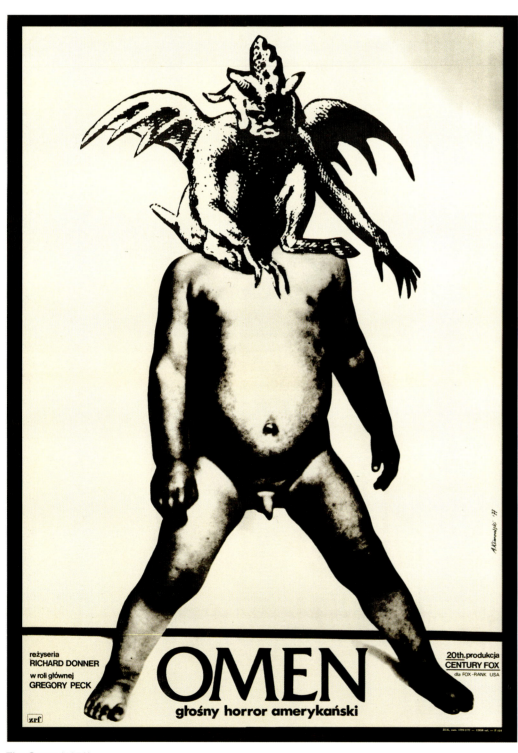

After *The Exorcist*, *The Omen* was the major possession movie of the 70s and created a sensation. Ten different advance teaser posters were printed in the run-up to the film's release in America. The last time this had been done was for *The Phantom Of The Opera* in 1925.

Born in 1949 to Polish émigré parents, **Andrzej Klimowski** studied at St Martin's School of Art in London before moving to the Academy of Fine Art in Warsaw. Several influences are evident in his work, including the designs of the Polish film poster artists and the paintings of Dalí and other surrealists, but his striking and often disturbing images also bear the stamp of an original and creative artist. He is currently head of illustration at the Royal College of Art.

The Omen (1976)
Polish 38 × 27 in. (97 × 69 cm)
Art by Andrzej Klimowski
Courtesy of The Reel Poster Gallery

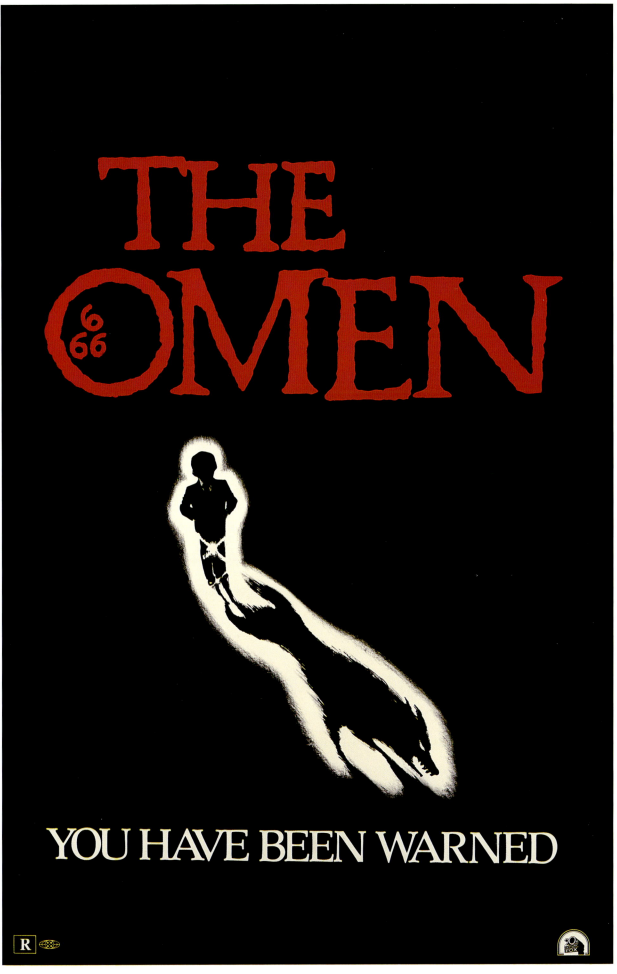

The Omen (1976)
US 41 × 27 in. (104 × 69 cm)
(Advance)
Courtesy of the Martin Bridgewater Collection

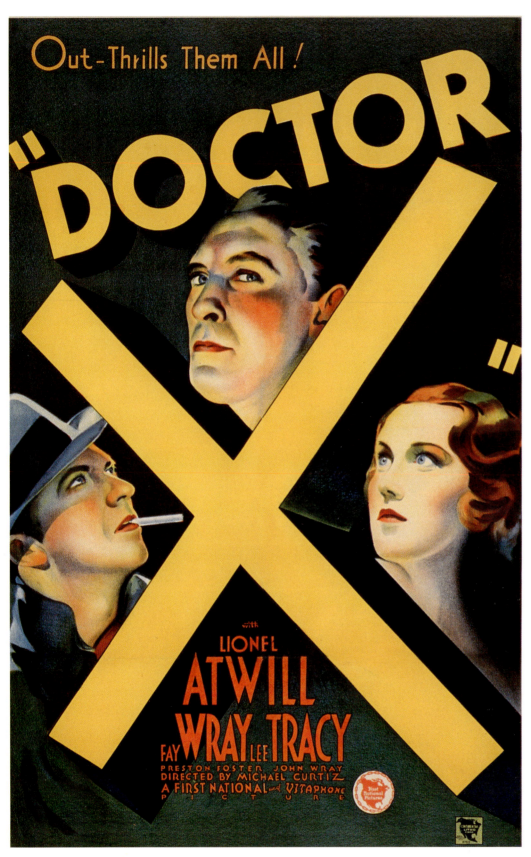

Doctor X (1932)
US 41 × 27 in. (104 × 69 cm)
Courtesy of the Andrew Cohen Collection

Horror from the 30s is often assumed to be synonymous with the great Universal Studios cycle, but *Supernatural* and *Doctor X* are just two examples of unsettling films from other studios. Atmospheric and chilling, *Supernatural* deals with the 'other worldly' and was one of the earliest possession movies. Indeed, the poster is an accurate reflection of the film itself and although the movie was not a massive hit, the artwork is one of the best and most striking examples in the horror genre.

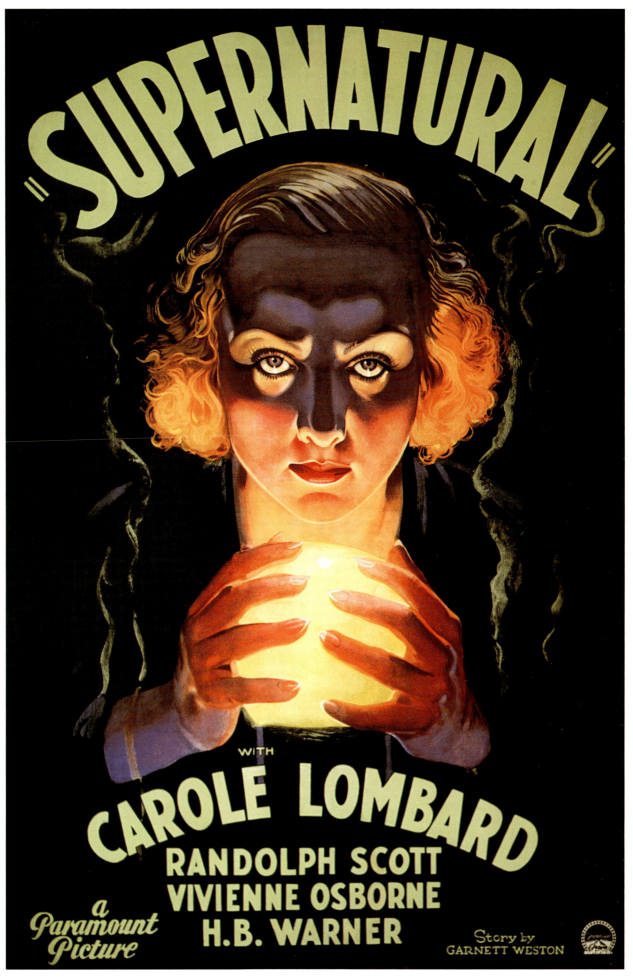

Supernatural (1933)
US 41 × 27 in. (104 × 69 cm)
Art direction by Vincent Trotta & Maurice Kallis
Courtesy of the Andrew Cohen Collection

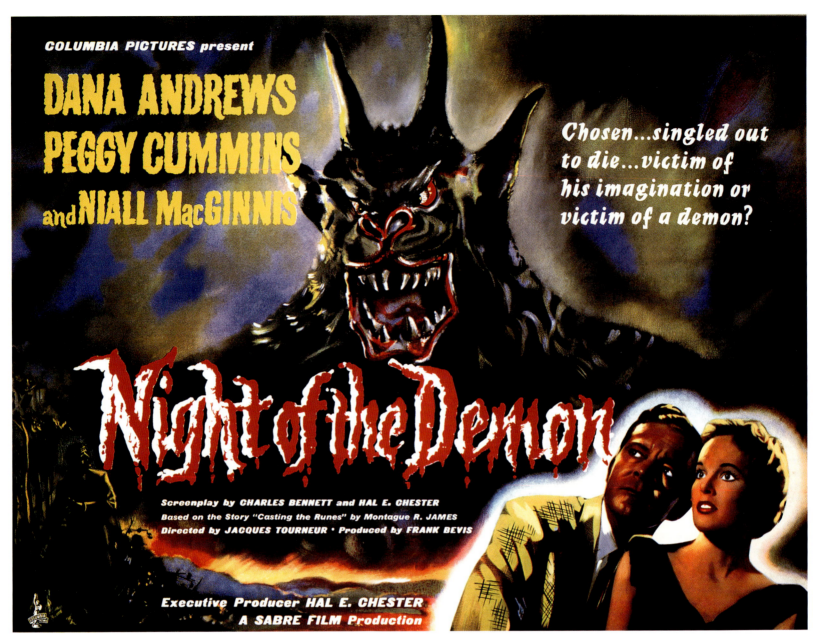

Night Of The Demon (1957)
British 30 × 40 in. (76 × 102 cm)
Courtesy of the Steve Smith Collection

Inspiration for successful horror films does not only come from the dark recesses of screenwriters' minds. History offers plenty of examples of torture and brutality that can form the basis of a movie. The cult classic, *The Wicker Man*, is one such film. It is a low-budget, atmospheric thriller whose plot centres on a group of modern-day druids and a police officer who is investigating the disappearance of a little girl and finds himself gradually becoming entangled in the sect's dangerous pagan rites . The Wicker Man of the title was actually part of an ancient Celtic practice that involved building a huge structure made from wicker which was was then filled with humans and animals and set on fire in order to appease the Gods. Ancient religion makes for great modern fiction.

Night Of The Demon is another tale of druids and ancient cults and is a spine-tingling horror classic. Inspired by an M. R. James' short story, it has been compared to Lewton's psychological thrillers of the 40s.

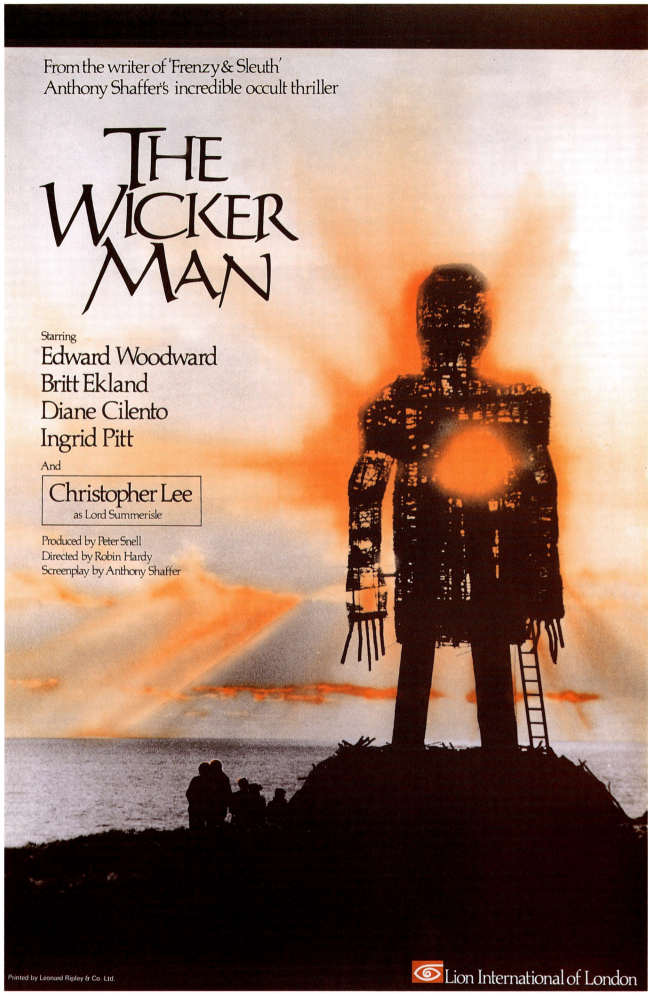

The Wicker Man (1973)
British 41 × 27 in. (104 × 69 cm)

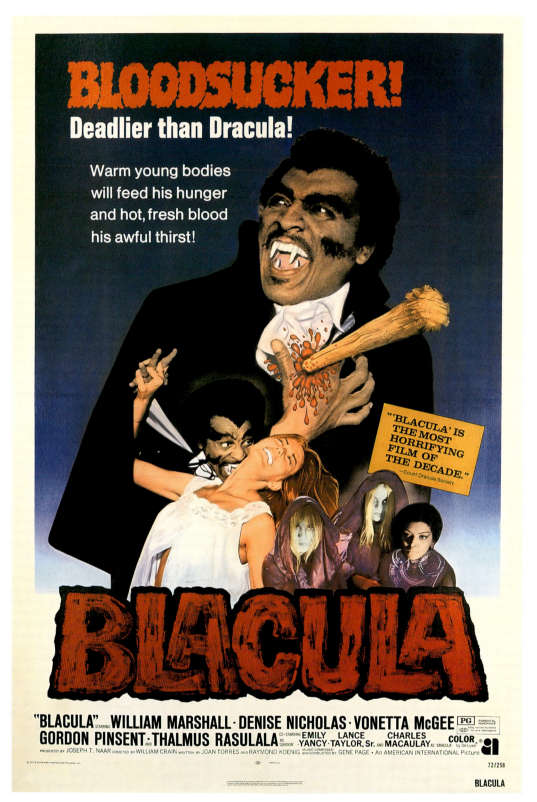

Blacula (1972)
US 41 × 27 in. (104 × 69 cm)
Courtesy of Separate Cinema

Over 200 blaxploitation films were produced between 1971 and 1975. Many were 'black' versions of genre classics; in the case of horror, *Blacula* and *Blackenstein* are obvious examples of remakes with an added blaxploitation element. *Blacula* is generally regarded as the real thing with a certain *je ne sais quoi*. It owes a good deal to the British Hammer-horror school and is genuinely scary while always keeping its tongue firmly in its cheek. However, *Blackenstein*, released a year later, is blatantly a cheap and exploitative rip-off.

Blackenstein (Black Frankenstein) (1973)
US 41 × 27 in. (104 × 69 cm)
Courtesy of Separate Cinema

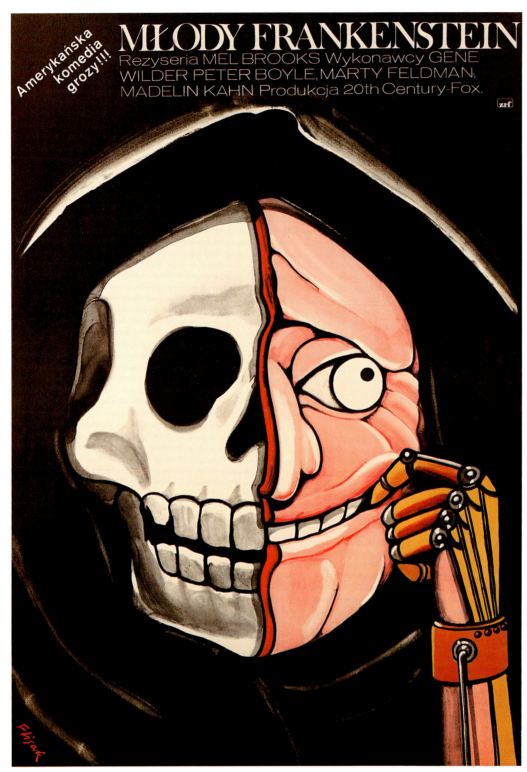

Young Frankenstein (Młody Frankenstein) (1974)
Polish 38 × 27 in. (97 × 69 cm)
Art by Jerzy Flisak
Courtesy of The Reel Poster Gallery

Mel Brooks is famous for his burlesque parodies of various film genres and *Young Frankenstein* was his droll take on horror. While satirizing Universal's monster-making days, it is also an intelligent and careful study of the genre and was one of Brooks' funniest and biggest hits. Both the Polish and Hungarian posters reflect this sense of mischief while still retaining a horrific element.

Famous for his satirical cartoons, **Jerzy Flisak** (b. 1930) was a perfect choice as artist of the Polish poster. Flisak is a respected graphic artist who has designed several book and magazine covers and won a number of awards. His work has been exhibited around the world.

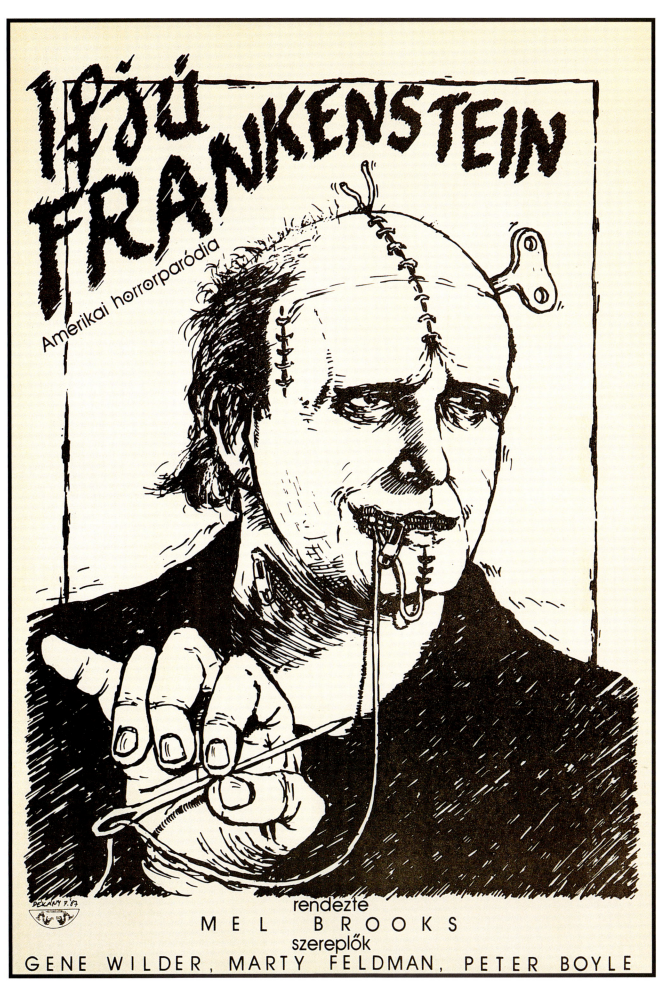

Young Frankenstein (Ifjú Frankenstein) (1974)
Hungarian 33 × 23 in. (84 × 58 cm)
Art by Dekany
Courtesy of The Reel Poster Gallery

Dr. Jekyll And Mr. Mouse (1947)
US 41 × 27 in. (104 × 69 cm)

The impact of the Universal horror cycle cannot be understated and the influence of the films even filtered down to children's cartoons. *The Mad Doctor* is an interesting black and white Disney short that is regarded as one of the most well-drawn and intriguing cartoons of the period. Heavily influenced by *Frankenstein* and other Universal horror hits, the cartoon is actually quite scary and the fearsome tale was considered so out of character for the mouse and his pals, that it was buried in the studio's vaults for decades. *Dr Jekyll And Mr Mouse* is another famous cartoon parody that was loosely based on the 1941 Spencer Tracey version of the well-known tale. The cartoon was nominated for an Oscar in 1948.

The Mad Doctor (1933)
US 41 × 27 in. (104 × 69 cm)

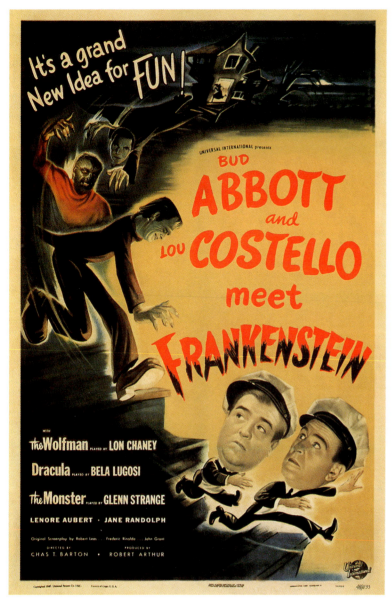

Abbott And Costello Meet Frankenstein (1948)
US 41 × 27 in. (104 × 69 cm)
Art by Bob Tollen

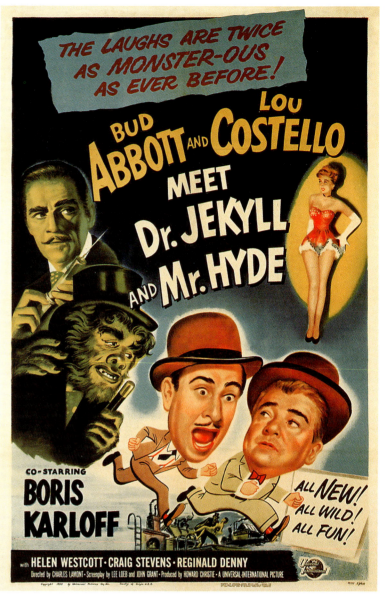

Abbott And Costello Meet Dr. Jekyll And Mr. Hyde (1953)
US 41 × 27 in. (104 × 69 cm)
Art by Bob Tollen

In an era of larger than life personalities, Abbott and Costello were a winning duo and remain one of the most famous comedy pairings in history. They started their double act in 1936 and moved from stage to radio to film and, finally, to TV. They were masters of the skit and turned the clown/straight man routine into an art form.

In their films, the pair liked to spoof contemporary box-office hits and their series of comic takes on Universal's horror cycle was extremely popular. *Abbott and Costello Meet Frankenstein* remains one of their biggest successes and has become something of a cult classic. It starred Bela Lugosi and Lon Chaney Jr. in their roles as Dracula and The Wolf Man and featured the voice of Vincent Price as The Invisible Man.

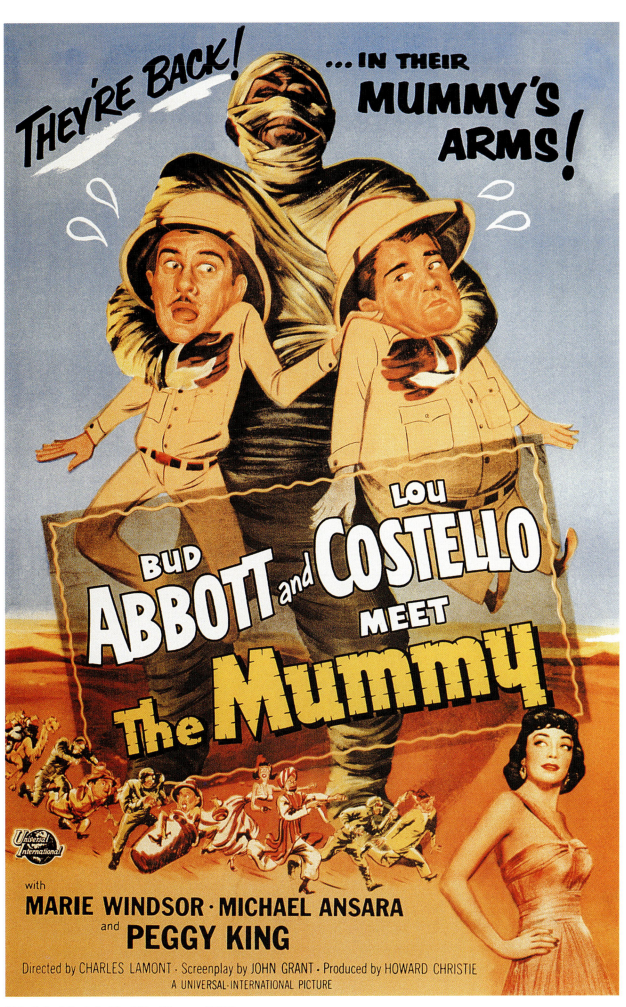

Abbott And Costello Meet The Mummy (1955)
US 41 × 27 in. (104 × 69 cm)
Art by Bob Tollen

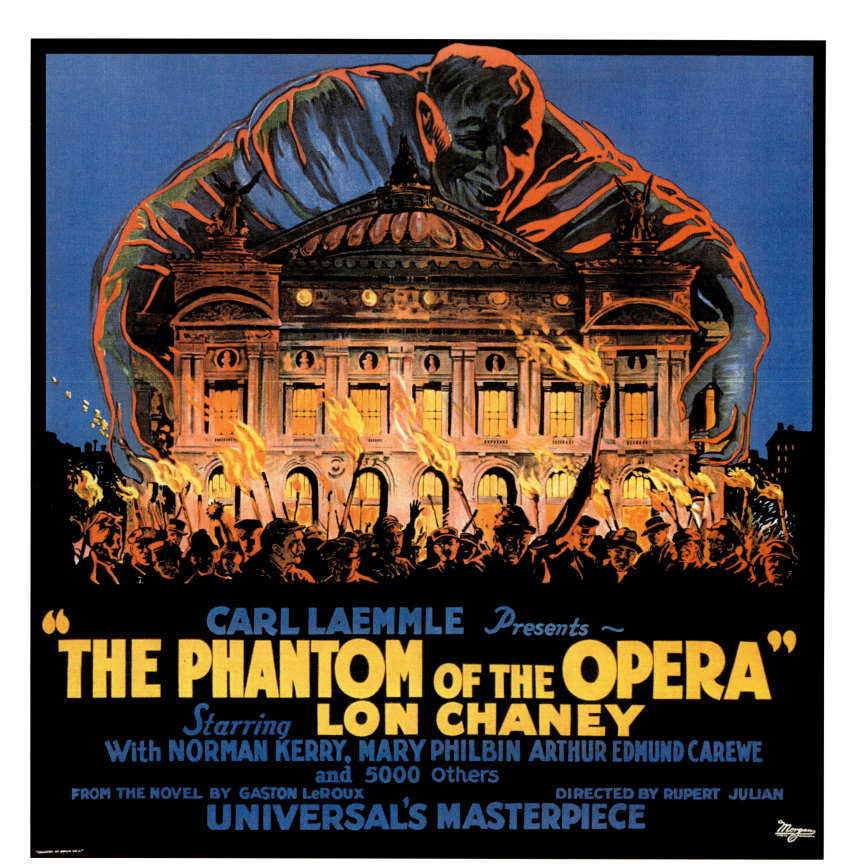

The Phantom Of The Opera (1925)
US 81 × 81 in. (206 × 206 cm)
Courtesy of The Reel Poster Gallery

The Phantom Of The Opera is the classic gothic horror and paved the way for Universal's horror cycle of the 30s. It was Lon Chaney's most famous role and a massive box-office hit. With its incredible sets, Technicolor sequences inserted after shooting and a massive advertising campaign, *Phantom* was a grand undertaking for Universal. An unprecedented twelve standard-size American posters were created, detailing different aspects of the story. The larger, billboard posters for the film were equally, if not more, stunning.

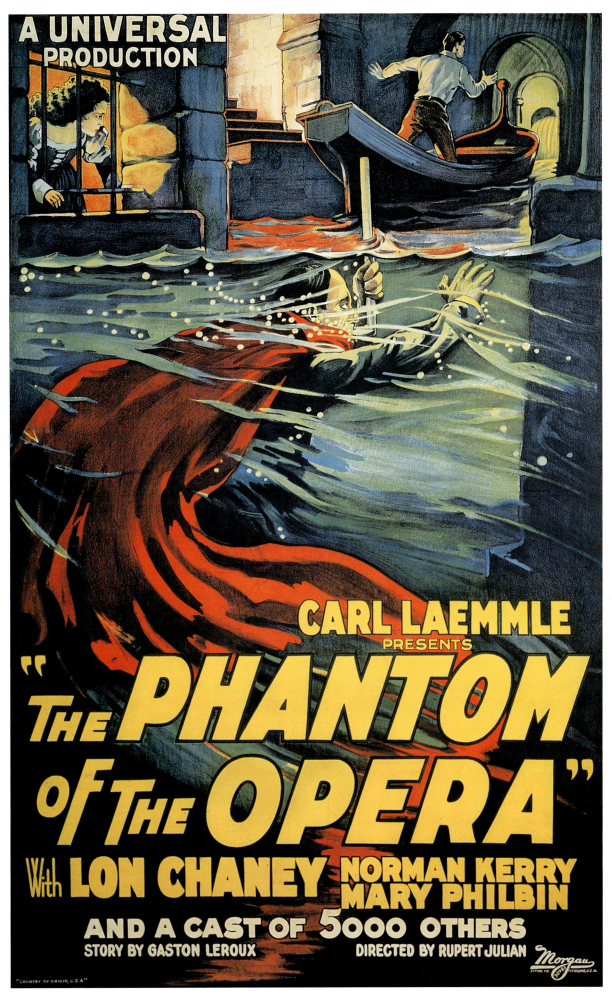

The Phantom Of The Opera (1925)
US 41 × 27 in. (104 × 69 cm)
Courtesy of The Reel Poster Gallery

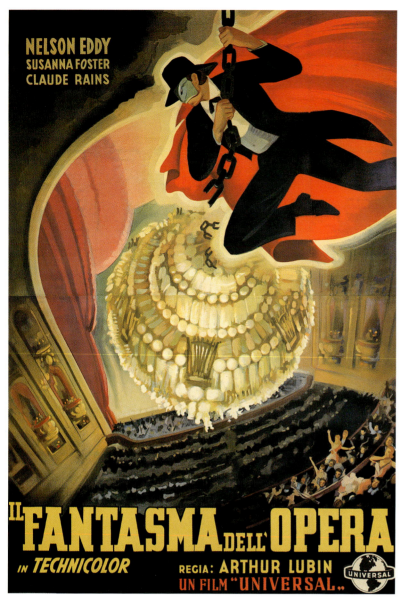

The Phantom Of The Opera (Il Fantasma Dell'Opera) (1943)
Italian 79 × 55 in. (201 × 140 cm)
Art by F. Carfagni
Courtesy of The Reel Poster Gallery

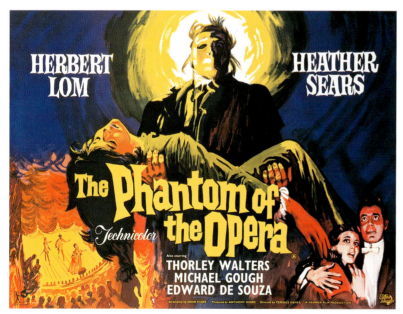

The Phantom Of The Opera (1962)
British 30 × 40 in. (76 × 102 cm)
Courtesy of the Andrew Cohen Collection

Gaston Leroux (1868–1927) was a French poet, journalist and novelist whose most celebrated stories include *The Haunted Chair* and *The Wax Mask*. The *Phantom Of The Opera*, however, remains by far his most famous work. Leroux wrote the story in 1908 and was inspired by the time he had spent in the Paris Opera House. Well known for his curiosity, he had explored all the nooks, alcoves, cellars and disused corridors in the building where, in 1896, he had been present when one of the counterweights of a chandelier fell on a patron during a performance of *Faust*. This incident, combined with the atmosphere of the building and the drama on-stage, were all contributing factors in the creation of *The Phantom Of The Opera*. The story has been adapted for the screen several times, most notably in 1925, 1943 and 1962. Universal were responsible for the first two adaptations and the third was handled in Hammer's inimitable style. *The Phantom* has remained one of the most popular ghost stories, its fame further enhanced by Andrew Lloyd Webber's musical version of the tale.

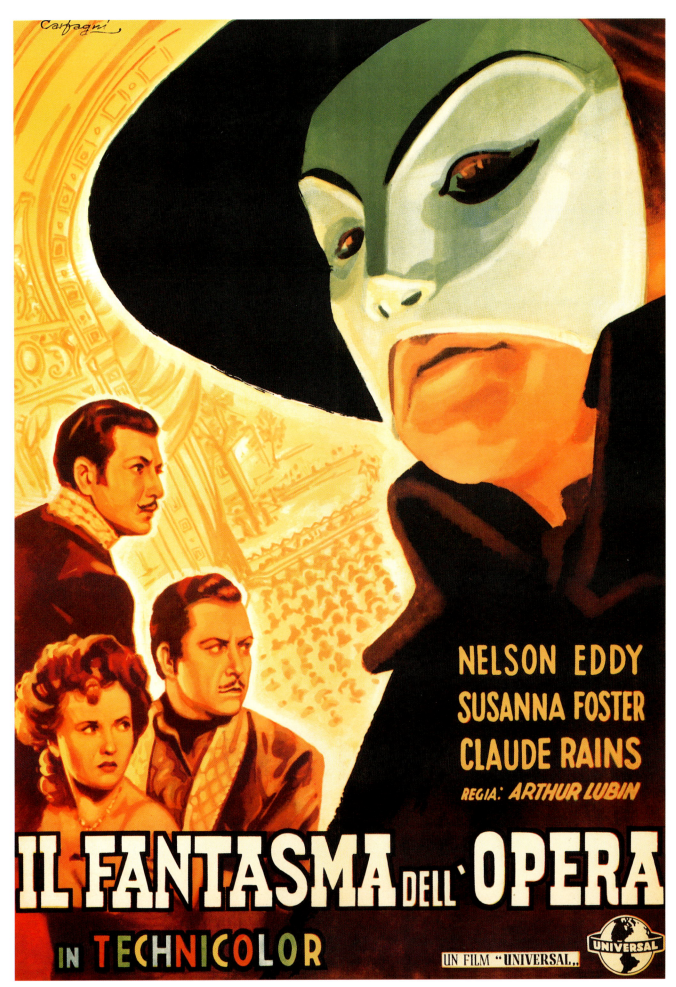

The Phantom Of The Opera (Il Fantasma Dell'Opera) (1943)
Italian 39 × 28 in. (99 × 71 cm)
Art by F. Carfagni
Courtesy of The Reel Poster Gallery

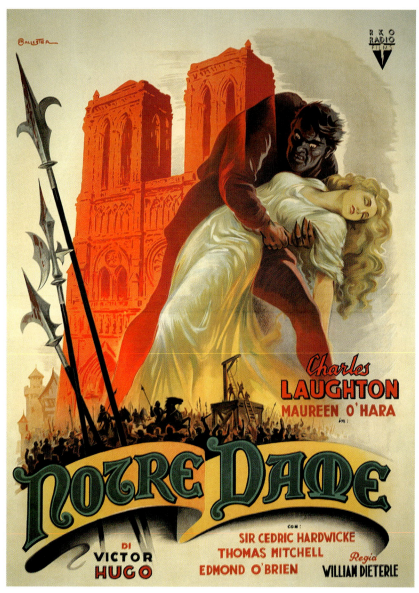

The Hunchback Of Notre Dame (Notre Dame) (1939)
Italian 39 × 28 in. (99 × 71 cm)
Art by Anselmo Ballester

The Hunchback Of Notre Dame, adapted from Victor Hugo's famous novel, was a massive Hollywood extravaganza that made Lon Chaney a major international star. His portrayal of Quasimodo is magnificent and the pain that he underwent while playing the part was all in a day's work for 'The Man of a Thousand Faces'. The hump weighed approximately forty pounds and his eyesight was permanently impaired by the grotesque make-up.

With its stunning black and white cinematography, RKO's 1939 version of the film is considered by many to be the best adaptation. Charles Laughton gives a memorable and moving performance that is as notable as Chaney's in 1923. The film does not adhere strictly to the plot of Hugo's novel but was adapted to comment on the rise of Nazism and the volatile political situation in Europe. Roland Coudon's artwork for the large French poster best captures the melancholic atmosphere of the film. Coudon was also responsible for one of the most famous French posters for *King Kong*.

The Hunchback Of Notre Dame (Quasimodo) (1939)
French 63 × 94 in. (160 × 239 cm)
Art by Roland Coudon

The Hunchback Of Notre Dame (1923)
US 41 × 27 in. (104 × 69 cm)

Lon Chaney (1883–1930) was born to deaf-mute parents and so learned from a young age to use exaggerated, pantomime-like gestures to communicate. He moved into acting and by the age of seventeen was touring with a play he had written with his brother. This upbringing prepared him perfectly for the world of silent movies and his breakthrough came in 1919 with *Miracle Man*. From his early days on the stage, Chaney had always used elaborate theatrical make-up to hide his plain and youthful features. This continued on the screen with Chaney frequently enduring massive physical discomfort in order to capture a role – whether it was caused by the make-up for *Phantom Of The Opera*, the heavy costume for *The Hunchback Of Notre Dame*, or by strapping his arms behind his back for Tod Browning's *The Unknown*. He earned the moniker 'The Man of a Thousand Faces' and had the ability to change his appearance so drastically from film to film that it was often difficult to believe it was the same actor.

The Italian poster for *The Unknown* is one of the earliest examples of Luigi Martinati's artwork. He would go on to have a prolific career in Italian film poster design.

The Unknown (Lo Sconosciuto) (1927)
Italian 15 × 10 in. (38 × 26 cm)
Art by Luigi Martinati
Courtesy of the Philip Masheter Collection

Born Charles Albert Browning, **Tod Browning** (1880–1962) left home at a young age to join the circus. After several years travelling the country, he moved to New York and then to Hollywood to pursue his theatrical aspirations. Brown was plagued by accidents, alcoholism and woman problems, and his career suffered several interruptions through the 20s and 30s; nevertheless he managed to forge a successful career as a director and his name is still celebrated today.

His important break came in the spring of 1918 when Browning joined Universal's smaller studio, Bluebird Productions. There he met studio executive Irving Thalberg who paired the young director with the studio's hottest talent – Lon Chaney. Their first film together was *The Wicked Darling* in 1919. The duo went on to work on several more projects together, mostly at MGM, including *The Unholy Three*, *London After Midnight* and *The Unknown*. Together they laid the foundations for the Universal horror cycle of the 30s. Indeed, Browning wanted Chaney to star in *Dracula*, his 1931 tour de force and it was only after 'The Man Of A Thousand Faces' sadly died of throat cancer that Bela Lugosi was chosen instead.

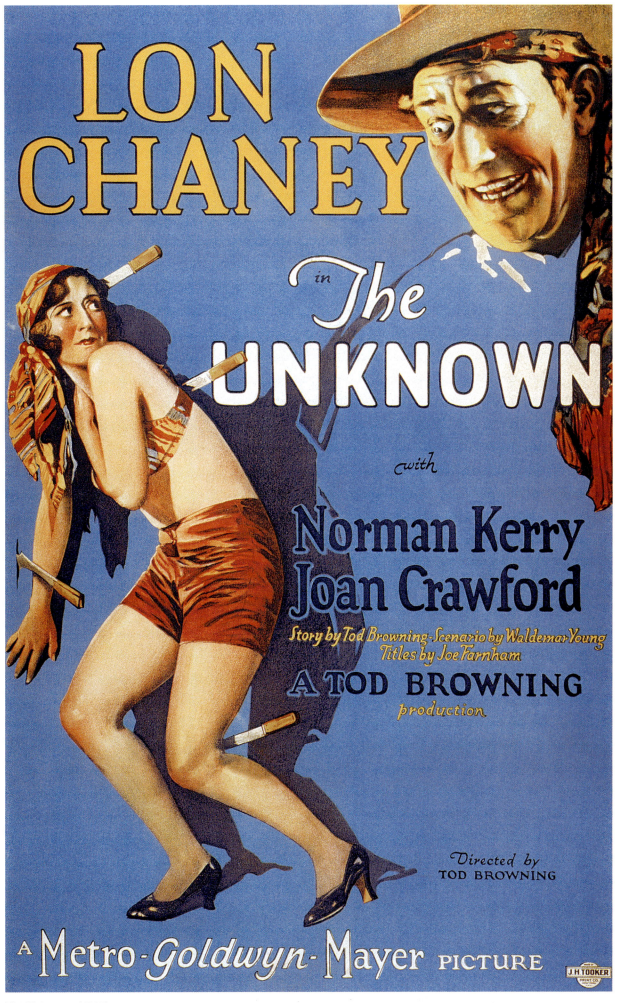

The Unknown (1927)
US 41 × 27 in. (104 × 69 cm)

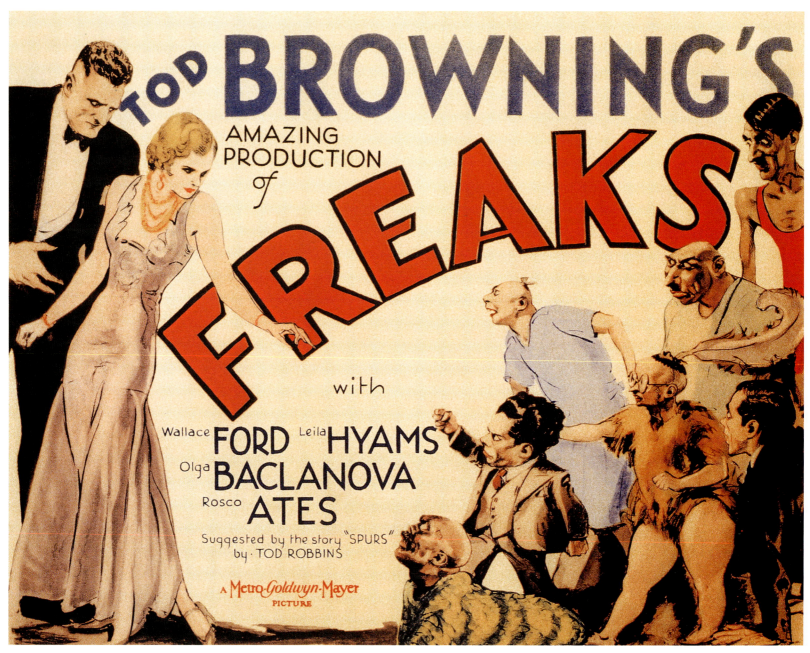

Freaks (1932)
US 22 × 28 in. (56 × 71 cm)

When *Freaks* was first released in 1932, both press and public greeted it with such revulsion and disgust that the film was widely banned and MGM was forced to withdraw it. The studio had wanted to build on the success of *Dracula* by creating something even more horrific, but the plan backfired with disastrous results and they spent the next thirty years trying to forget that it had ever happened. The director, Tod Browning, had had a background in the carnival business and his film is about circus people. What caused the uproar was the casting of genuine 'freaks' to play key roles; this was just a little too realistic for a 30s audience. The film effectively destroyed his career as a director.

In *Freaks*, Browning was seeking to highlight the prejudice which led society to ostracize disabled or eccentric individuals and, seventy years after its disastrous debut, the film is now regarded as one of the finest and most important works from this period.

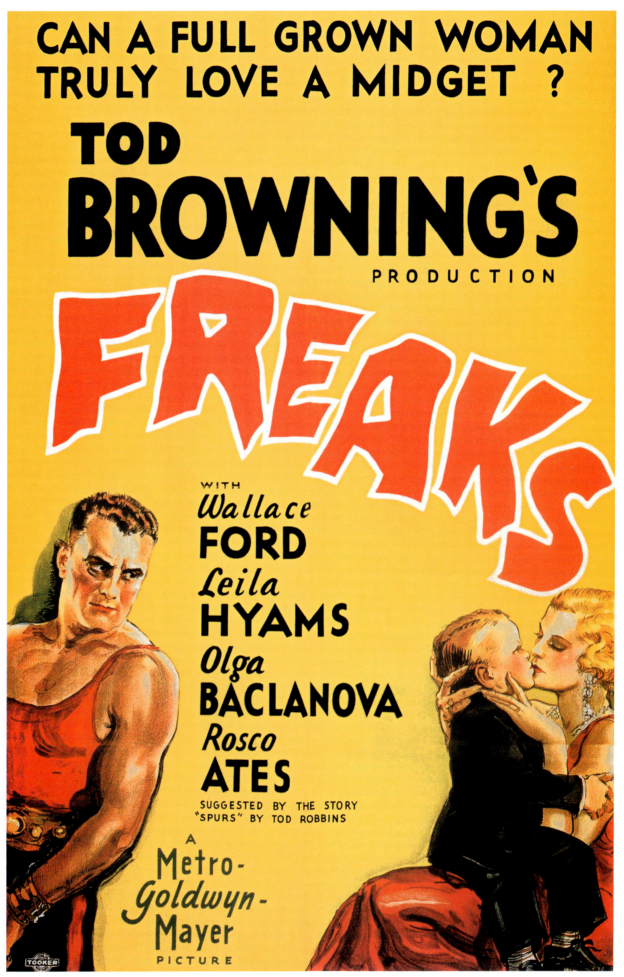

Freaks (1932)
US 41 × 27 in. (104 × 69 cm)
Art by Ted Ireland ('Vincentini')
Courtesy of the Todd Feiertag Collection

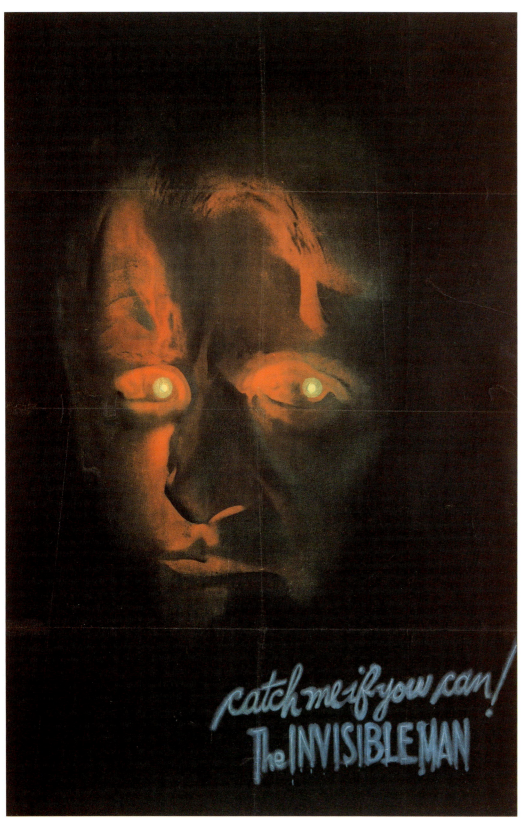

The Invisible Man (1933)
US 41 × 27 in. (104 × 69 cm)
(Style B – Teaser)
Art by Karoly Grosz

Universal's monsters from the 30s have become legendary. Boris Karloff as Frankenstein and Bela Lugosi as Dracula are still instantly recognisable over seventy years later. Universal brought cinematic terror to the masses for the first time and was responsible for the original and most influential horror cycle in the history of the cinema.

The release of *Dracula* in 1931 reversed a decline in Universal's fortune. Although Lon Chaney had starred in a number of successful 'scary' films in the silent 20s, the advent of sound brought an exciting new element of terror to the mix and *Dracula* and his fellow monsters were a massive success. Many of the classic horror stories were still relatively unknown to the mass audience who thus came to the movie houses not knowing what to expect, but eager to be scared. The decade made massive stars out of the actors involved, most notably Boris Karloff and Bela Lugosi.

Unlike many modern horror films that achieve their effect by reminding us that dreadful things *could* happen to any of us in familiar surroundings, Universal's movies were set in remote locations – usually an Eastern European country replete with swirling mists, ruined castles, foreign accents and full moons. The aim was to offer escapist entertainment coupled with a satisfactory *frisson* of fear to a generation all-too anxious to escape the grim realities of the Depression era.

Born in Hungary, **Karoly Grosz** was the art director for Universal Studios in their glorious horror hey-day and he was responsible for the majority of their posters from this period. He worked mainly in oils and watercolours and a number of his posters are as legendary as the films themselves. Although his designs were usually constrained by the traditions and expectations of the studio, his artwork for the teaser posters for *Frankenstein* and for *The Invisible Man* are stunning, featuring striking, avant-garde designs. Even by today's standards, the posters are ultra-modern and would be arresting pasted on any contemporary hoarding.

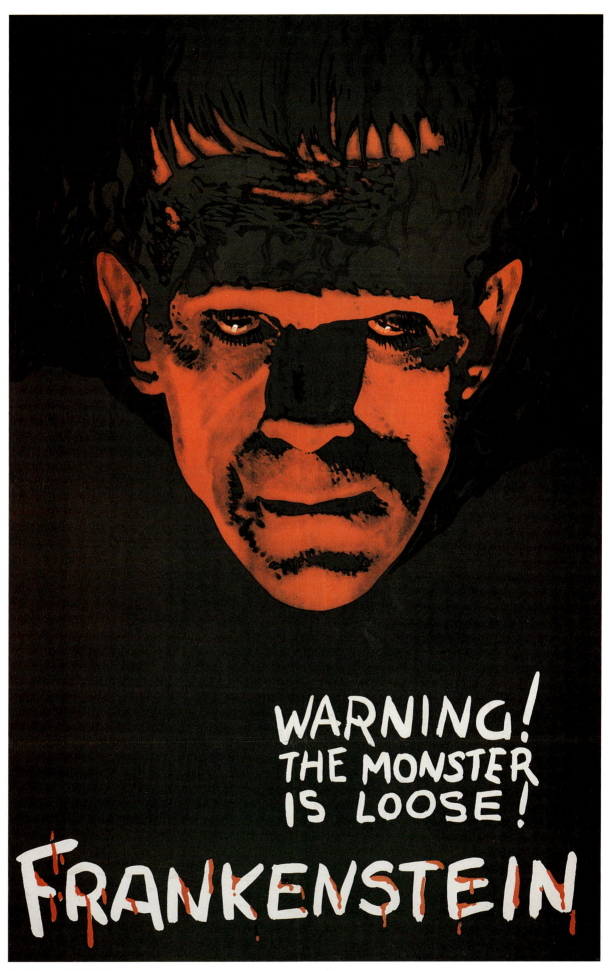

Frankenstein (1931)
US 41 × 27 in. (104 × 69 cm)
(Style B – Teaser)
Art by Karoly Grosz
Courtesy of the Kirk Hammett Collection

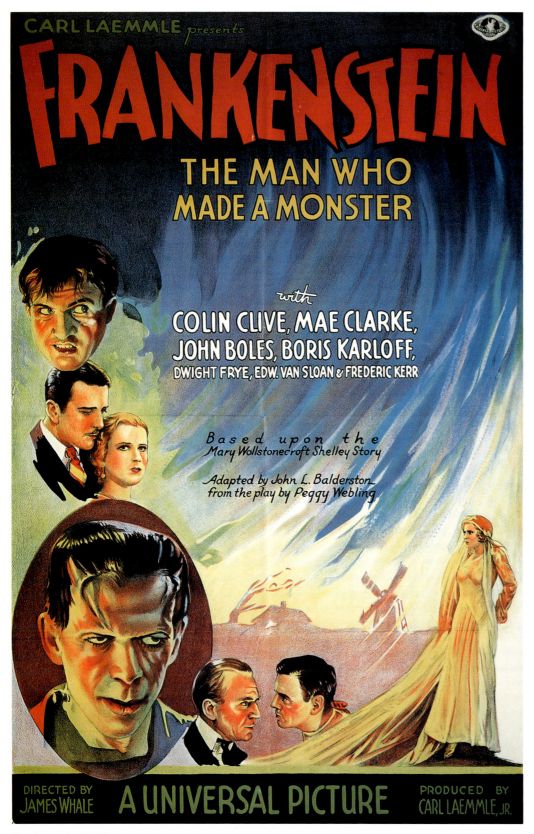

Frankenstein (1931)
US 41 × 27 in. (104 × 69 cm)
(Style A)
Art by Karoly Grosz

Born William Henry Pratt, **Boris Karloff** (1887–1969) knew he wanted to be an actor from the age of nine. After dropping out of his studies at Kings College, London, he sailed to the New World to seek his fortune on the stage. Because of his dark complexion, he secured a number of film roles in which he played either villains or Arabs. He had appeared in over sixty films by the time Universal approached him for the part of Frankenstein. They had offered it first to Lugosi, but he turned it down because there was no dialogue and too much make-up. Karloff accepted it – little knowing that it would be his passport to worldwide fame. Barely a year later, he was given the great honour of being billed in *The Mummy* by his surname alone.

The make-up for *Frankenstein* took over four hours to apply and his costume weighed over 65 pounds, causing him severe spinal problems for the rest of his life. The effort was worth it. *Frankenstein* proved as popular as *Dracula*, another triumph for Universal's monster-making machine.

The Bride Of Frankenstein was James Whale's sequel to his 1931 classic. With a massive budget, a stellar cast and infused with a warmth and tongue-in-cheek wit, the film is generally regarded as superior to the original and, indeed, as the best of all the Universal horrors.

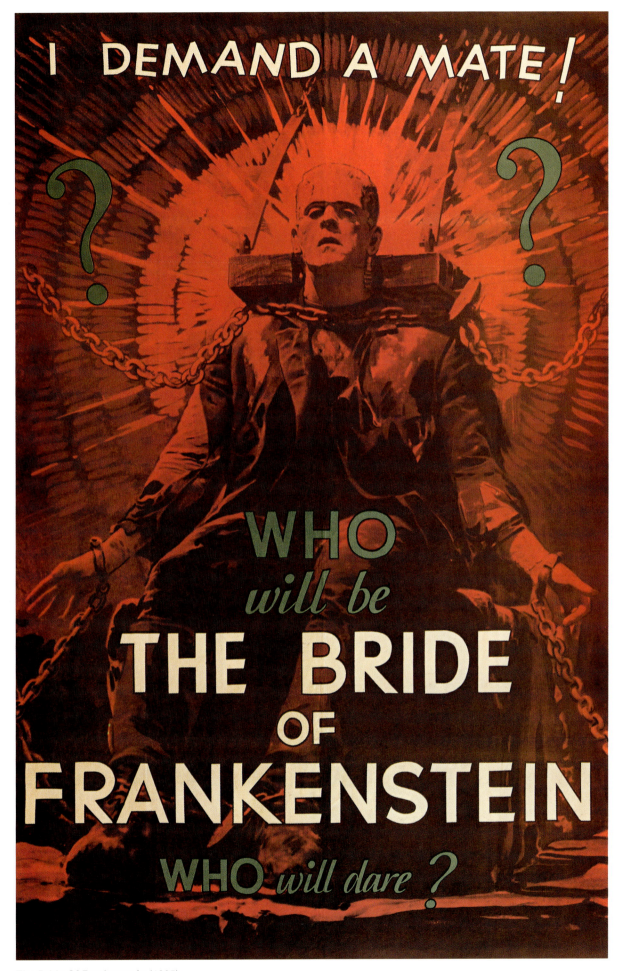

The Bride Of Frankenstein (1935)
US 41 × 27 in. (104 × 69 cm)
(Style E)
Art by Karoly Grosz
Courtesy of the Todd Feiertag Collection

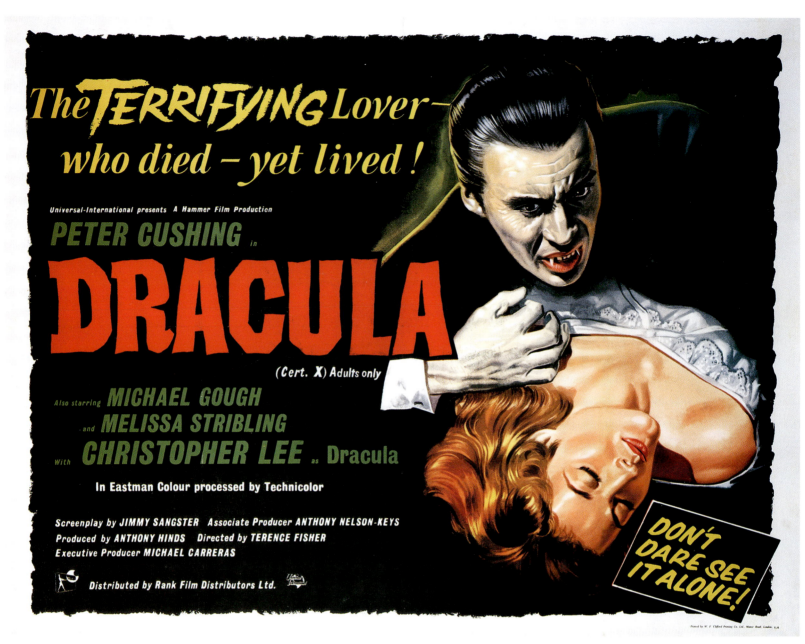

Dracula (1958)
British 30 × 40 in. (76 × 102 cm)
Courtesy of The Reel Poster Gallery

Born in Hungary, **Bela Lugosi** (1882–1956) left home at twelve to follow his dreams of becoming an actor. He played many classical roles on the Hungarian stage and earned a reputation as one of his generation's finest talents. After starring in his first film, *The Leopard,* in Germany in 1917, he worked his way to America as a ship's engineer. For his first theatrical roles in America his inadequate English meant that he had to learn his lines phonetically. In 1927, he was cast as Dracula on the Broadway stage and took New York by storm; the show ran for over 260 performances. His interpretation of Bram Stoker's anti-hero as a charming, attractive but profoundly evil figure was a huge success and the show caught the eye of Universal, who were looking for subject matter for a new 'talkie'. The studio originally wanted Lon Chaney for the starring role, and it was only after he died tragically from throat cancer that they began to consider Lugosi for the part. The script was adapted from the stage play and, with Lugosi as its star, the movie repeated the success of the Broadway production right across the country.

According to the *Guinness Book of Records,* Dracula is the character most frequently portrayed in horror films with over 160 screen appearances. Despite this, only two names come to mind when Dracula is mentioned; Bela Lugosi and **Christopher Lee** (b. 1920). Born and raised in Britain, Lee worked as a bank clerk before joining the RAF and working for British intelligence during World War II. After the war, he trained as an actor and secured a number of small film roles including a part in *Hamlet* (Lee's future horror partner, Peter Cushing, also had a small part in the film). Like Cushing, a close friends off-screen, Lee owed his international fame to Hammer Studios. He is also famous for his portrayal of Sherlock Holmes and his Fu Manchu series in the 60s and he recently returned to the screen as the wizard Saruman in the successful *Lord Of The Rings* trilogy. Lee has managed to escape the typecasting suffered by Peter Cushing and by his predecessor Lugosi and has had a thriving and diverse career. He has appeared in an amazing total of 300 films.

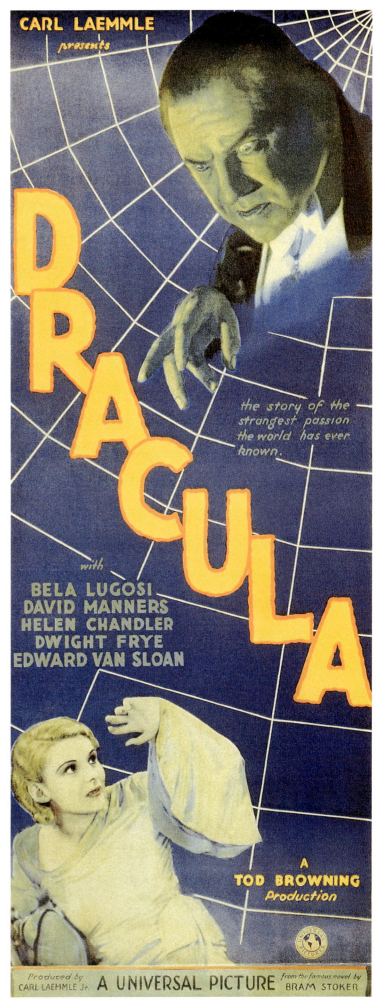

Dracula (1931)
US 36 × 14 in. (91 × 36 cm)

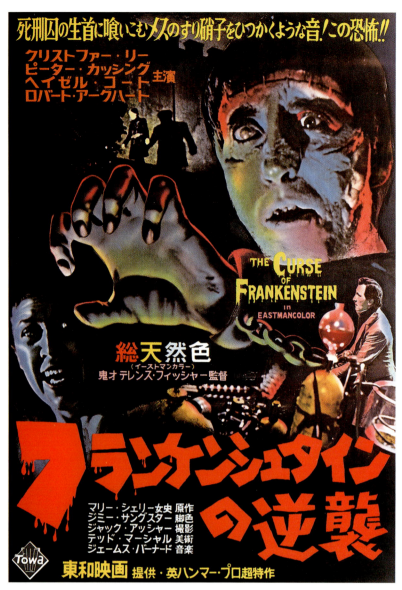

死刑囚の生首に喰いこむ刃のすり硝子をひつかくような音!この恐怖!!

クリストファー・リー
ピーター・カッシング
ヘイゼル・コート 主演
ロバート・アークハート

THE CURSE
OF
FRANKENSTEIN
IN
EASTMANCOLOR

総天然色
（イーストマンカラー）
鬼才 テレンス・フィッシャー監督

フランケンシュタインの逆襲

マリー・シェリー女史 原作
ジミー・サングスター 脚色
ジャック・アッシャー 撮影
テッド・マーシャル 美術
ジェームス・バーナード 音楽

Towa
東和映画 提供・英ハンマー・プロ超特作

The Curse Of Frankenstein (1957)
Japanese 30 × 20 in. (76 × 51 cm)
Courtesy of the Tony Sasso Collection

NO-ONE WHO SAW IT
LIVED TO DESCRIBE IT!

THE CURSE
OF FRANKENSTEIN

CERT X

COLOUR BY
EASTMAN COLOUR

STARRING
PETER CUSHING with HAZEL COURT · ROBERT URQUHART
and CHRISTOPHER LEE AS THE CREATURE
Produced by ANTHONY HINDS Directed by TERENCE FISHER Screenplay by JIMMY SANGSTER
Based on the classic by MARY SHELLEY Executive Producer MICHAEL CARRERAS
A HAMMER FILM PRODUCTION Distributed by WARNER BROS.

The Curse Of Frankenstein (1957)
British 30 × 40 in. (76 × 102 cm)
Courtesy of The Reel Poster Gallery

Formed in 1934, Hammer Studios struggled to survive for the next 23 years as a small, independent British film company. Its fortunes changed in 1957 with the release of *The Curse Of Frankenstein*, a landmark in the history of horror. Within just a few short months of the film's premiere, 'Hammer' was a world-famous brand. Mixing sex, blood and Technicolor with panache and style, the studio added a modern twist to the traditional horror formula. Over the next twenty years, they produced more than seventy films, including re-makes of all the Universal classics. What Karloff and Lugosi had been to audiences in the 30s, Peter Cushing and Christopher Lee became to a new generation of horror fans.

When *The Curse Of Frankenstein* premiered at the Warner Theatre, Leicester Square on 2 May 1957, the press were repulsed and the public delighted. This, Britain's first colour horror film, was a garish and lurid production full of black comedy and grotesque sequences. It breathed fresh life into a dying genre. The Japanese poster for the film is interesting in that it is one of the only posters for the film that reveals the monster's face.

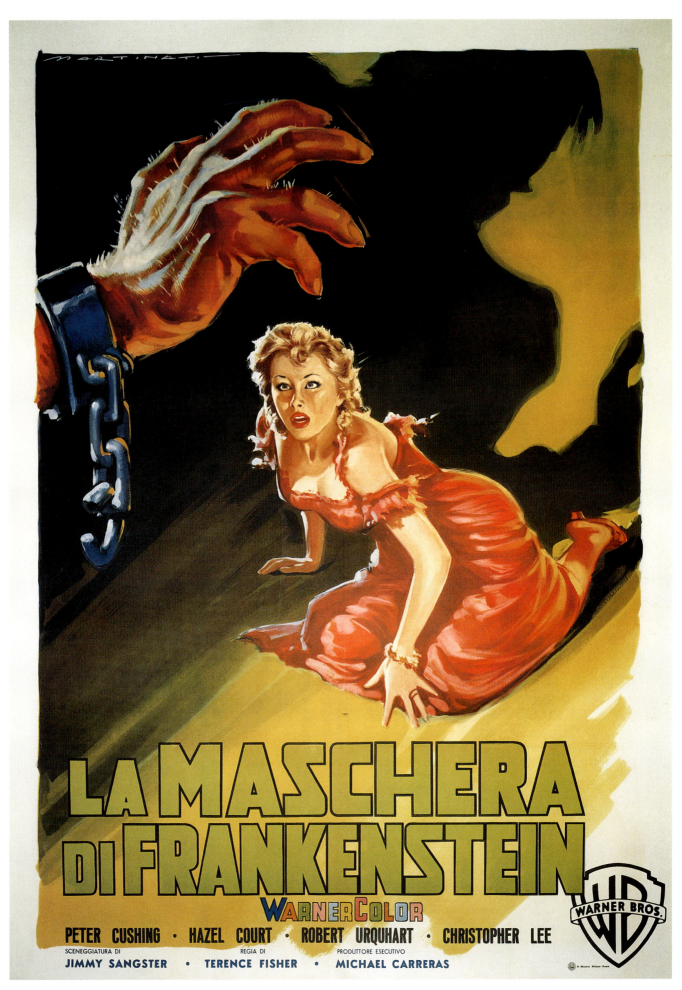

The Curse Of Frankenstein (La Maschera Di Frankenstein) (1957)
Italian 55 × 39 in. (140 × 99 cm)
Art by Luigi Martinati
Courtesy of the Helmut Hamm Collection

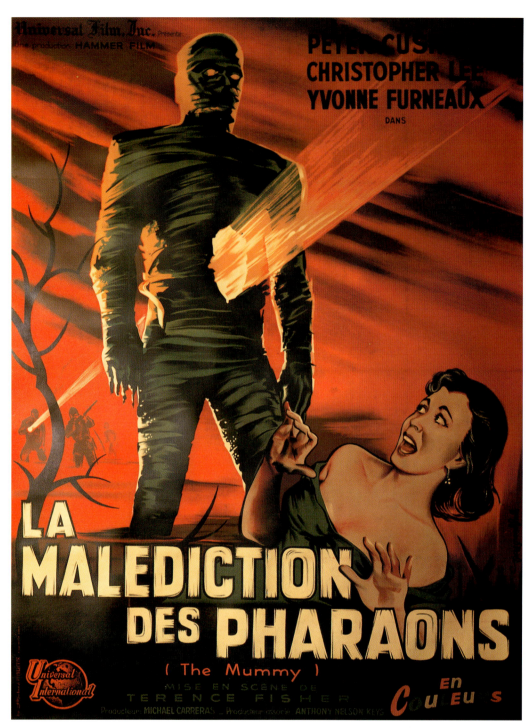

The Mummy (La Malediction Des Pharaons) (1959)
French 63 × 47 in. (160 × 119 cm)
Art by Guy Gerard Noël

Peter Cushing (1913–1994), who showed a love of acting and art from a young age, studied at the Guildhall School of Music and Drama. He left Britain in 1939 for Hollywood, where he secured a number of small parts in notable films including *Man In The Iron Mask* and *A Chump At Oxford*. He also performed on the Broadway stage before moving back to the UK in the 40s. After serving in the Second World War, his first British film role was in Laurence Olivier's *Hamlet*, however Cushing had to wait another decade before he finally achieved the international fame and success he had been dreaming of. In 1957, Hammer Studios chose him to star in their Technicolor horror flick, *The Curse Of Frankenstein*, little realizing the massive global impact the film would have. The film paired Cushing with another British actor, Christopher Lee, and together they formed a winning horror team unequalled since the days of Lugosi and Karloff.

Universal horror remains extremely popular today and the most sought-after movie posters date from this period of cinematic history. Both *Frankenstein* and *The Mummy* posters broke world records when sold at auction (the former fetching $198,000 in 1993 and the latter $453,500 in 1997) and *The Mummy* sold for more than twice the highest price ever paid for a Toulouse-Lautrec poster. This makes *The Mummy* the most expensive poster ever sold.

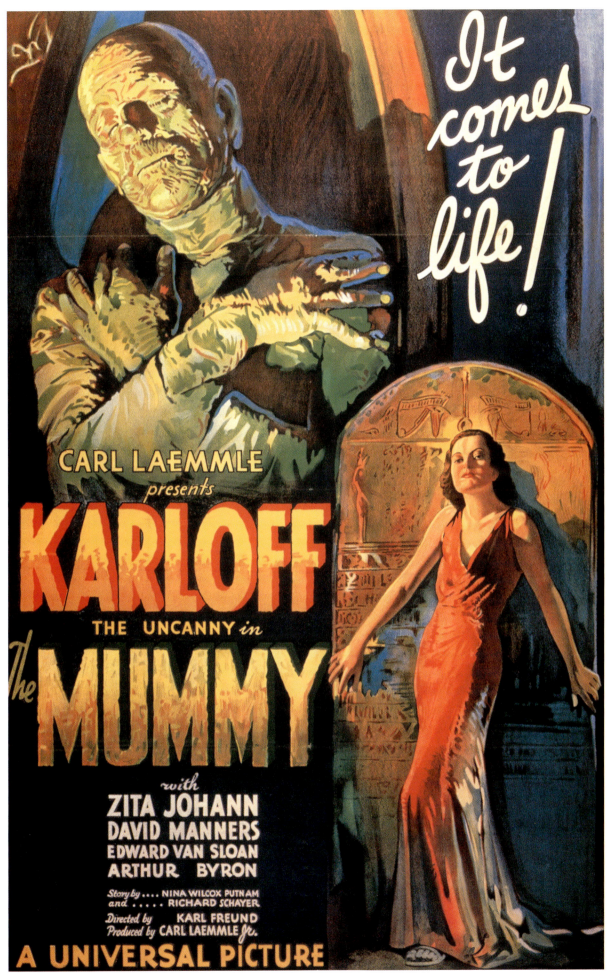

The Mummy (1932)
US 41 × 27 in. (104 × 69 cm)
(Style D)
Art by Karoly Grosz

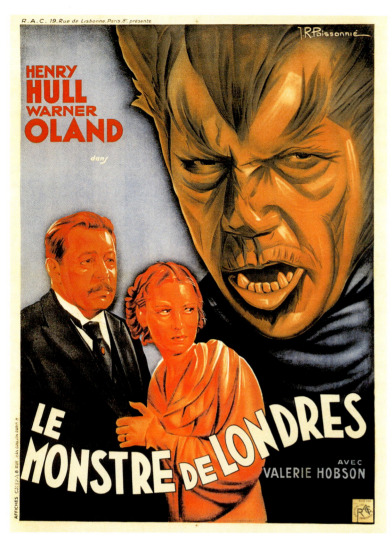

The Werewolf Of London (Il Monstre De Londres) (1935)
French 63 × 47 in. (160 × 119 cm)
Art by I. R. Poissonnié
Courtesy of The Reel Poster Gallery

Curse Of The Werewolf (L' Implacabile Condanna) (1961)
Italian 55 × 39 in. (140 × 99 cm)
Courtesy of The Reel Poster Gallery

Universal released *The Werewolf Of London* in 1935, but it was six years later that *The Wolf Man* made the myth of lycanthropy popular. With a stellar cast headed by Lon Chaney Jr., it is the definitive werewolf movie. *The Curse Of The Werewolf* in 1961 was Hammer's distinctive take on the classic.

The beautiful and eerie Italian design for *The Wolf Man,* by Paolo Tarquini, depicts the final and most memorable scene where Maleva, the gypsy seer, ministers to the slain and metamorphosing body of the Wolf Man uttering:

The way you walked was thorny, through no fault of your own.
But as the rain enters the soil, the river enters the sea,
So tears run to a pre-destined end.
Your suffering is over.
Now you will find peace for eternity.

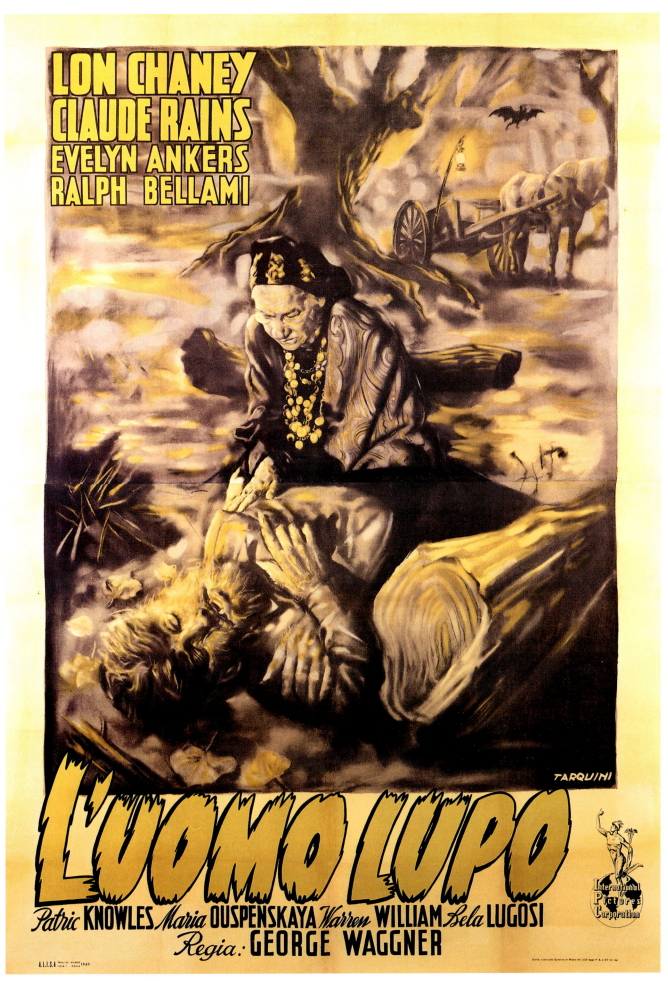

The Wolf Man (1941)
Italian 79 × 55 in. (201 × 140 cm)
Art by Paolo Tarquini
Courtesy of the Martin Bridgewater Collection

143

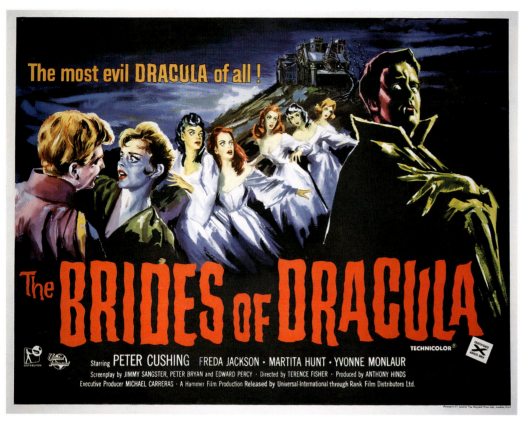

The Brides Of Dracula (1960)
British 30 × 40 in. (76 × 102 cm)

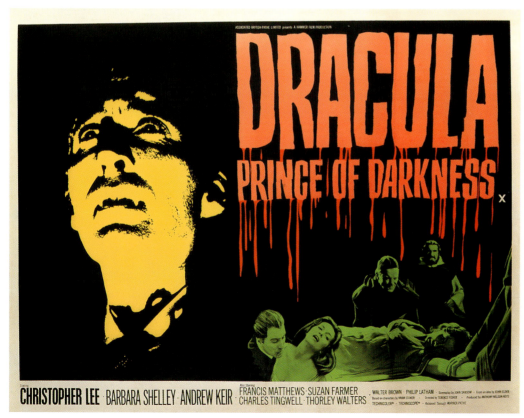

Dracula: Prince Of Darkness (1965)
British 30 × 40 in. (76 × 102 cm)
Courtesy of the Russell Mulcahy Collection

The success of *Dracula* and *Frankenstein* was phenomenal and it was not long before sequels began to appear. Thirty years later, Hammer adopted the same tactics and exploited the famous monsters for all they were worth in another series of successful sequels.

144

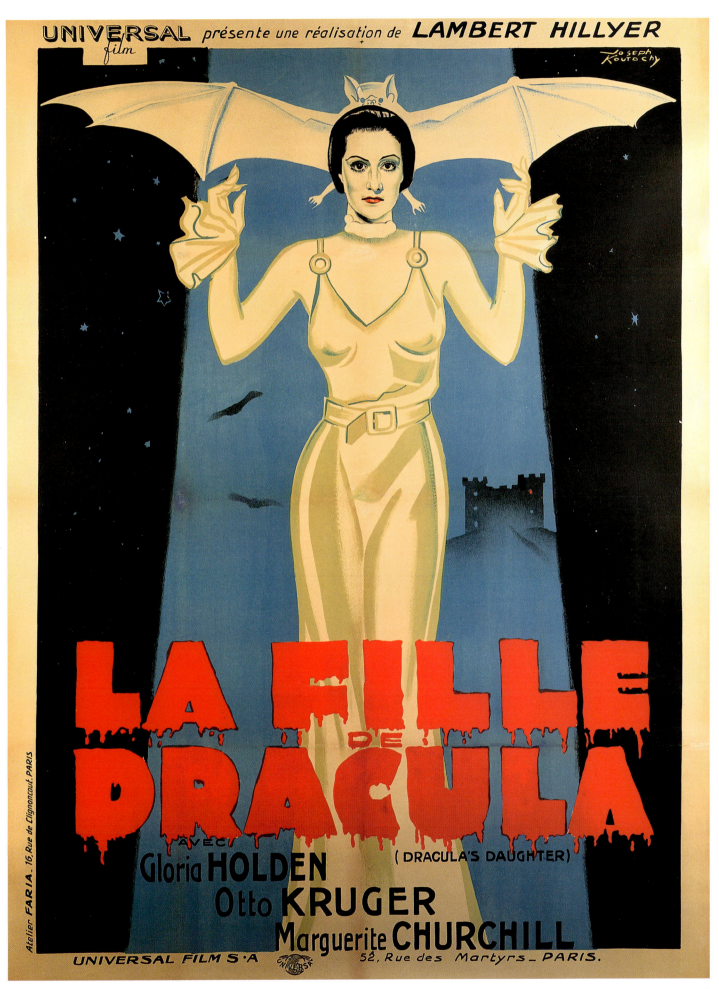

Dracula's Daughter (La Fille De Dracula) (1936)
French 63 × 47 in. (160 × 119cm)
Art by Joseph Koutachy
Courtesy of The Reel Poster Gallery

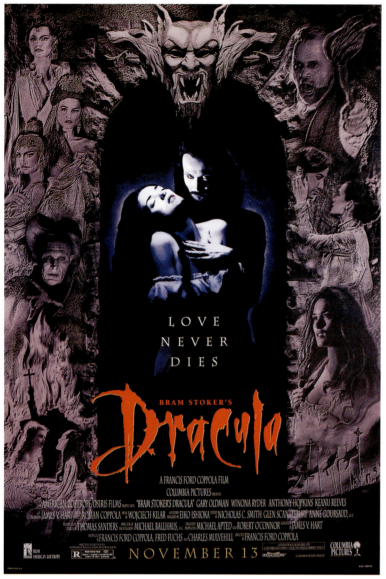

Bram Stoker's Dracula (1992)
US 41 × 27 in. (104 × 69 cm)
Photo by Albert Watson
Art direction by John Kehe & John McTague

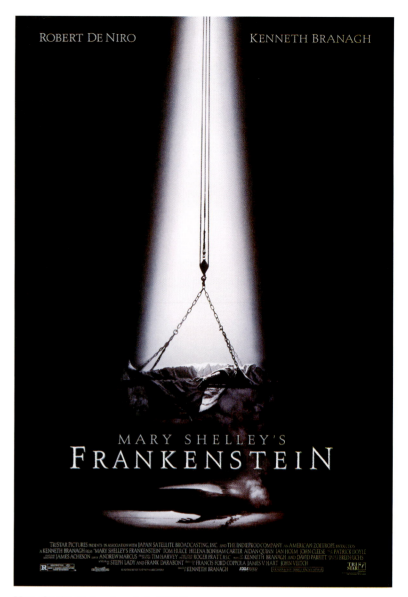

Mary Shelley's Frankenstein (1994)
US 41 × 27 in. (104 × 69 cm)
Creative direction by Tony Seinger
Photo by David Appelby

The recent 90s remakes of the classic horrors *Frankenstein*, *Dracula* and *The Mummy* show the enduring appeal of the Victorian ghost story. The latter is almost a spoof of the genre and contains several references to Universal horror classics.

The Mummy (1999)
US 41 × 27 in. (104 × 69 cm)

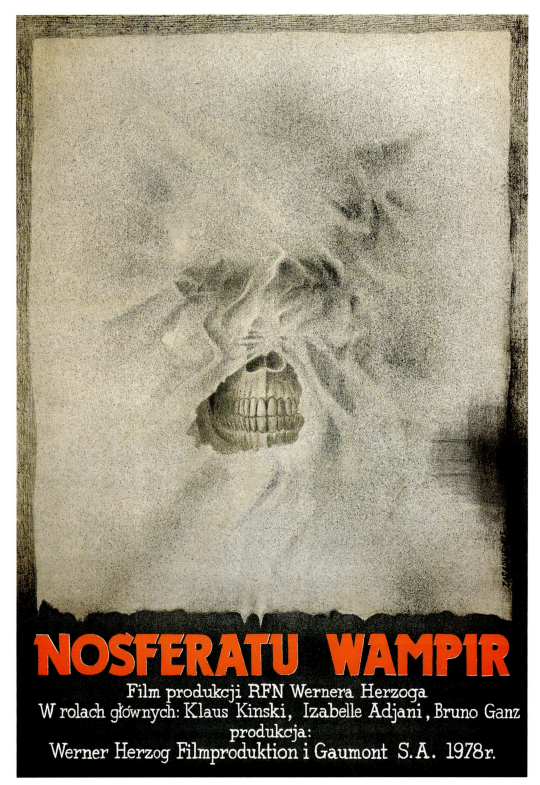

Nosferatu: Phantom Der Nacht (Nosferatu The Vampyre) (1979)
Polish 38 × 27 in. (97 × 69 cm)
Art by Zygmunt Zaradkiewicz
Courtesy of The Reel Poster Gallery

Werner Herzog's *Nosferatu* is an eerie and atmospheric remake of the 1922 classic which paid tribute to the original without slavishly copying it. The story of the repugnant Nosferatu can be seen as a metaphor for the rise of Nazism. The film was also a product of the New German Cinema, a post-war generation of filmmakers who were trying to come to terms with Germany's Nazi past while looking to a new and prosperous future.

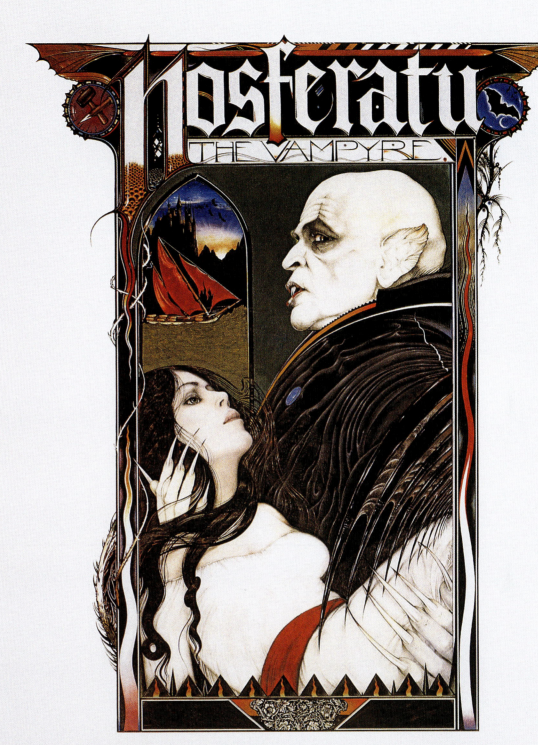

Nosferatu: Phantom Der Nacht (Nosferatu The Vampyre) (1979)
US 41 × 27 in. (104 × 69 cm)
Art by David Palladini

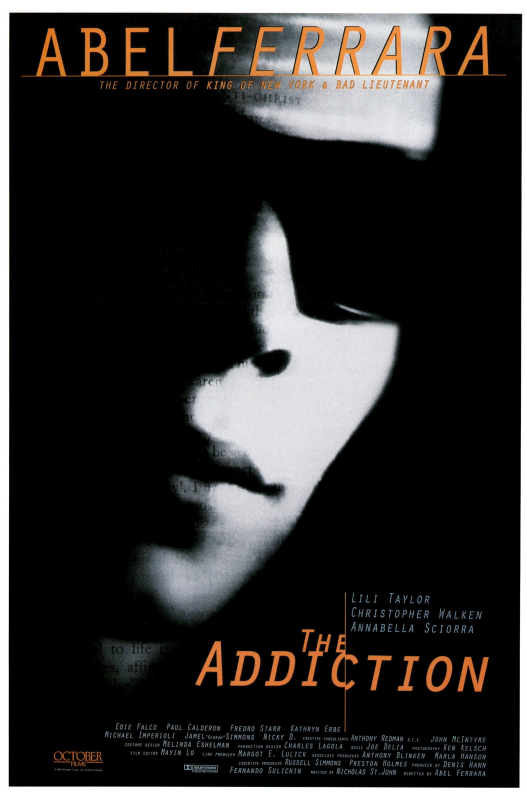

The Addiction (1995)
US 41 × 27 in. (104 × 69 cm)
Courtesy of The Reel Poster Gallery

The Addiction offers an eccentric twist on the vampire genre. Unique and intelligent, the film contains strong allusions to heroin addiction. Like much of Ferrara's work, it stresses mankind's inherent capacity for evil.

Although it is another tale of modern vampires, *The Lost Boys* is a very different film to *The Addiction*. A mix of teen flick and horror movie, it was a classic of the 80s with a great soundtrack, cast and script and remains something of a pop-culture phenomenon.

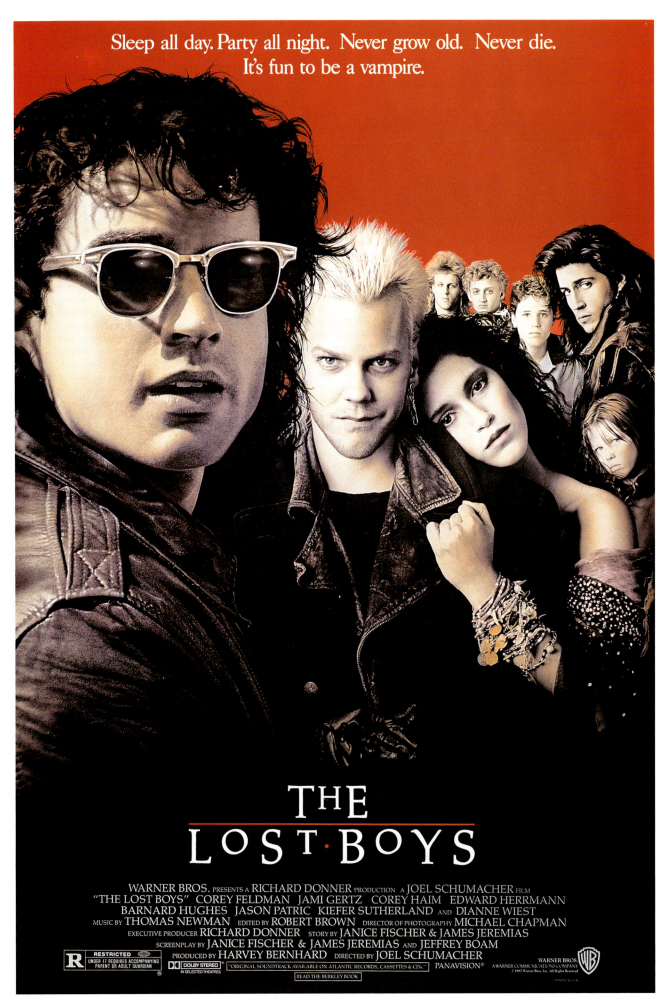

The Lost Boys (1987)
US 41 × 27 in. (104 × 69 cm)
Courtesy of the Martin Bridgewater Collection

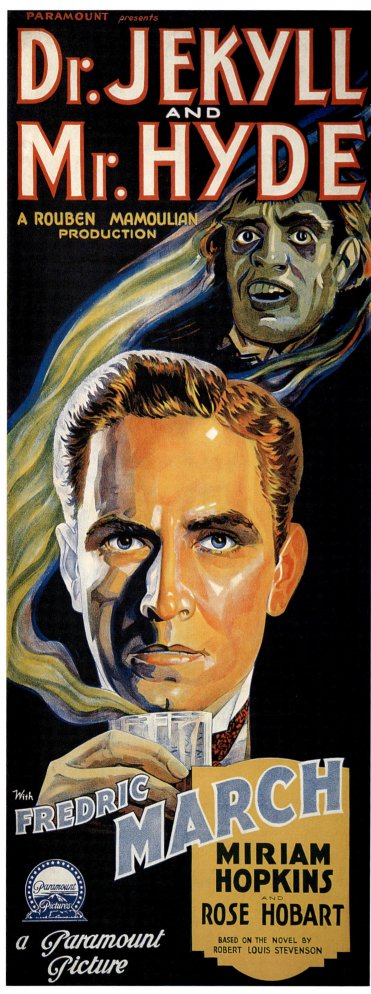

Dr. Jekyll And Mr. Hyde (1931)
Australian 30 × 12 in. (76 × 33 cm)

Robert Louis Stevenson (1850–1894) was born and raised in Edinburgh. Though celebrated as an essayist, poet and travel writer, it was his adventure stories that brought him international recognition. He suffered from tuberculosis from childhood and spent many hours in bed exercising his imagination by composing and writing stories. He went to Edinburgh University to study engineering but switched to law because of his weak constitution, and, while still a student, published his first work in *The Edinburgh University Magazine* (1871) and *The Portfolio* (1873). When he finished his studies, he took the decision to devote himself to literature rather than law. In 1883, he published his classic story of adventure and piracy, *Treasure Island*, and this was followed three years later by *The Strange Case Of Dr Jekyll And Mr Hyde*.

The story, which was written and published within ten weeks, was partly inspired by a dream of Stevenson's but was also based on the eighteenth-century case of Deacon Brodie. Brodie, a respected and well-known Edinburgh businessman by day, but a gambler and murderer by night was eventually caught and hanged. The story of the respectable Dr Jekyll and his monstrous alter ego can be seen as a metaphor both for the double standards of Victorian society and for the eternal struggle between good and evil in the human soul. The book was quickly recognized as a classic of the horror genre and inspired several other works. It has been adapted for the screen several times, most notably in 1931 by Paramount Pictures. The film was actually quite risqué for the time and many of the wilder scenes were lucky not to fall foul of the Hayes Code, which was brought into effect just two years later. Most of the posters for the film, regardless of country of origin, feature the two contrasting characters of Jekyll and Hyde. The Swedish poster is especially striking because of its unusual art deco style.

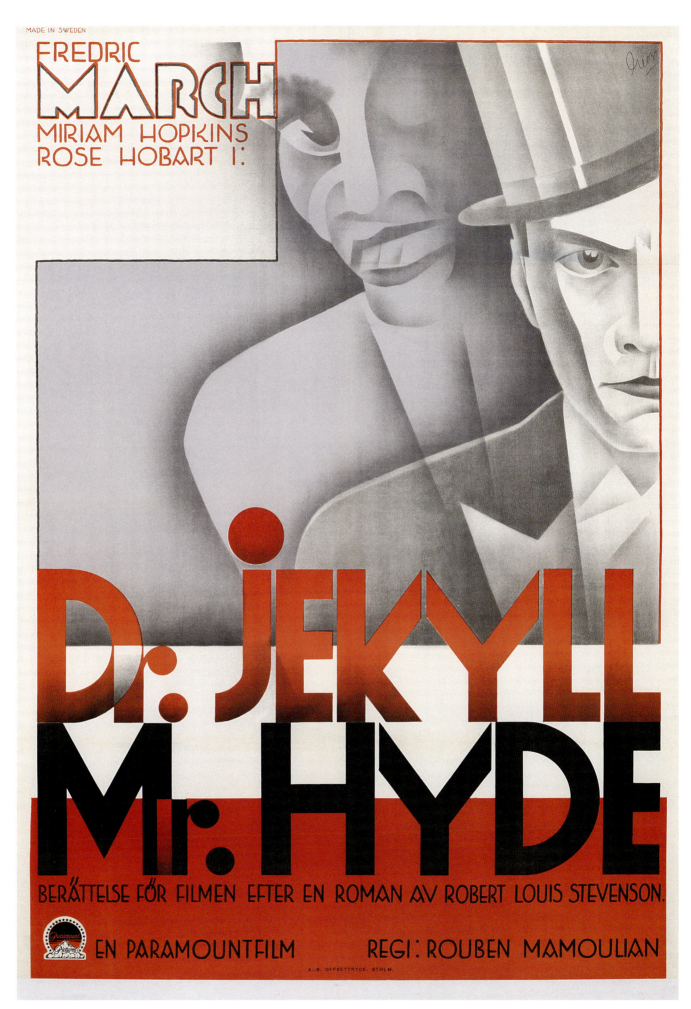

Dr. Jekyll And Mr. Hyde (1931)
Swedish 39 × 28 in. (99 × 71 cm)
(Style B)

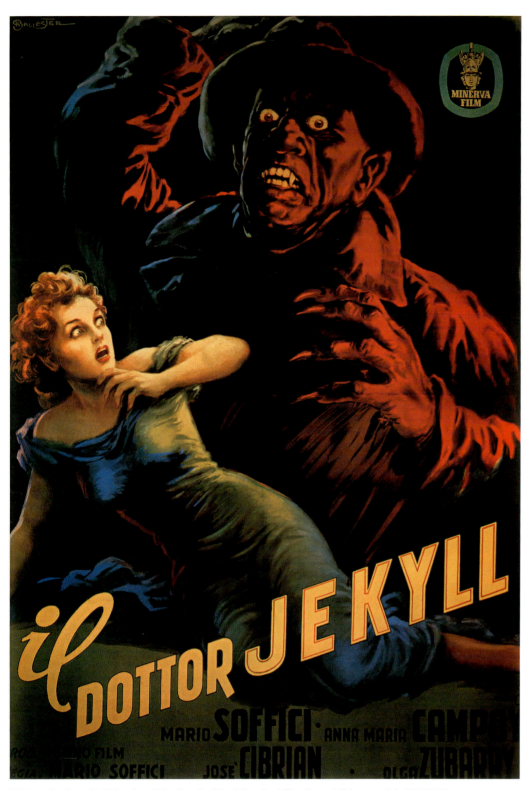

El Extraño Caso Del Hombre Y La Bestia (The Man And The Beast/ Il Dottor Jekyll) (1952)
Italian 79 × 55 in. (201 × 140 cm)
Art by Anselmo Ballester
Courtesy of the Richard Allen Collection

Anselmo Ballester (1897–1974) is famous for his beautiful film poster art and designed more than 500 posters over a 45-year period. He is best known for his work with the independent production company, Minerva Films, where he was employed as the main artist. This Italian company distributed many of the non-American films of the time, of which *El Extraño Caso Del Hombre Y El Bestia* is just one example. Ballester designed the two main posters, very different in style, for the film. His artwork for the smaller poster, executed in classical style and showing two faces merging into one, is so renowned and effective that any description is redundant. In contrast, the larger poster is a more traditional 'killer-victim' piece. The man's arm raised against the woman can, however, be seen as foreshadowing the slasher movies of the 80s.

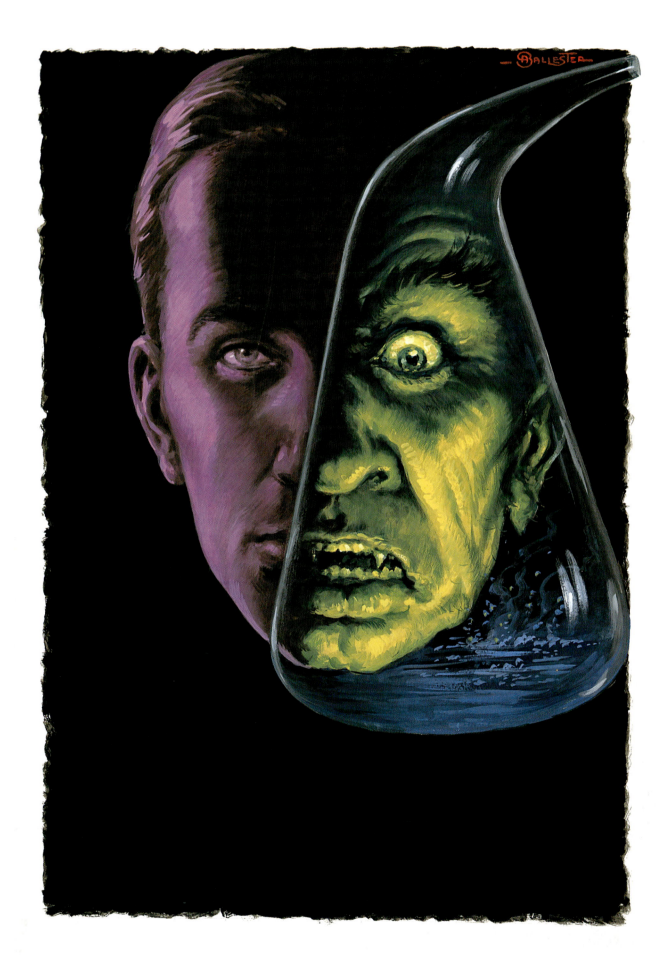

El Extraño Caso Del Hombre Y La Bestia (The Man And The Beast/ Il Dottor Jekyll) (1952)
Italian 23 × 16 in. (58 × 41 cm)
Original Artwork. Gouache on board. Signed top right.
Art by Anselmo Ballester
Courtesy of The Reel Poster Gallery

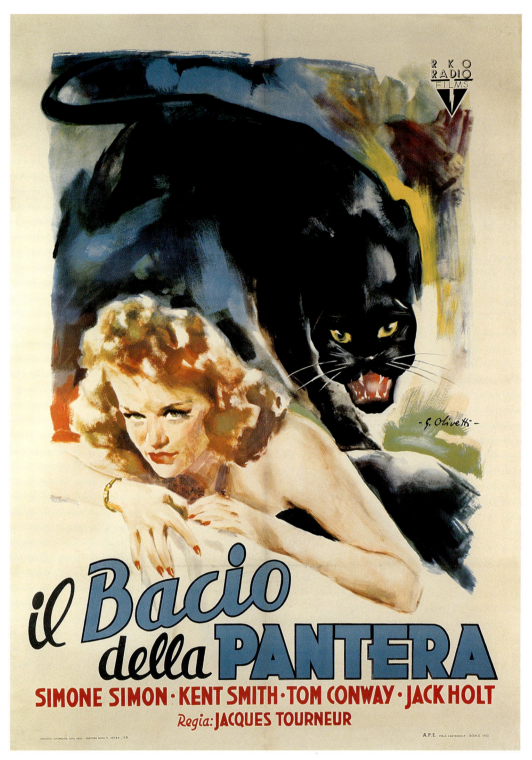

Cat People (Il Baccio Della Pantera) (1942)
Italian 55 × 39 in. (140 × 99 cm)
Art by Georgio Olivetti

Cat People marked a new departure for horror movies. Val Lewton's first film for RKO, it bears all the hallmarks of his later works; the plot is subtle and suggestive, and tension is ratcheted up slowly and progressively. Lewton, who wrote the screenplay with DeWitt Bodeen, suffered from a cat-phobia which frequently gave him nightmares and this undoubtedly gave the film an intensity and urgency which it might otherwise have lacked.

Studio bosses were initially angry when they saw the finished product as it seemed not to have enough 'traditional' scares. However, when the movie played to sell-out audiences they quickly realized that in hiring Lewton they had, in fact, made the wisest of investments. The film recovered RKO's fortune.

William Rose was responsible for the striking artwork for the film and he designed several more posters for RKO throughout the 40s. Olivetti's design is very different in style and is one of the earliest examples of the renowned artist's work. His most famous poster design was for *La Dolce Vita* almost a decade later.

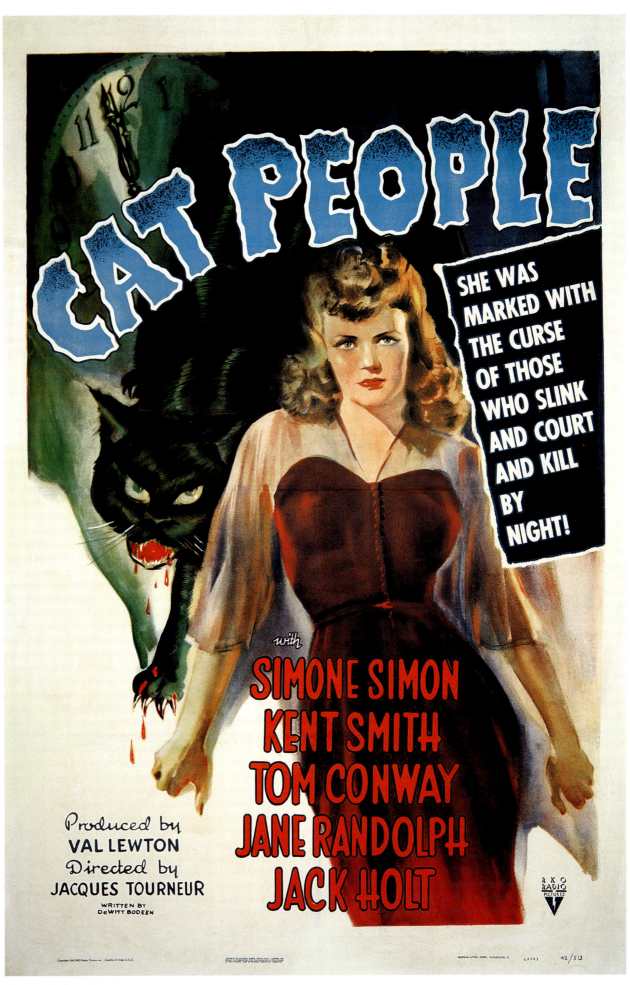

Cat People (1942)
US 41 × 27 in. (104 × 69 cm)
Art by William Rose
Courtesy of The Reel Poster Gallery

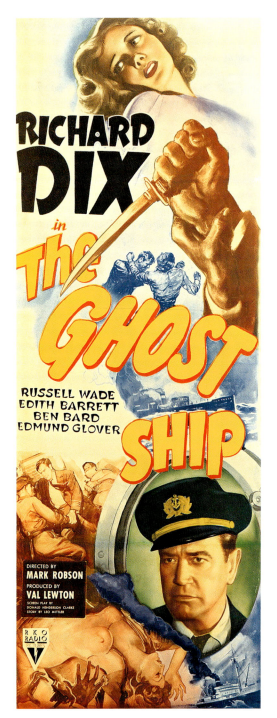

The Ghost Ship (1943)
US 36 × 14 in. (91 × 36 cm)
Courtesy of The Reel Poster Gallery

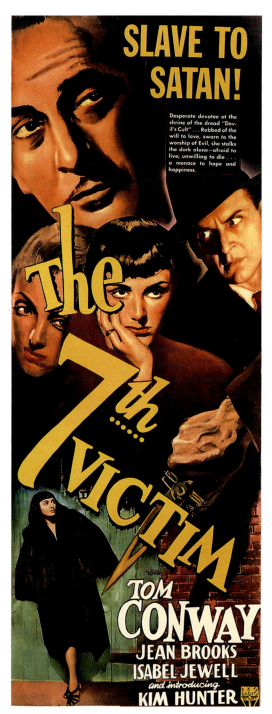

The Seventh Victim (1943)
US 36 × 14 in. (91 × 36 cm)

Vladimir Ivan Leventon (1904–1951) was born in Russia and moved to the United States when he was just five years old. After graduating from Columbia University, he wrote for a variety of newspapers and magazines, both mainstream and X-rated, and he also worked on a number of novels. It was as a freelancer that he started using he pseudonym under which he would become famous, Val Lewton. In 1933, he secured a job with David O. Selznick as general film assistant and story editor, then, in 1938, he was given the opportunity to co-direct the Bastille scene in *A Tale Of Two Cities*.

Around this same time, RKO were looking for new talent and ideas to turnaround the studio's increasingly dire financial situation. The success of Universal's famous horror productions had not been lost on them and they decided to create a unit to produce horror B-movies that would cost so little to make that they were almost guaranteed to make a profit. In 1942, Val Lewton was chosen to head this new unit.

The studio wanted short films, under 75 minutes, made on low budgets that could be shown as one half of a double bill. They frequently provided Lewton with no more than a title, and he was sent away with a small team of writers who were expected to come up with a script. The results exceeded expectations. Between 1942 and 1946, Lewton produced eleven films that were superior to much of the 'A' product from the same period. This was the start of a new and influential cycle of horror as the monsters and straightforward scares of the 30s were replaced by a more subtle, psychological approach to scaring the pants off movie-goers.

The artwork for the Brazilian poster for *Curse Of The Cat People* is an extraordinary combination of 60s, psychedelic design and Grimm Brothers' fairy-tale imagery.

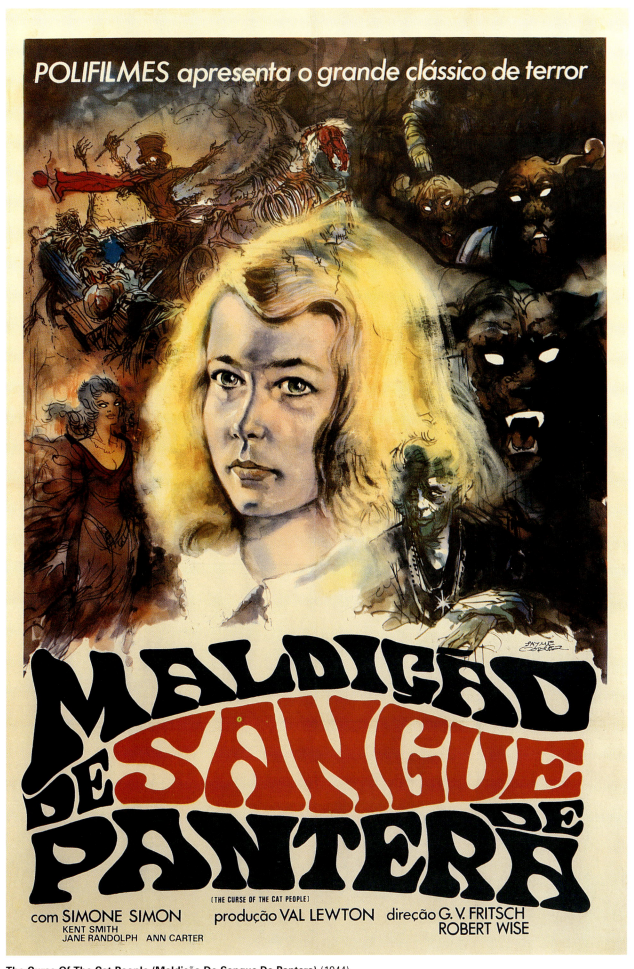

The Curse Of The Cat People (Maldição De Sangue De Pantera) (1944)
Brazilian 44 × 30 in (112 × 76cm)
Poster circa 1960s.
Art by Payne Gomez
Courtesy of The Reel Poster Gallery

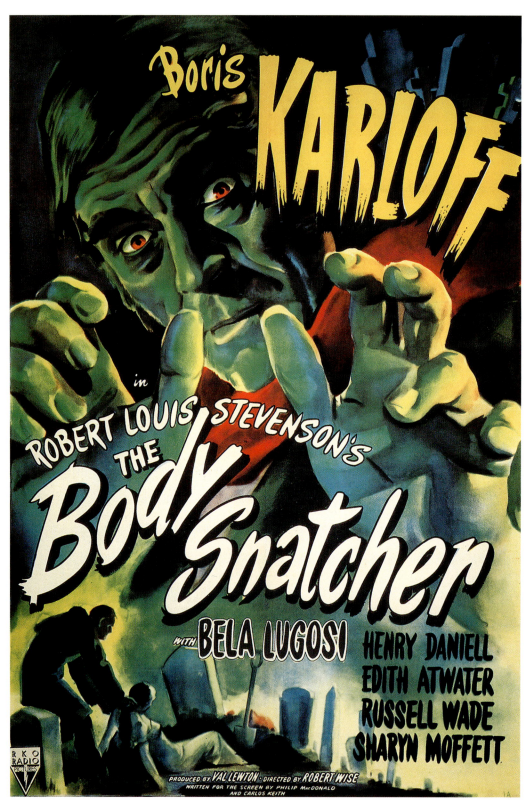

The Body Snatcher (1945)
US 41 × 27 in. (104 × 69 cm)

Robert Louis Stevenson was a master of the Victorian ghost story. *The Body Snatcher* is one of his most chilling tales – perfect material for a 40s horror film. *The Body Snatcher* saw Lewton move away from his stock psychological horrors to make a film in a more gruesome and macabre tradition. Like *Jekyll And Hyde*, *The Body Snatcher* was based on a grisly episode from Scottish history. Burke and Hare were two nineteenth-century grave robbers who were employed by a respected doctor to provide cadavers for dissection at his public lectures. When the supply of bodies for their gruesome trade ran short, the duo started seeking out living victims to meet their customer's demands. Lewton's film is noted for featuring one of Boris Karloff's best performances and for being Robert Wise's directorial debut.

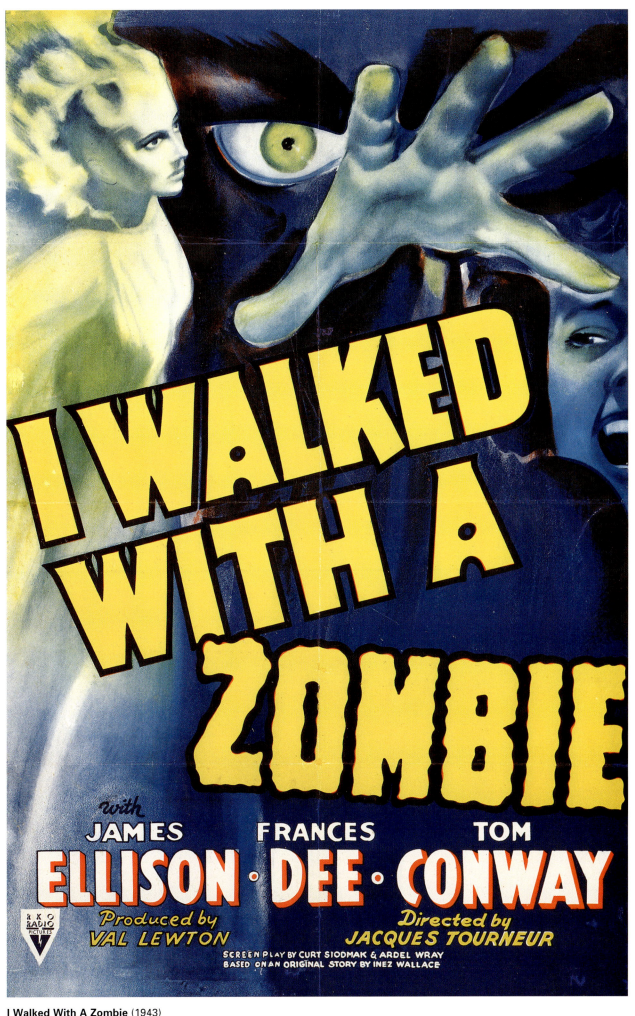

I Walked With A Zombie (1943)
US 41 × 27 in. (104 × 69 cm)

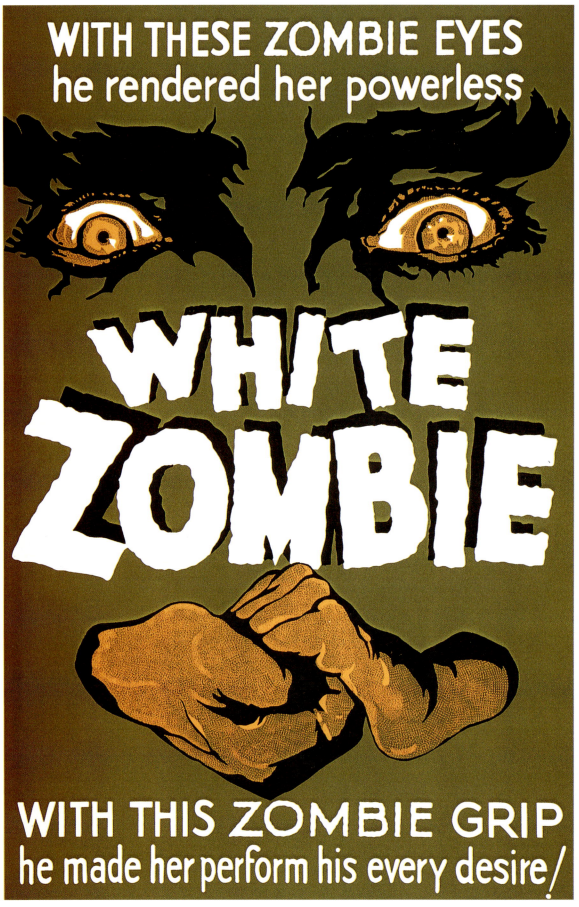

White Zombie (1932)
US 41 × 27 in. (104 × 69 cm)
Re-release 1930s
Courtesy of the Helmut Hamm Collection

The word 'zombie' was first introduced to readers in *Magic Island*, a novel by William B. Seabrook published in 1929. Three years later the word appeared for the first time in the movies in *White Zombie*. From then on zombies remained a firm staple of horror B-flicks – bringing the dead back to life was a popular pastime in the 30s and 40s, and not just for Frankenstein. Unlike the gory and repugnant creatures of Romero's *Night Of The Living Dead*, the early zombies were basically genteel beings; a little lumbering and white around the gills, but generally sympathetic and sensitive types, who always had a valid reason to be out killing and maiming.

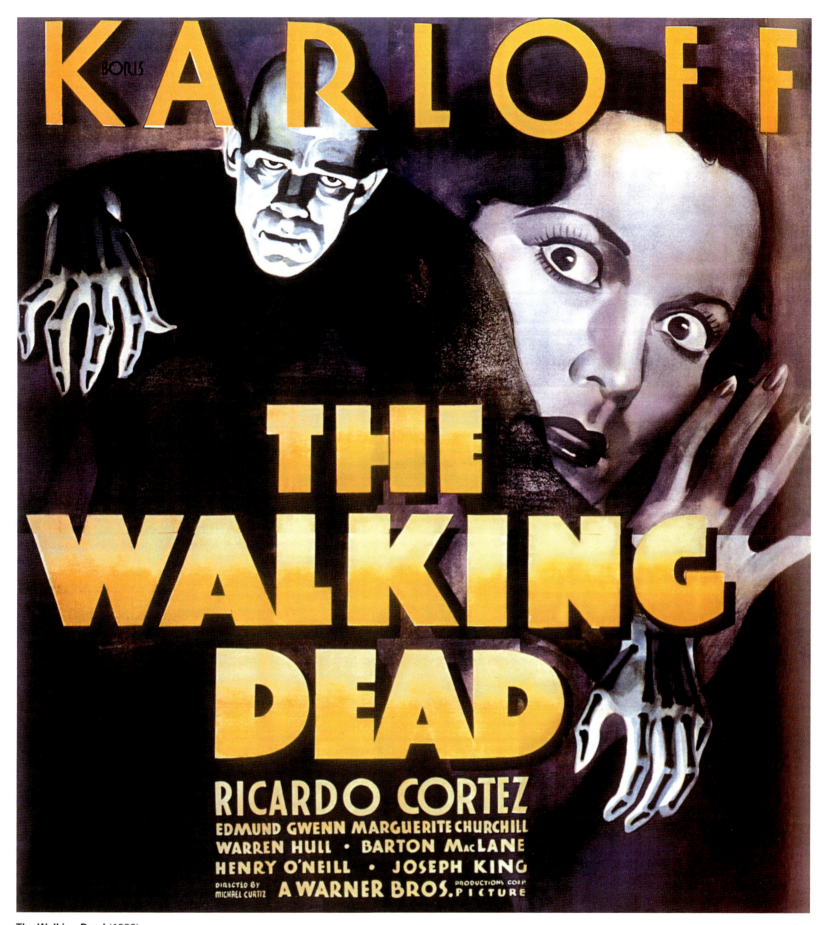

The Walking Dead (1936)
US 81 × 81 in. (206 × 206 cm)

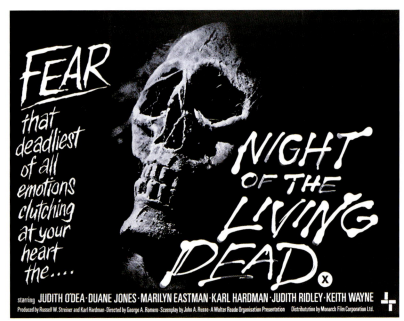

Night Of The Living Dead (1968)
US 41 × 27 in. (104 × 69 cm)

Born in New York in 1940, **George Romero** became a renowned horror director. In the late 60s, he formed his own production company, Image Ten Productions, with friends. They each contributed $10,000 of their own funds and this formed the budget for *Night Of The Living Dead*, the massive horror hit that made Romero world famous. Although he has had other successes, it is his *Dead* series that remains his most popular works by far.

When Romero made *Night Of The Living Dead* in 1968, he gave birth to the modern zombie flick and the film has had a lasting influence. Extremely gory, it was initially dismissed as exploitation, but when re-released in 1969, it struck a chord with a disillusioned generation angry with the deepening quagmire in Vietnam. Romero cast a black man, Duane Jones, as the hero of the film and his death is clearly a reference to the recent assassinations of liberal leaders Martin Luther King and Robert F. Kennedy. *Night Of The Living Dead* was one of the first successful independent horror productions, inspiring countless rip-offs and parodies. It also gave birth to two equally celebrated sequels; *Dawn Of The Dead* and *Day Of The Dead*.

Night Of The Living Dead (1968)
British 30 × 40 in. (76 × 102 cm)
Courtesy of the Stephen O'Connor Collection

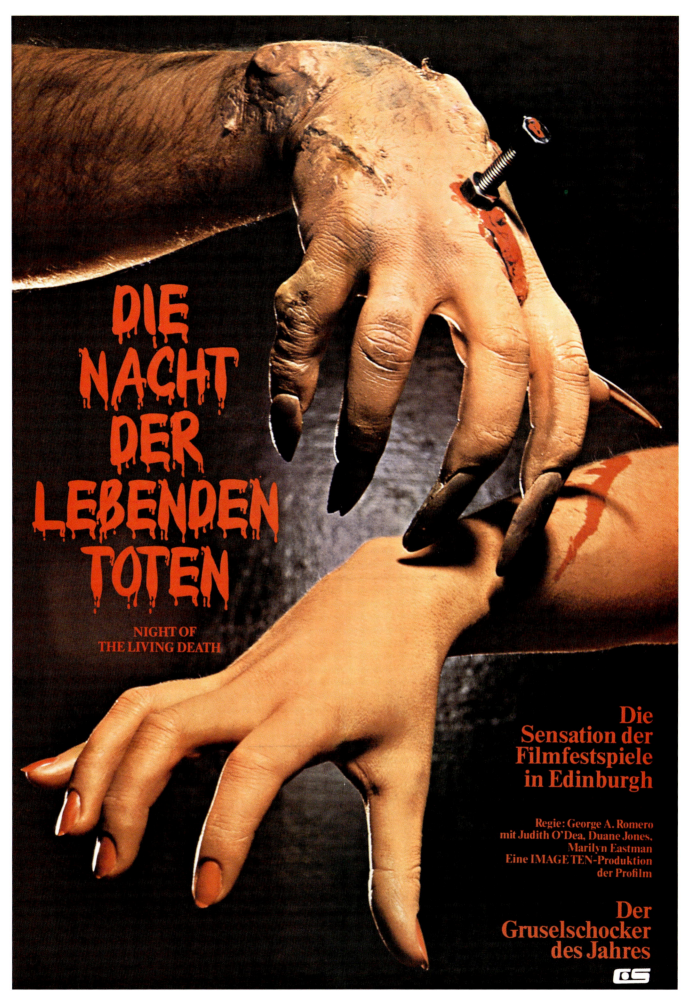

Night Of The Living Dead (Die Nacht Der Lebenden Toten) (1967)
German 33 × 23 in. (84 × 58 cm)
Courtesy of The Reel Poster Gallery

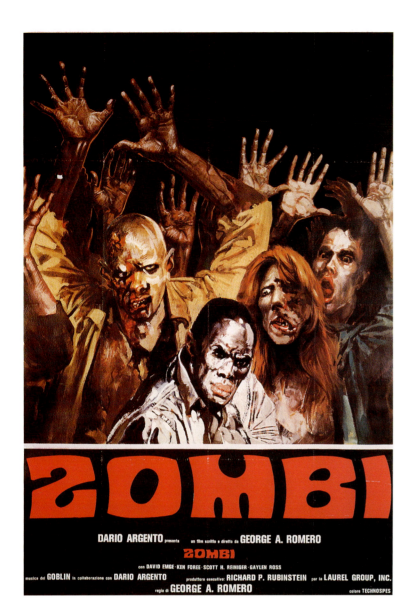

Dawn Of The Dead (Zombi) (1978)
Italian 79 × 55 in. (201 × 140 cm)

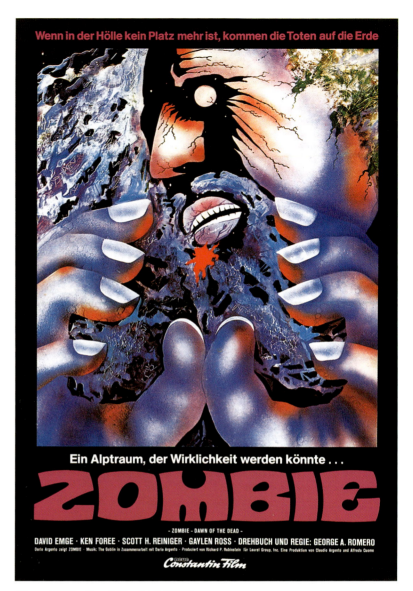

Dawn Of The Dead (Zombie) (1978)
German 33 × 23 in. (84 × 58 cm)
(Style B)
Courtesy of The Reel Poster Gallery

With *Night Of The Living Dead*, George Romero reinvented the zombie film and he has had a lasting influence on the horror genre. His sequel, *Dawn Of The Dead*, is equally legendary and one of the most successful independent films ever made. Combining gore and adventure with skilful characterization and plot, the film is a metaphor for mindless American consumerism – the action is in fact played out in a shopping mall. By the film's conclusion, it is clear who the real zombies are. *Dawn Of The Dead* was the second film in a trilogy that concluded with *Day Of The Dead*.

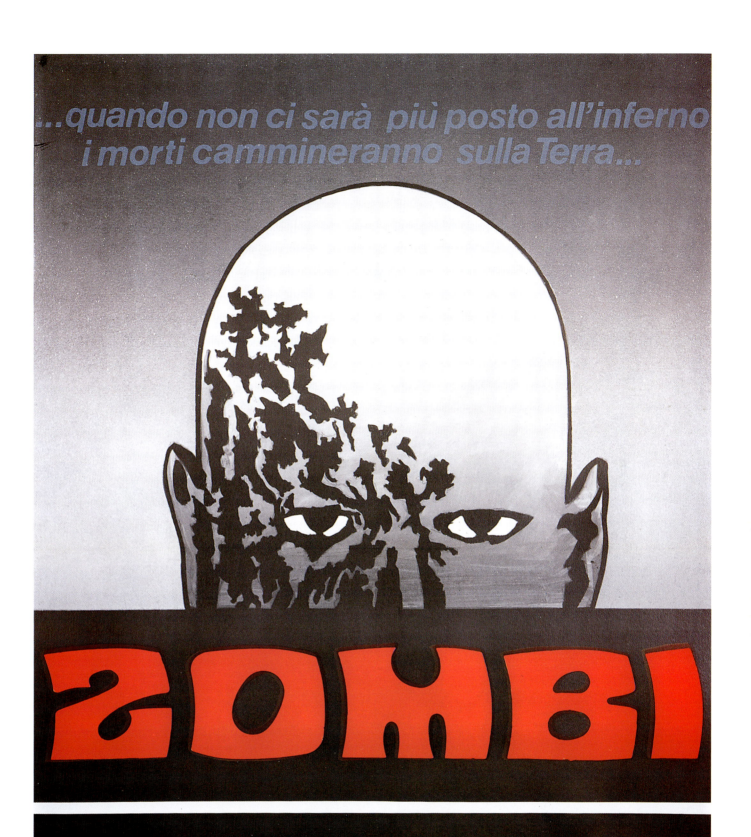

Dawn Of The Dead (Zombi) (1978)
Italian 55 × 39 in. (140 × 99 cm)

A STORY SO UNUSUAL IT WILL BURN ITSELF INTO YOUR MIND

A WEIRD TALE OF THE UNNATURAL

A PICTURE THAT WILL HAUNT YOU

CARNIVAL OF SOULS

starring
CANDACE HILLIGOSS
and
SIDNEY BERGER

PRODUCED AND DIRECTED BY HERK HARVEY
A HARCOURT PRODUCTION

A HERTS-LION INTERNATIONAL CORP. RELEASE

Carnival Of Souls (1962)
US 41 × 27 in. (104 × 69 cm)
Courtesy of the Joe Burtis Collection

Carnival Of Souls and *Dementia 13* are two subtle horror films from the early 60s that explore the characters' dark secrets and personal demons. The latter is remembered for being one of the earliest directorial ventures by Francis Ford Coppola. Shot in just three weeks on a budget of $30,000, *Carnival Of Souls* mostly played to drive-in audiences but it is an important and influential film that was groundbreaking for its time. This surreal film focuses on a woman caught between life and death, and the haunting and eerie atmosphere is oppressive and unrelenting throughout.

Dementia 13 (1963)
US 41 × 27 in. (104 × 69 cm)

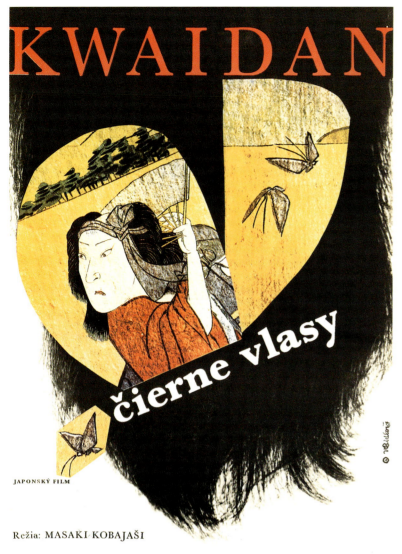

Kwaidan (Cierne Vlasy) (1964)
Czechoslovakian 33 × 23 in. (84 × 58 cm)
(Style B)
Art by Vladimir Bidlo
Courtesy of The Reel Poster Gallery

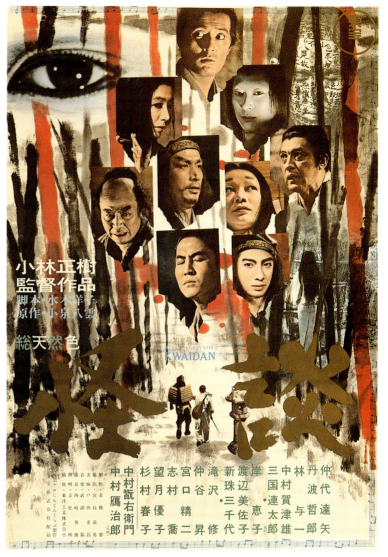

Kwaidan (1964)
Japanese 30 × 20 in. (76 × 51 cm)
(Style B)
Courtesy of the Martin Bridgewater Collection

In Japanese, 'Kwaidan' literally means 'ghost story'; a perfect description for this most unsettling and visually spectacular film. It won the Special Jury Prize at the 1965 Cannes Film Festival and was the last film made by the acclaimed director Masaki Kobayashi. Accompanied by a groundbreaking score by Toro Takemitsu it was, at the time, the most expensive film made in Japan.

Kwaidan is a collection of four short ghost stories based on the writings of Lafcadio Hearn, a Greek-born writer who lived in the United States before taking up residence in Japan at the age of forty. He immersed himself completely in the culture of the country and became a subject of the Empire, changing his name to Koizumi Yakuno. His insight into the traditions and mores of his adopted country was profound and Kwaidan remains one of the most celebrated Japanese films of the twentieth century.

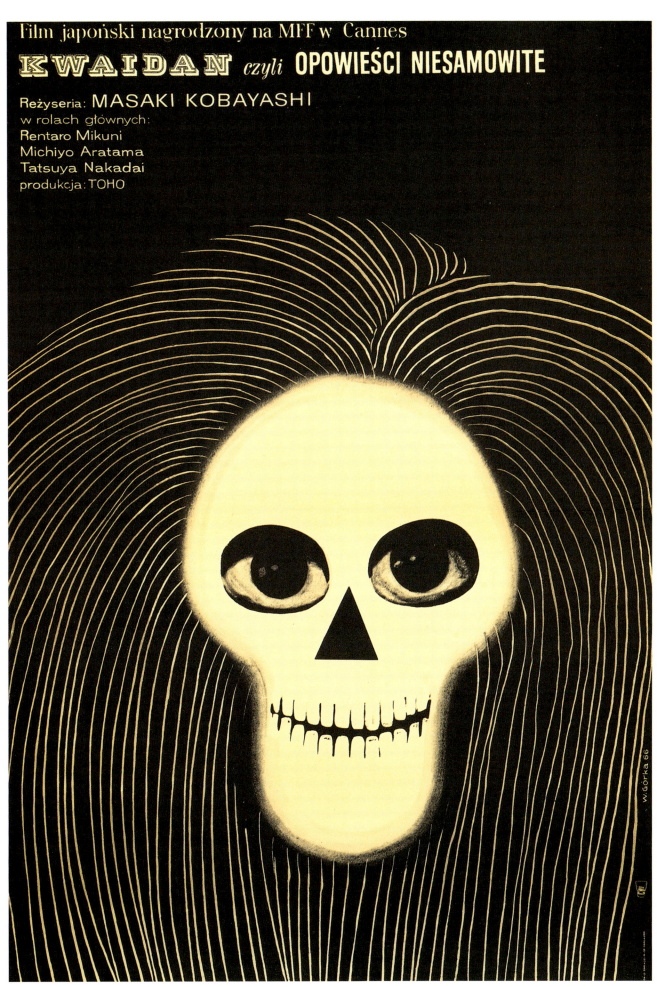

Film japoński nagrodzony na MFF w Cannes

KWAIDAN *czyli* **OPOWIEŚCI NIESAMOWITE**

Reżyseria: MASAKI KOBAYASHI
w rolach głównych:
Rentaro Mikuni
Michiyo Aratama
Tatsuya Nakadai
produkcja: TOHO

Kwaidan (1964)
Polish 33 × 23 in. (84 × 58 cm)
Art by Wiktor Gorka
Courtesy of the Martin Bridgewater Collection

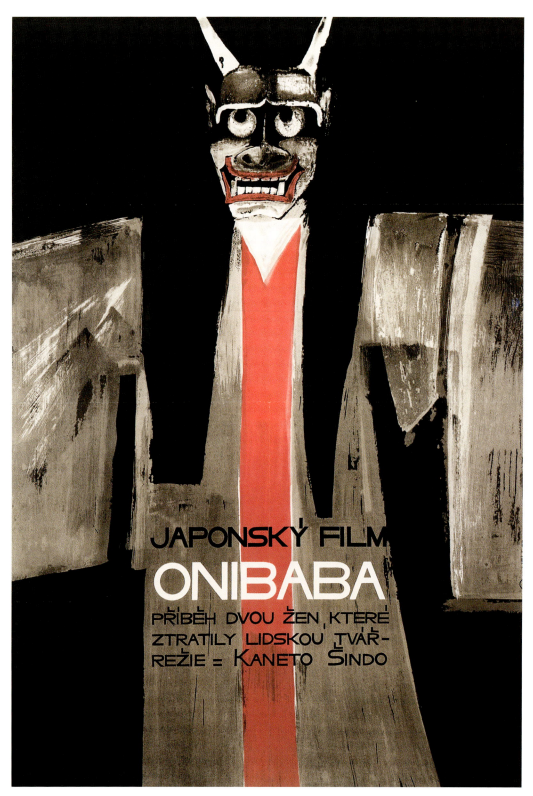

Onibaba (1964)
Czechoslovakian 33 × 23 in. (84 × 58 cm)
Art by H. Meli
Courtesy of the Martin Bridgewater Collection

Onibaba, a hypnotic tour de force, is a sepulchral work that combines shocking horror with beautiful photography. It is the haunting tale of a mother who is destroyed by her own jealousy. After donning a mysterious devil-mask to frighten away her daughter-in-law's suitor, she finds the mask is stuck to her face and can only be removed with horrific results. The East German and Czechoslovakian posters are both striking portrayals of this central image.

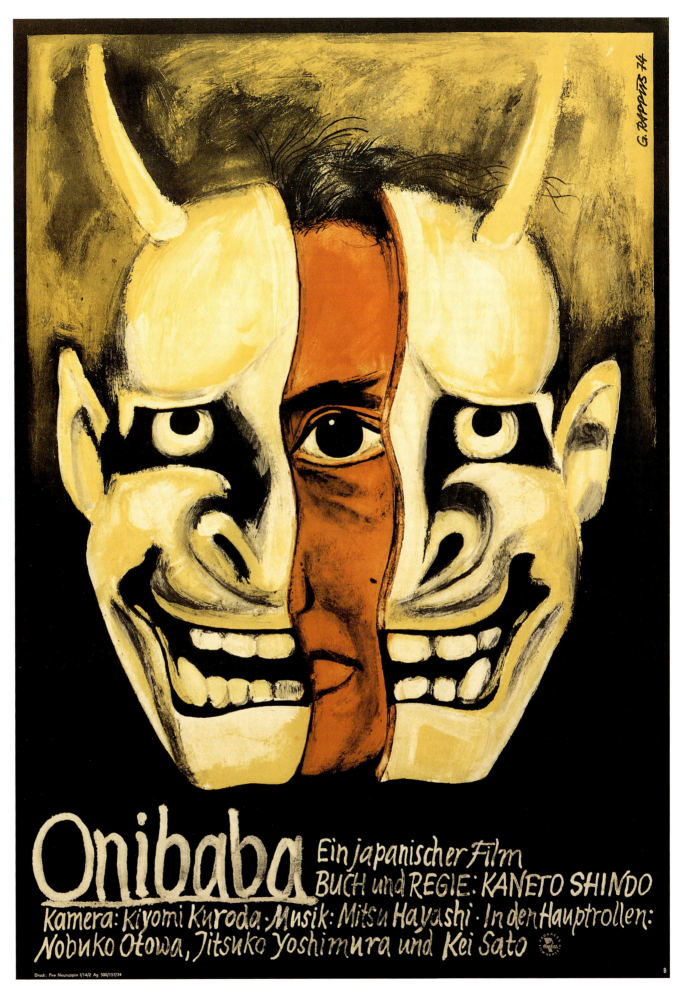

Onibaba (1964)
East German 33 × 23 in. (84 × 58 cm)
(Style B)
Courtesy of the Martin Bridgewater Collection

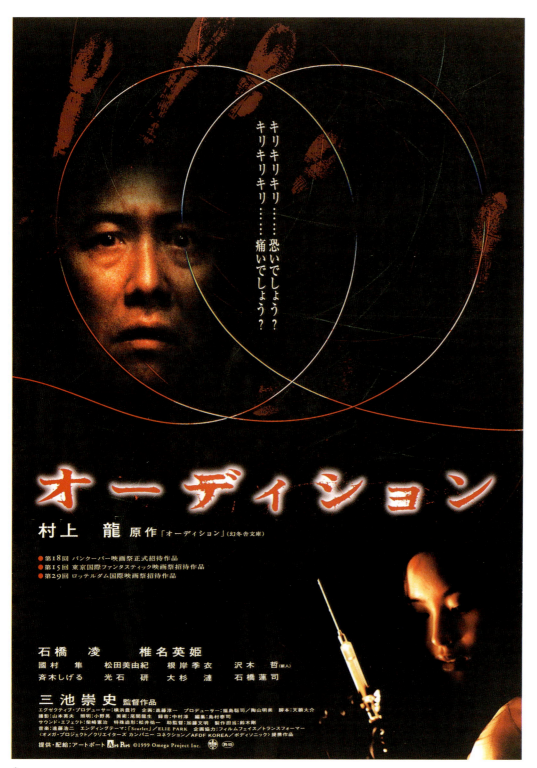

Ôdishon (Audition) (2000)
Japanese 29 × 20 in. (74 × 73 cm)
Courtesy of The Reel Poster Gallery

Ringu became a cultural phenomenon on its release in the Far East and took the box office by storm. A spooky and subtle Japanese ghost story, the film is part of a new wave of Japanese horror films that have been extremely popular, both in their country of origin and around the world. *Ôdishon* is another recent hit.

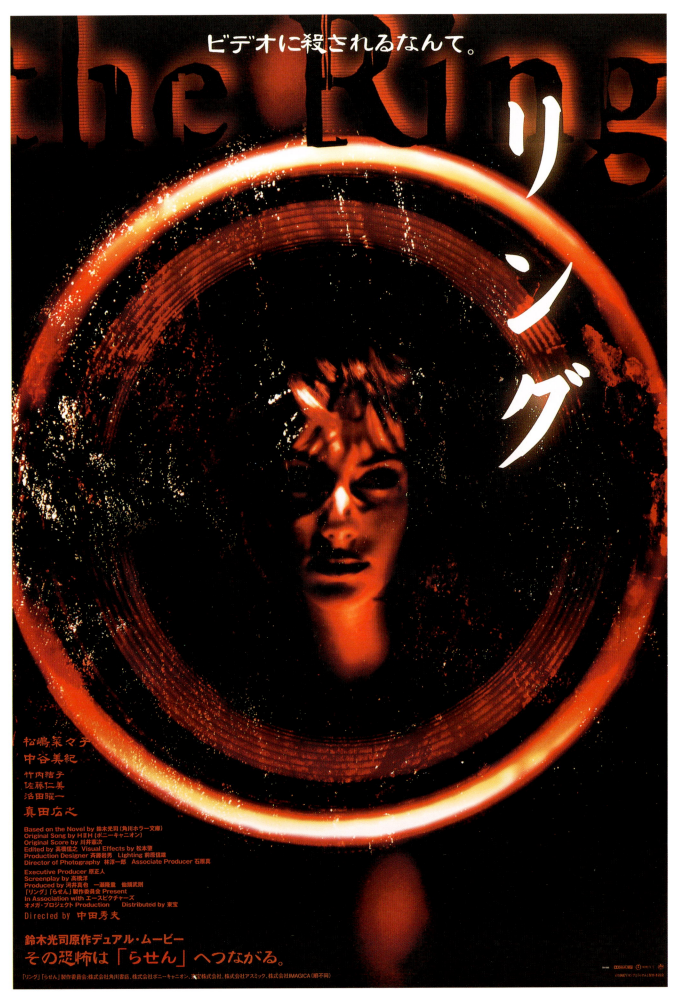

Ringu (The Ring) (1998)
Japanese 30 × 20 in. (76 × 51 cm)
Courtesy of The Reel Poster Gallery

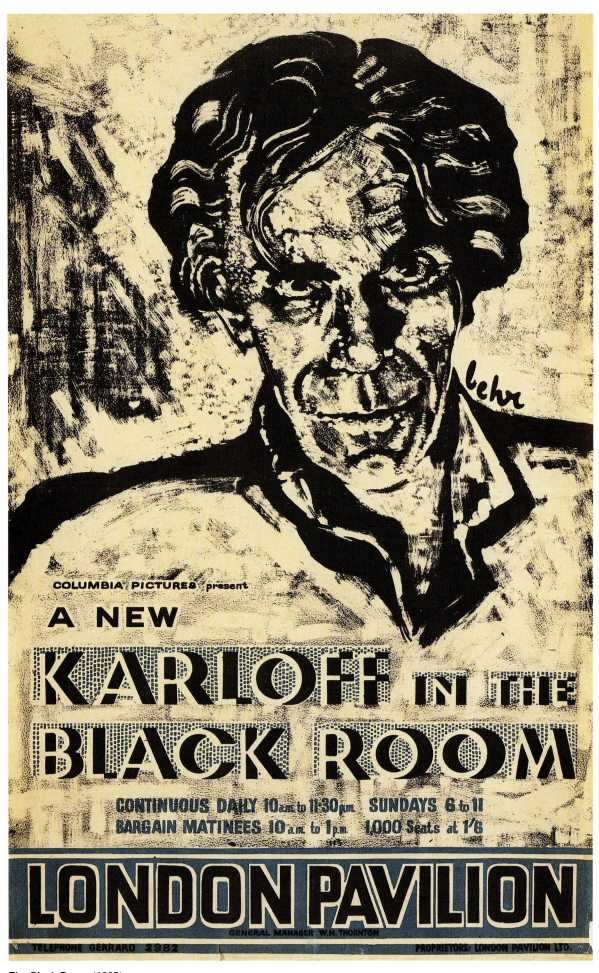

The Black Room (1935)
British 20 × 13 in. (51 × 33 cm)
Courtesy of the Philip Masheter Collection

Boris Karloff was born in Britain and after forging a successful career in Hollywood, returned to his native country to make *The Ghoul*, Britain's first true horror film. Although Karloff is often remembered only for his work with Universal Studios, he had a long career in horror that encompassed many other projects – *The Ghoul* and *The Black Room* are two examples and the former is the most important role he had in the 30s outside Universal. Karloff also starred in a number of successful Val Lewton RKO horrors in the 40s and he worked with Mario Bava in the 50s.

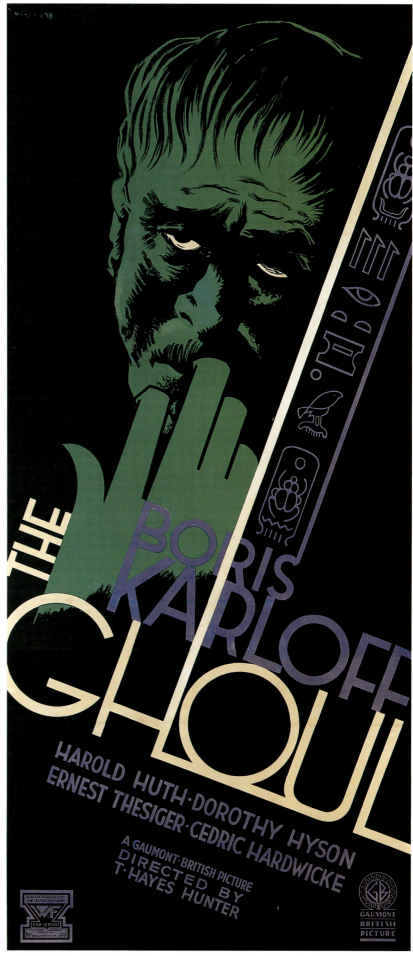

The Ghoul (1934)
British 88 × 40 in. (224 × 102 cm)
(Style B)
Art by Marc Stone
Courtesy of the Chris Dark Collection

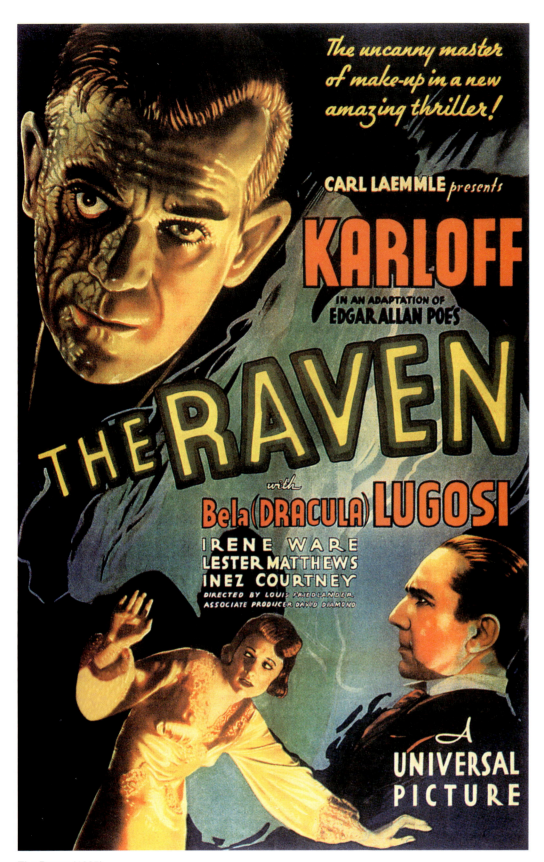

The Raven (1935)
US 41 × 27 in. (104 × 69 cm)
Art by Karoly Grosz

Famous not only as a poet, but also as one of the pioneers of the detective story and for his macabre psychological thrillers, **Edgar Allan Poe** (1809–1849) provided much of the raw material for horror and science fiction cinema. He was a master of the short-story form and his works have inspired and influenced several films. Even one of his poems, *The Raven*, a dark and haunting modern fairy-tale, was successfully adapted for the screen by Universal – though Poe never saw a cent of the earnings, having originally allowed a newspaper to publish the work for free and thus forfeited his copyright. *Murders In The Rue Morgue* was another Universal success and the story is adapted from what many consider to be the first-ever detective story.

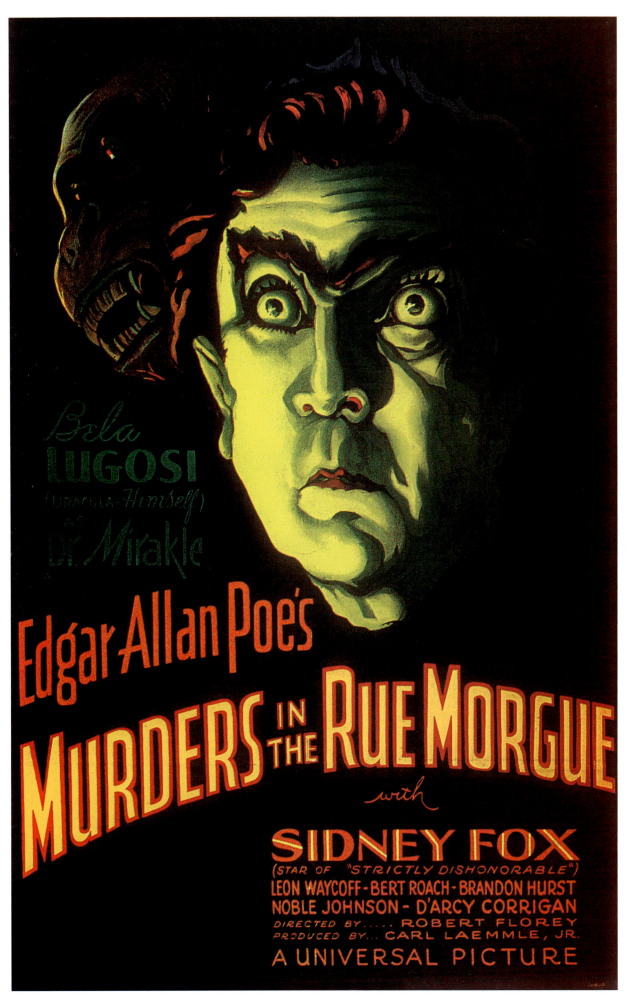

Murders In The Rue Morgue (1932)
US 41 × 27 in. (104 × 69 cm)
Art by Karoly Grosz

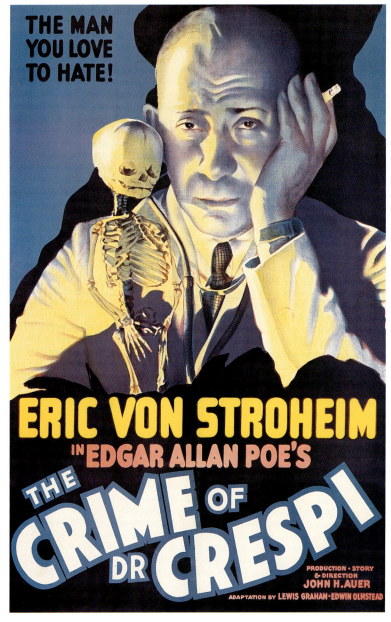

The Crime Of Dr. Crespi (1935)
US 41 × 27 in. (104 × 69 cm)
Courtesy of the Andrew Cohen Collection

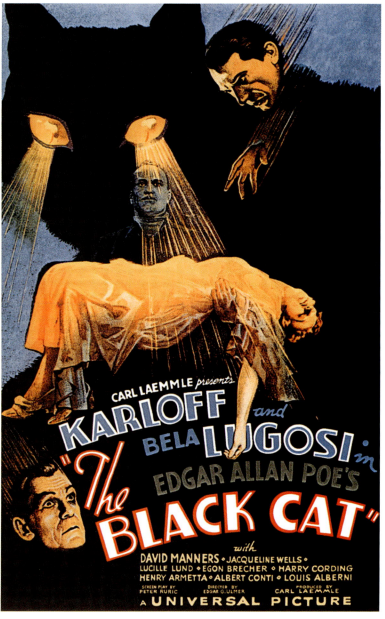

The Black Cat (1934)
US 41 × 27 in. (104 × 69 cm)

Lugosi and Karloff were first teamed together in the film of Edgar Allan Poe's *The Black Cat*, released in 1934. The duo, who were life-long friends off-screen, were re-united the following year in *The Raven* and would come together on several other occasions in the course of their on-screen careers.

Leader Press was a small company that existed from 1930 to 1936. It provided an alternative to the more ordinary, and some argued 'uninspired' film posters of the time. Holding contracts with several of the major studios, the company's only stipulation was that the studio name would not appear anywhere on the design. The results were creative and avant-garde.

The Black Cat (1934)
US 41 × 27 in. (104 × 69 cm)
(Leader Press)

The Pit And The Pendulum (1961)
US 41 × 27 in. (104 × 69 cm)

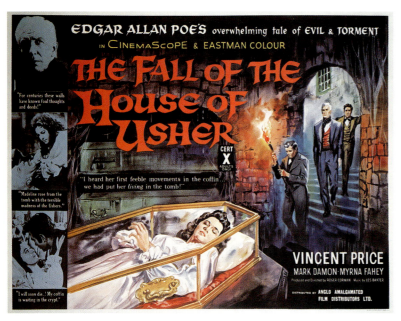

House Of Usher (The Fall Of The House Of Usher) (1960)
British 30 × 40 in. (76 × 102 cm)
Courtesy of the Stephen O'Connor Collection

Roger Corman (b.1926), the 'King of the B's', is a maestro of low-budget horror and science-fiction movies. Combining the roles of producer, director and distributor, he has a legendary eye for talent and many famous names, including Francis Ford Coppola, Martin Scorsese, Jack Nicholson and Robert DeNiro worked with Corman early on in their careers. He was renowned for being able to shoot very quickly on a very low budget – his *Little Shop Of Horrors* was filmed in two days and a night. He earned his reputation in the early 60s with a series of Edgar Allan Poe adaptations starring Vincent Price. The first of these, *House Of Usher*, was the first film Corman had made with a shooting schedule of more than two weeks – it was completed in fifteen days – and it had his largest ever budget. The series began when American International Pictures, who frequently double-billed two black and white horror or science-fiction films, approached Corman to make two more black and white numbers, but he convinced them to let him make a single picture in colour. *House Of Usher* was such a success that AIP asked Corman to make a second Poe picture: so Corman chose *Pit And The Pendulum*.

angielski film grozy

GROBOWIEC LIGEI

wg. Edgara Allana Poe
Reżyseria: Roger Corman

w rolach
głównych:

Vincent Price

Elisabeth Shepherd

Derek Francis

Produkcja
Alta Vista
Roger Corman

The Tomb Of Ligeia (Grobowiec Ligei) (1965)
Polish 33 × 23 in. (84 × 58 cm)
Art by Maciej Hibner
Courtesy of The Reel Poster Gallery

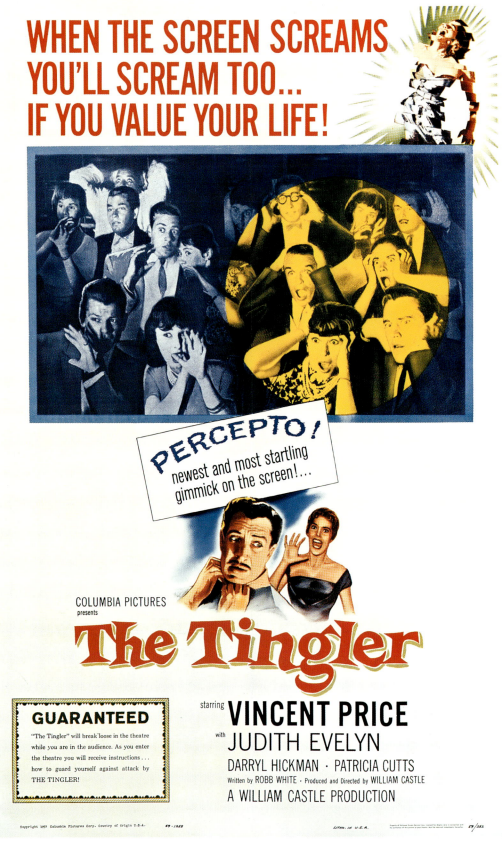

The Tingler (1959)
US 41 × 27 in. (104 × 69 cm)
Courtesy of The Reel Poster Gallery

Schlockmeister **William Castle** (1914–1977) had a prolific career in B-movies. Born William Schloss (his surname means 'castle' in German), Castle started out as a stage actor before moving to Hollywood in the late 30s. He directed his first feature in 1943 but it is for his work in the late 50s that he is remembered. As an independent producer, Castle recognized the necessity of having an edge on his competitors; he also saw the growing public interest in shock-horror and science-fiction movies. He capitalized on this trend by developing various gimmicks to accompany his films. For *The House On Haunted Hill*, he pioneered a process called 'Emergo' which featured a luminous skeleton that swung out over audiences' heads during particularly tense scenes. For *The Tingler*, Castle wired up certain cinemas so that audiences would be given mild electric shocks through their chairs.

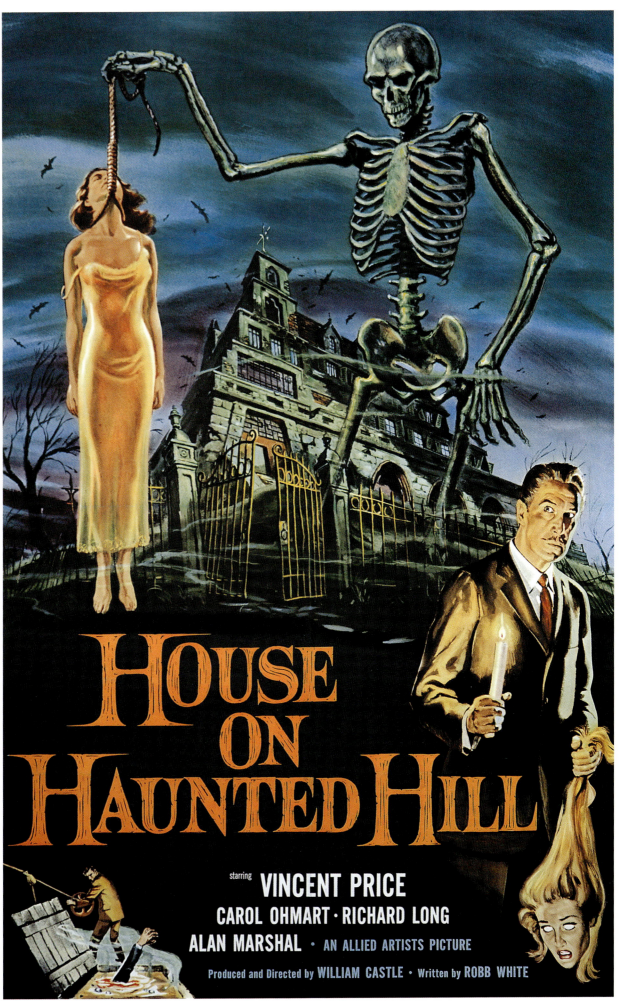

The House On Haunted Hill (1959)
US 41 × 27 in. (104 × 69 cm)

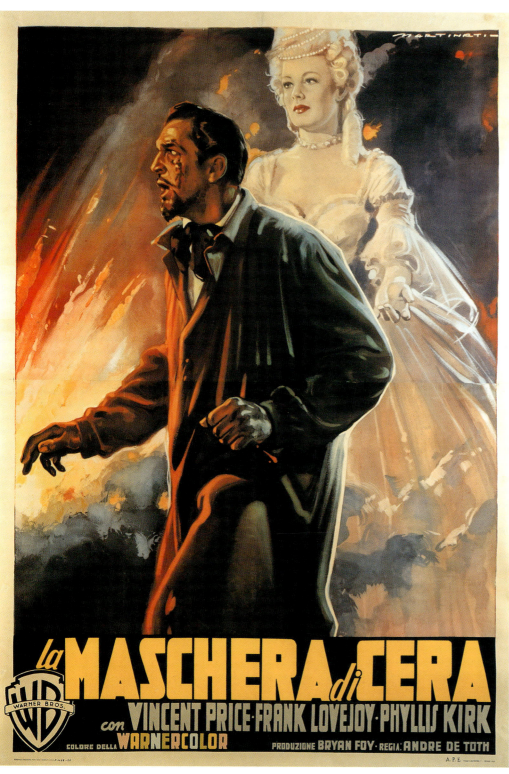

Born within hours of his contemporaries Christopher Lee and Peter Cushing, **Vincent Price** (1911–1993) is one of the most famous and enduring villains in horror cinema. His dark, quizzical expression and his voice, which was sufficient by itself to create an atmosphere of threat and danger, ensured that he had a long and distinguished career. After graduating from both Yale and the University of London, he made his stage debut in 1935 and first appeared on the screen in *Service De Luxe* in 1938. Initially, Price struggled to find decent film parts and continued to do a lot of stage work. The breakthrough came in 1946 with his first starring role as the murderous villain in *Shock*. He had finally found his niche but fame took a few more years to come, and it was not until 1953 that one of the low-budget horrors in which he continued to star, *House Of Wax*, became a hit and the offers finally started pouring in. In 1958 he starred in the science-fiction hit of the year, *The Fly* and this was followed by *The House On Haunted Hill* in 1960. His reputation as a master of the horror genre was further consolidated by his starring roles in *House Of Usher* and a series of popular Edgar Allan Poe adaptations directed by Roger Corman.

House Of Wax (La Maschera Di Cera) (1953)
Italian 79 × 55 in. (201 × 140 cm)
Art by Luigi Martinati
Courtesy of the Tony Sasso Collection

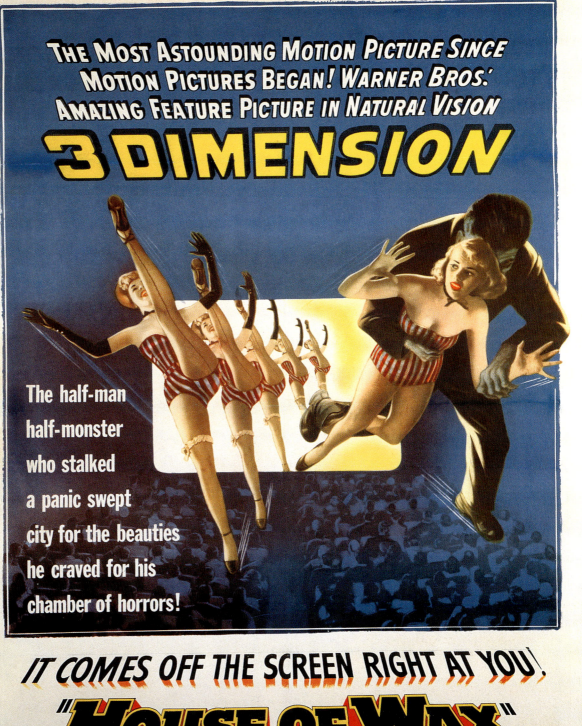

House Of Wax (1953)
US 41 × 27 in. (104 × 69 cm)
(3-D)

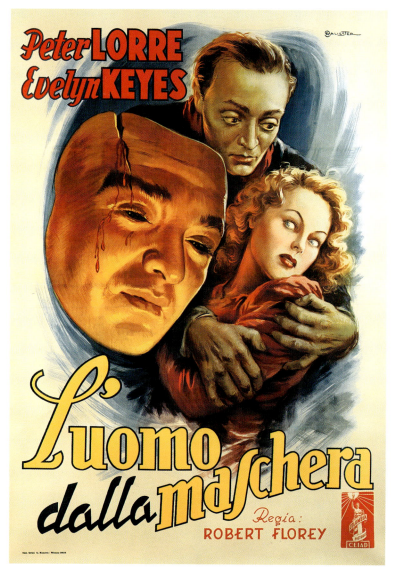

The Face Behind The Mask (L'Uomo Dalla Maschera) (1941)
Italian 79 × 55 in. (201 × 140 cm)
Art by Anselmo Ballester
Courtesy of The Reel Poster Gallery

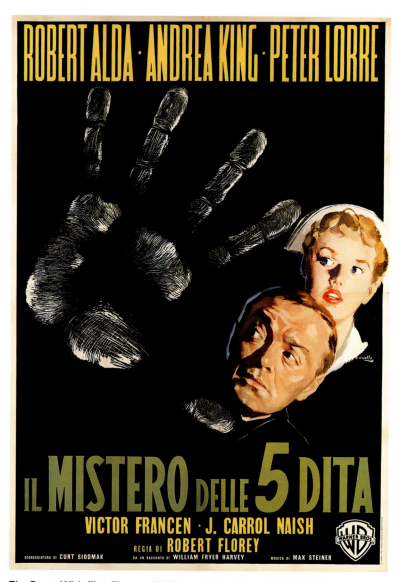

The Beast With Five Fingers (Il Mistero Delle Cinque Dita) (1947)
Italian 79 × 55 in. (201 × 140 cm)
Art by Averardo Ciriello
Courtesy of The Reel Poster Gallery

Peter Lorre (1904–1964), who was once described by Charlie Chaplin as 'the world's greatest actor', had a film career that spanned 33 years and included such classics as *M*, *Casablanca* and *The Maltese Falcon*. Born Laszlo (Ladislav) Löwenstein in Hungary, he grew up in Vienna before running away from home at seventeen. In 1921, desperate to pursue a career as an actor, he moved to Berlin where he secured parts in several plays and became a favourite of the playwright Bertolt Brecht. His big break was in 1931 when he was cast as the lead in Fritz Lang's first talkie, *M*, playing a child molester and serial killer. His outstanding portrayal of this tortured soul is still a model for actors today.

Lorre left Germany in 1933 when Hitler came to power (he was allegedly warned by Goebbels himself to leave the country). He made his way to Britain, where he starred in Hitchcock's *The Man Who Knew Too Much*, learning his lines phonetically because of his poor English. He then moved on to Hollywood, where he had a number of starring roles. But, to his frustration, he often found himself typecast as a mad or dangerous criminal; it is a tribute to his inimitable style that he always managed to transform even the most stereotypical of these characters into a live and unique creation. Given that he had become one of Hollywood's favourite villains, it was inevitable that Lorre would star in many horror films, including *The Man Behind The Mask*, but even his talents could not rescue movies like *Mad Love*, one of MGM's biggest flops of 1935.

Lorre was instantly recognisable by his bulging eyes set in a round face and his nasal voice. By the end of the 40s, he was so well known that he was caricatured in Warner Brothers cartoons and on Spike Jones records. He died of heart failure in 1964, but remains one of the film world's most memorable personalities.

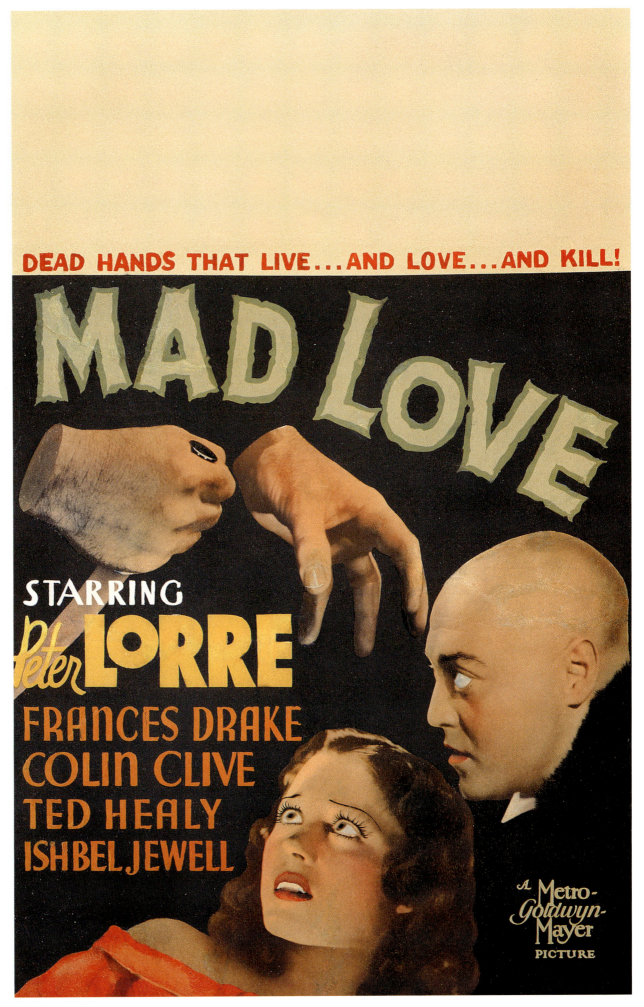

Mad Love (1935)
US 22 × 14 in. (56 × 36 cm)

TITLE INDEX

ARTIST, DESIGNER AND PHOTOGRAPHER INDEX

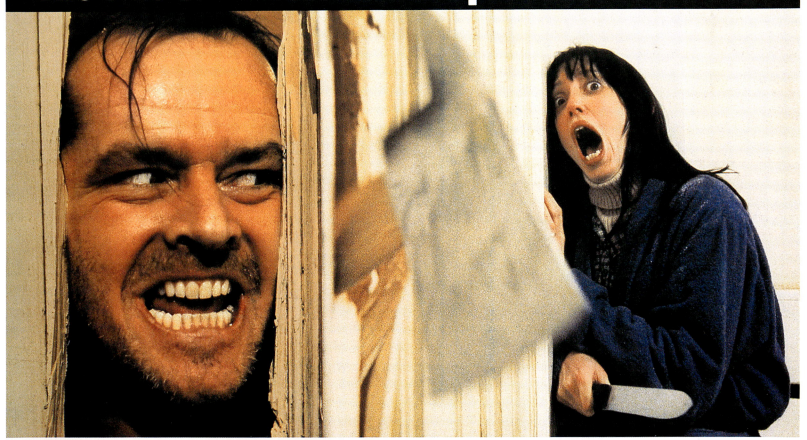

The Shining (1980)
British 30 × 40 in. (76 × 102 cm)
Courtesy of The Reel Poster Gallery